D0146245

· Redesigning the World ·

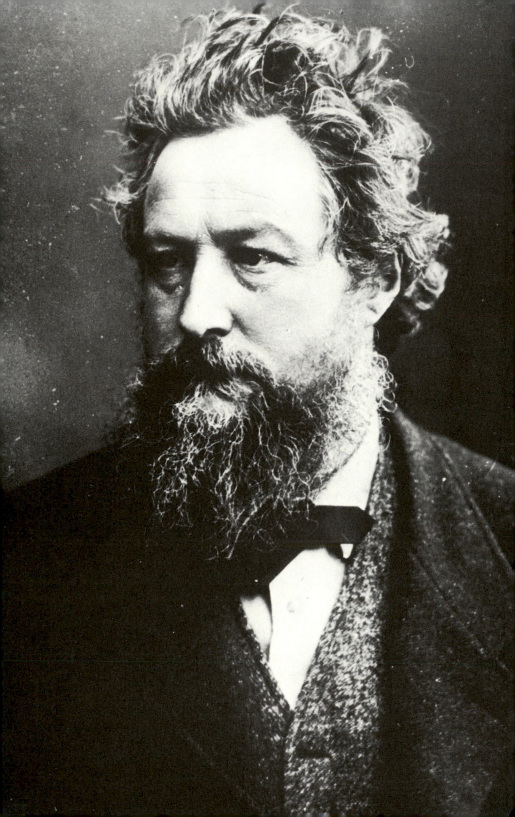

PETER STANSKY

Redesigning the World

William Morris, the 1880s, and the Arts and Crafts

PRINCETON UNIVERSITY PRESS

PRINCETON, NEW JERSEY

Copyright © 1985 by Princeton University Press

Published by Princeton University Press, 41 William Street,
Princeton, New Jersey 08540
In the United Kingdom: Princeton University Press, Guildford, Surrey

All Rights Reserved

Library of Congress Cataloging in Publication Data will be
found on the last printed page of this book

ISBN 0-691-06616-7

This book has been composed in Linotron Bembo

Clothbound editions of Princeton University Press books
are printed on acid-free paper, and binding materials are
chosen for strength and durability

Printed in the United States of America by Princeton University Press
Princeton, New Jersey

Designed by Laury A. Egan

NK
1142
.S7
1985
c.1

FOR WILLIAM ABRAHAMS

McIntyre Library
DISCARDED
FEB X X 1985
EAU CLAIRE, WI

DISCARDED
FEB X X 1985
EAU CLAIRE, WI

I have only one subject
on which to lecture:
the relation of art
to labour.
WILLIAM MORRIS
1883

· CONTENTS ·

· LIST OF ILLUSTRATIONS ·

· PREFACE ·

A PREFACE to a monograph reveals something of the long history behind a book, and gives an author an acute sense of inadequacy: so many people and institutions have been extraordinarily helpful and kind over such a long period of time, yet the result of it all is but a modest monograph. But I reassure myself that my study has not been the only fruit of so many kindnesses. I have had the opportunity to learn much for which I could find no place in this study. I've met many splendid people and had some adventures in the making of a book. Such reflections remind me of the pleasures of investigating just a few of the aspects of a most multifaceted and yet unified life, that of William Morris.

Many institutions and individuals have helped me. I began my first serious reading in the world of Morris more years ago than I care to remember while spending a term at the Wesleyan Center for the Humanities, and I worked on the manuscript while a Visiting Fellow at All Souls College, Oxford. To those institutions I am grateful, as I am to others— various libraries, more specifically the British Library, the Library of the Victoria and Albert Museum, the Huntington Library, the Bodleian, and, most significantly, the Library of the William Morris Gallery in Walthamstow, and Norah Gillow, Peter Cormack, and Jill Halliwell there, and over the long term, the library of my own university, Stanford, where many of the staff have helped me, notably James Knox, David Rozkuszka, and William Allan, as has Agnes Peterson of the Library of the Hoover Institution. Susan Bell has also been extremely helpful. And I wish to thank Eric Hutchinson for lending me an office at Stanford in which to write, and for sharing his interests in Morris and calligraphy with me. The staff of the History Department at the university has been of assistance far beyond their obligations.

I am also deeply grateful for fellowships from the John

Simon Guggenheim Memorial Foundation and the American Council of Learned Societies.

I hardly know where to begin to name the many individuals who have given me of their time and have shared with me a fascination with Morris. There have been the meetings I've attended of the William Morris Society, and the talks I've had with and the help given me by such members as Ron Goldstein, as well as the president of the Society, Asa Briggs. The American secretary of the William Morris Society, Joseph Dunlap, was generous of his time and gave the manuscript a close reading that saved me from many mistakes. (Here let me say that the merits of this study belong to others; its errors to myself.) From practically the very beginning of my interest in Morris, Sanford and Helen Berger have entertained me well, have put their Morris collection—probably the most important in private hands—at my disposal, and made the exhibition, largely based on their collection, at Stanford in 1975, a delight, as did the many others involved in putting together that Morrisian celebration and catalogue. These included students, both undergraduate and graduate, faculty, and staff, who played their roles in the continuing experience that was part of my own Morris enterprise. There were the scholars who came to lecture and who, then and at other times, were most helpful, in particular Norman Kelvin, whose edition of William Morris's letters is putting us all in his debt. William Peterson has shared his knowledge of the Kelmscott Press. And I've enjoyed conversations with E. P. Thompson about William Morris as well as his central *William Morris: Romantic to Revolutionary* (1955, 1977).

Many in England were very helpful. Alan Crawford, the biographer of C. R. Ashbee, over the years couldn't have done more through conversations and letters—written in the midst of a busy life—and was also kind enough to read the manuscript. He organized the Arts and Crafts Conference of the Victorian Society in 1978 and its trips, talks, and conversation had great value. (Although I have not included here a discussion of Ashbee's Guild of Handicraft because of Alan

Crawford's forthcoming study; the research I did on it formed a part of the background for my work, and I must thank Ashbee's daughter, Felicity, for her help and for the good times we had together.) Chimen and Miriam Abramsky shared their vast knowledge and Morris collection. Richard Murry assisted me with the Art Workers' Guild Archive. Lady Mander talked with me and showed me Wightwick Manor. Ian Fletcher discussed Herbert Horne and the period of the 1890s with me and arranged for me to read Elizabeth Tickner's dissertation on Selwyn Image. I am grateful to her for allowing me to quote from it. A. R. Dufty was splendid in showing me Kelmscott Manor and the Society of Antiquaries was kind enough to grant me permission to quote from unpublished works by Morris. Marina Vaizey sustained me with catalogues and a sense of the English art world, as did Peyton Skipwith. Robin Maclean advised me on the illustrations. Helen Brooks kindly allowed me to consult the archives of the Arts and Crafts Exhibition Society, now at the Victoria and Albert Museum, and two chairmen of the successor organization—The Society of Designer-Craftsmen—were very helpful: G. Hugh Spendlove and Jeanne Werge-Hartley, the latter of whom arranged for a splendid visit to Edward Barnsley who pursues the ideals of the Arts and Crafts movement to this day.

Princeton University Press, its readers, and particularly Rita Gentry, in her painstaking editorial work, have been consistently helpful.

Many others helped me along the way, and to all I express my deepest thanks. My greatest debt is expressed in my dedication.

July, 1983 P. S.
Stanford, California

· LIST OF ABBREVIATIONS ·

BL British Library, London.
SDCA Society of Designer-Craftsmen Archives,
 Victoria and Albert Museum, London.
WMGW William Morris Gallery, Walthamstow,
 London.

· Redesigning the World ·

· INTRODUCTION ·

WILLIAM MORRIS is so protean a figure, so varied in his ambitions, talents, and achievements, so unflagging in his energies, that he is difficult to encompass in a single convenient phrase or formula. A force in the Victorian age, yes; but also an innovator, an influence, a precursor of the age of the Modern in art and politics. As Nikolaus Pevsner, tracing the "sources" of the twentieth century, has written of him: "The great impetus in the fields of aesthetic and social renewal came from England and centres in the larger-than-life figure of William Morris, poet, pamphleteer, reformer, designer—trained a little at university, a little in architecture, a little in painting— and ending by being a manufacturer and shopkeeper, though a very special one."[1]

As a "shopkeeper, though a very special one," he was the main founder—in 1861—of one of the most important firms of decorators in the second half of the nineteenth century. Determined to restore aesthetic values to craftsmanship, he was the driving force behind the business, but many others were involved in it with him, most importantly perhaps Edward Burne-Jones, the painter; Philip Webb, the architect; and later, J. H. Dearle, the designer. And there were others of note who participated in the enterprise, ranging from Dante Gabriel Rossetti to Morris's daughter May, and not least the workmen themselves, mostly forgotten by name though some are to be found in the surviving record books of the firm. All, to greater or lesser degree, were part of a markedly significant change in theory and practice that occurred in English design at the time, and that would have continuing ramifications for the future, even to our own day.

At first glance, and measured against the innovative

[1] Nikolaus Pevsner, *Gateway to the Twentieth Century* (New York, 1962), p. 232.

achievements that were presently to succeed them—from Charles Rennie Mackintosh to the Bauhaus—the designs of Morris & Co. may seem old-fashioned and sometimes quaintly "period." Measured, however, against the fantastic elaboration and suffocating "concealment" of most of the designs displayed at the Crystal Palace in the Great Exhibition of 1851, which so horrified the adolescent Morris, they are comparatively simple and make no pretense of being other than what they are. The firm did, on occasion, indulge in showpieces that may strike us as unduly overwrought, but much of its manufacture was—and continues to be—eminently practical, as in the traditional "Sussex" chair, made of ash, with a rush seat, produced from 1865 on.

The designs at the Crystal Palace had been mostly of an ostentatious kind, deliberately so, flaunting their cost to their owners. Morris, like his master John Ruskin, was as devoted to the ethos of work as any proper Victorian, but not in the service of ostentation. He worked for the fulfillment of an ideal: to achieve a world whose environment would be determined by beauty and necessity, harmoniously joined. It is an ideal that has yet to be achieved, and merely to state it is to be reminded of how valuable Morris's activities and influence, so important in his lifetime, continue to be to the present age.

Much of his work had its point of departure in the conventions of his own period, however little he might privately subscribe to them. Thus, although an atheist himself, he had no hesitation as businessman and artist in accepting the many commissions for stained-glass windows that grew out of the passion for church building that raged in Victorian England. (From 1877 on, after his founding of the Society for the Protection of Ancient Buildings, he would not accept commissions for stained glass in older churches.) Responding to the demand, the firm set about in a practical way to devise methods of stained-glass manufacture that would combine the best aspects of medieval and modern techniques, although the minute subdivision of labor in that workshop was the most dra-

matic example of the conflict between Morris's theory of the necessary unity of labor and the actual practice of his firm. Morris's "medievalism" was not a kind of romantic costumery: he advocated a return to what he considered the sounder procedures of an earlier time for both idealistic and practical reasons. But it may have been chiefly a matter of spirit since in actual practice and divisions of labor the shop was similar to others of the time. Usually the ideal and the practical were kept in balance—which may help explain why the firm succeeded financially as well as artistically—and if Morris tended rather to disdain the machine, he was not, as is commonly supposed, unwilling to use it should it serve his purposes. He recognized the necessity to work within the mechanical and financial context of the age, in order to transform it.

Morris had a genius for design, and a talent for business. And yet, as Paul Meier has remarked, "his success was the outcome of psychological qualities rather than commercial acumen. He was an admirable trainer of men. His infectious faith and his consuming activity enabled him to get an exceptional return from the hundred or so artisans and employees working under his orders and by his side. And, perhaps above all, he had an extraordinary flair for surrounding himself with really able executives."[2]

But when the balance went askew, the results were odd, not to say paradoxical. His belief, for example, that any man could do any task meant, in effect, that some of his workers might not have the time to develop the skill, and hence the joy, in their craft that he advocated. A successful businessman who was also a prophet of socialism, he was not troubled by the inconsistent position in which he found himself, for his Marxist beliefs persuaded him that his commercial activities would hardly delay the coming revolution in society and in the means of production, and his political activities were intended to accelerate it. Nor should we be distracted by his

[2] Paul Meier, *William Morris: The Marxist Dreamer*, trans. Frank Grubb (Brighton, 1978), I, 30.

inconsistencies from recognizing what is central to Morris: for his firm and for others he preached a message of truth to material, simplicity, and practicality, to which modern thought and practice in art and architecture owe an immense debt.

A further paradox: Morris, hating the Renaissance with its emphasis on individual genius, was himself, as much as anyone of his period, a Victorian version of the Renaissance man. He tried his hand, often with remarkable success, at an astonishing variety of endeavors. He learned every aspect of the operation of the firm; he was a prolific poet (his greatest fame in his own day); he threw himself energetically into politics; he took up the cause of the protection of ancient buildings; he helped launch the revival of printing and bookbinding as a fine art—the founder of Morris & Co. was the founder also of the Kelmscott Press.

What Morris was unprepared to recognize was that his was truly the exceptional case. He believed in a universal capacity to learn, that anyone (as with the workers in the firm) could be trained to do anything, and so achieve the rich, satisfying life that he felt ought to be made universally available—and of which he wrote so beguilingly in *News from Nowhere*. But that noble possibility was blighted under capitalism, in the pollution, ugliness, and squalor of the industrial age: hence his dedication to creating a more beautiful environment in which to live, and his vision of a better society.

Morris had been well known as a poet for years, having established his reputation with the publication of *The Earthly Paradise* in 1868-1870. But it was not until the late 1870s, beginning with his lecture on the lesser arts, that he began to talk about art and society: his bridge to socialism.

There can be no doubt that Morris himself saw a necessary, inevitable linkage between the problems of politics and artistic endeavor. But, even granting his magnetic influence upon the movement, it does not follow that others recognized (or recognize) the connection, and their unwillingness to do so proved (or proves) that a truly apolitical stand is a self-contained contradiction. (Disdaining politics, one is in effect taking a

political position. Or to put it another way: to declare oneself "above the battle" is an acknowledgement that the battle is going on.) Some of his later admirers prefer a compartmentalized Morris, with one compartment sealed off from another, and choose to consider his artistic activities as separate from his political influence and activities, or even ignore the one in favor of the other. But so monumental a study as E. P. Thompson's *William Morris: Romantic to Revolutionary* (1955; revised edition 1976) makes the "separatist" position increasingly hard to maintain.

I myself tend to agree with the argument of that impressive work that Morris's career was, at the deepest level, essentially seamless, even though it had, as every life will, its ebbs and flows, and its different sets of interests. It is worthwhile to note, in this context, that the rather conservative G. M. Young, the doyen of Victorian historians and the author of the brilliant *Portrait of an Age*, remarked more than forty years ago that Morris's "socialism was the final synthesis of all his purposes; and without it his character would have been unfinished, his life incomplete."[3]

It is more than a coincidence that when he became a more public figure, design organizations of a new kind started to emerge. Hermann Muthesius, attached to the German embassy in London from 1896 to 1903 as an observer of English architecture and design, and later a crucial figure in the founding of the German Werkbund, remarked justly in 1904 that "Morris was a pioneer in all areas which he incorporated in his activities. He laid the groundwork for the development which all branches of the new art movement experienced later. . . . [In the 1880s] a young generation now stood upon Morris's shoulders. . . . They were the representatives of a truly original application of the arts that had developed in the twenty-five years of Morris's activity."[4] Pevsner has remarked, "The

[3] G. M. Young, "Topsy" in *Daylight and Champaign* (London, 1948), p. 66.

[4] Hermann Muthesius, *Das Englische Haus* (Berlin, 1904), I, 98; translation courtesy Susan Bell.

first effect of Morris's teaching was that several young artists, architects, and amateurs decided to devote their lives to the crafts. What had been an inferior occupation for more than half a century, became once more a recognized task."[5] In England in particular the class aspect was quite important. Morris, an undoubted gentleman, had helped make crafts respectable. Pugin had been primarily an architect, although he had also designed furniture and other objects. Ruskin did draw, but was primarily a writer. Morris wished to do everything himself—he had moved rapidly through the more gentlemanly occupations of architect and painter before deciding to master as many of the crafts as possible. Status was a frequently unstated problem and it particularly plagued architecture toward the end of the century. Quite a few prominent figures in the Arts and Crafts movement were both architects and designers: among them, Arthur Mackmurdo, C. R. Ashbee, and C.F.A. Voysey.

Moreover, under Morris's aegis a new public was being created. It might not be considerable in numbers, but it exercised an important influence on how the world looked and how it was looked at toward the end of the century, and ultimately much of the look of the world in the twentieth century. This new public, with its less grandiose expectations, led to the creation of a more modest style. As James Kornwolf has remarked, speaking of those who engaged such architects as Voysey and Baillie Scott: "It seems obvious that the client for whom Voysey and Scott built—the client content with the small house envisioned by Ruskin, unpretentious yet thoroughly artistic—did not exist in 1882. . . . The appearance of this client in the nineties can be explained by the various Arts and Crafts societies begun throughout the eighties, all inspired by William Morris."[6]

Indeed, it would be difficult to overestimate Morris's role

[5] Nikolaus Pevsner, *Pioneers of Modern Design* (1st ed., *Pioneers of the Modern Movement*, 1936; Harmondsworth, 1960), p. 54.

[6] James D. Kornwolf, *M. H. Baillie Scott and the Arts and Crafts Movement* (Baltimore, 1972), pp. 25-26.

in setting an example for others, leading to an extraordinary renaissance in English design. This, in Nikolaus Pevsner's interpretation, was a crucial factor in the shaping of the Modern movement. That Pevsner may see the movement in somewhat historical deterministic terms is suggested by the full title of his *Pioneers of Modern Design: From Morris to Gropius*. For him, Morris is a founder of the Modern movement. And certainly he is correct in assessing the importance of Morris as an influence upon it. In Pevsner's scheme, Hermann Muthesius, cultural attaché at the German embassy in London from 1896 to 1903 and author of *Das Englische Haus* (1904) transmitted the new English ideas about design to the German Werkbund, and ultimately to the Bauhaus: in effect from "artist-craftsman to industrial designer." Herwin Schaefer too claims a similar, educational role for Muthesius: "Muthesius saw the basis for England's contemporary design in the refined commonsense designs of the late eighteenth century. These had been discarded, forgotten, and overlaid by tawdry manufactured artware in the earlier Victorian period, but their principles (if not always their practice) were reinstated by William Morris and his followers in the late 1800s, with the idea of the unpretentious, styleless country house and its qualities of commodious, friendly homey living—in other words, the vernacular."[7]

Paradoxically, though the new English ideas were being transmitted to the Continent, the English were not able themselves to reap the full benefit—if benefit it fully was—of what they had begun. In an interesting brief article written in 1933, John Betjeman, who played so significant a role in reviving interest in the taste of the past (although probably a half century later, he was more interested in the objects Morris might have hated than those he created) pointed out the significance of the Morris movement which we have "alone to thank for re-awakening appreciation of simplicity of form." Betjeman recognized the great importance of the Arts and Crafts Ex-

[7] Herwin Schaefer, *Nineteenth Century Modern* (New York, 1970), p. 180.

hibitions, but he also mentioned the reluctance of the exhibitors, who were in some sense practitioners of a trade, to become true tradesmen. Too many of the Arts and Crafts figures felt that to be considerable moneymakers was somehow not in keeping with their artistic, social, and class commitments. Many of them could not come to terms with the problems of scale. Betjeman comments about the Arts and Crafts Exhibitions: "In the 1900s and earlier, these exhibitions at the New Galleries rivalled the Academy in importance." But, he continues, the importance of the Society was fatally snapped in 1913 when a delegation consisting of Ambrose Heal and others appealed to the Society to set up a permanent shop and go into trade. The Society refused, according to Betjeman, because gentle folk could of course have nothing to do with trade. The enemy was commercialism, but, if the new design was to succeed commercialism would have to be taken over rather than ignored. In 1914 the Design and Industries Association was formed—an important organization—and a continuation of the Arts and Crafts movement, but there was still a weakness, which Morris might have called a reluctance, to bridge art and life. It did not seem really possible, in any deep sense, to combine commerce and gentility in England.[8]

Morris was such an active man, so voluble and excitable, that it is almost impossible to prevent him from dominating any scene in which he appears. Nevertheless, my intention here is to discuss this undeniably central and incandescent figure in a sense tangentially, or obliquely, allowing a place center-stage to certain of the organizations that came into being under his sometimes reluctant influence. I also wish, to some degree, to set these organizations, and indeed Morris himself, against the background of the political and aesthetic atmosphere of their time. I argue that how we view the world,

[8] John Betjeman, "There and Back 1851 A.D. to 1933 A.D. A History of the Revival of Good Craftsmanship," *Architectural Review* (July 1933), pp. 4-8.

and how it should look, changed in the 1880s under Morris's influence. But the English, because of their belief in amateurism and their difficulties with questions of class, were not fully able to benefit from the revolution in design they had themselves brought into being.

· CHAPTER I ·

William Morris and
the Arts and Crafts
in the 1880s

THE TERM "Arts and Crafts" was coined by Thomas Cob-
den-Sanderson in 1888, but the movement it belatedly labelled
had been in ferment since the beginning of the decade. Arts
and Crafts developed under the pervasive influence of Morris,
rather than by his direct instigation or conscious intervention.
"Morrisism," it might be said, was in the air that artists and
craftsmen needed if they were to flourish.

It is historical fact that a number of significant organiza-
tions, dedicated to the arts and crafts, came into being in the
1880s, giving the movement a form and a substance it would
otherwise have lacked. The question immediately arises: why
then, why the 1880s? It seems to me that the standard ex-
planatory "how," true enough as far as it goes, does not really
tell us "why" that remarkable flowering took place in that
particular decade. Although there are those who would prefer
to do so, I don't believe we can separate the Arts and Crafts
movement from the peculiarities of the age in which it emerged
and against which it in large part reacted: we have to take
into account its social and political context.

The 1880s were a time of particular fascination and reso-
nance when England not only was at its apogee as a world
power, but also, paradoxically, was beginning to experience

severe difficulties in maintaining the role her power imposed upon her. Some latter-day art-lovers, with a distaste for politics in general and for Morris's politics in particular, would prefer to write off the 1880s as no more than a time of fulfillment of the Aesthetic movement of the previous two decades, quite lacking in a creative impetus and originality of its own. Such a position fails to take into account an obvious truth: that every decade, every year, every moment is part of a continuum. Whatever came before, and no matter what came after, it is clear that the 1880s have a particular significance of their own.

They were to be a troublesome decade. There were the economic problems that had begun to plague England seriously in the late 1870s, and that showed little signs of abatement or resolution. There were the problems of Ireland, emphasized by the political activities of Charles Stewart Parnell and by Gladstone's commitment to the idea of Home Rule. There were the problems of increasing rivalry with Germany and the United States.

It was an all too appropriate time for concern not only about the nature of contemporary politics and economics, but also—irrelevant though it may seem at first thought—about the arts and decoration that this most powerful of nations was bringing into being. The comparative diminishment of confidence in England's role in a world it had grown accustomed to dominate led, perhaps not surprisingly, to a not dissimilar questioning in other areas, among them the arts and their industrial appanages. Certainly, since the days of the Great Exhibition there had been confident production of popular pictures; of solid, not to say stolid, furniture; and of buildings, "official" and "private," in a medley of historical styles. Under the impact of the "doubt" that asserted itself in the 1880s toward Anglo-Saxon attitudes that had been taken as fixed laws, so too components of the man-made, English visual world—paintings to be hung on walls, the walls themselves, and the roofs that boxed them in—began to be looked at with a little more critical attention, and the objections raised by

Pugin and Ruskin decades earlier in the century came to seem more relevant.

All of these concerns associated with the 1880s—political, economic, artistic—were to have their effect upon Morris, some strongly and enduringly, others only transiently. Perhaps we would do best, then, to begin with some simple reconsideration of the political and social climate in which Morris conducted himself and in which those who owed so much to him were coming into maturity.

THE 1880s

HISTORIANS have generally singled out as a date of particular concern the passing by the Liberals of the third Reform Act in 1884. In theory, the act made England a democracy. In fact, this was far from the case. But it has always been important in England for a principle to be established, and this the act did. No matter how limited its actuality, it held a promise for the future, as it increased the electorate from three to five million. Only men had the vote, and many men over twenty-one did not have it because they were not heads of household, or the various regulations of registration and period of residence deprived them of it. But these were details—albeit important ones—and the result of the 1884 act was that there was less of a barrier now, than there had been in the great Reform Acts of 1832 and 1867, to an eventual franchise for all men, and ultimately for women. Those two earlier acts had been connected with property as a qualification for the vote, and in principle that proviso was now ended.

There is no question that politics in the 1880s were becoming increasingly democratic: thanks to the third Reform Act there were many more voters who had to be wooed, and the question was whether the two traditional parties would succeed in doing so. The politicians of the day were not stupid; they were aware of the challenge that faced them. Not only the third Reform Act, but also the passing of the Corrupt

Practices Act of 1883, the Redistribution Act of 1885, and the split and subsequent breakup over the question of Ireland in the Liberal party in 1886, had modified politics and "cumulatively created a situation in which political allegiance was more fluid and uncertain than it had been for a long time."[1]

William Morris had made his entry into politics eight years before—in 1876—on the side of William Gladstone, the leader of the Liberal party, supporting his agitation against Disraeli over the massacre of the Bulgarian Christians by the Turks. It was an issue in which Gladstone deeply believed. With his rare ability to combine moralism and political shrewdness, he was highly successful in calling upon the voters to think beyond themselves and take a moral stand on an international issue. He reaped an immediate political benefit in 1880 when he and the Liberals were returned to power, and he proceeded to form his second ministry.

Ironically, it was Gladstone's belief in his obligation to fulfill British imperial concerns that led to Morris's disillusionment, not only with Gladstone, but with traditional politics altogether. In 1881 the Liberal government passed an Irish Coercian Act. In that same year the government ordered the Navy to bombard Alexandria, to protect Britain's interest in the Suez Canal, which had been acquired by Gladstone's archenemy Disraeli. Realism prompted Gladstone's actions, but Morris's idealism was not prepared to accommodate a realism that tolerated coercion and military action as instruments of policy. He despaired of traditional politics, which exacted so much even from a man of Gladstone's character, and began to move toward socialism, a politics outside the major governing parties. Eventually, in 1886, Gladstone's own idealism inadvertently triumphed in the conflict between his sense of what was right and what was expedient. He broke up his party over the issue of Home Rule for Ireland. Convinced of the morality of the Home Rule bill, he was still anything but

[1] E. P. Hennock, "Poverty and Society Theory in England: The experience of the eighteen-eighties," *Social History* 1 (January, 1976), 68.

a quixotic politician and went ahead with it, hopeful that it would be passed. Certainly he had no intention of withdrawing it for reasons of expediency, on the chance that it might be defeated—as in fact it was. But by this time Morris was deeply involved in socialist politics and had little interest in the fate of the Liberal party. (From the point of view of the new politics Gladstone was, many felt, hopelessly caught between the old liberalism of earlier in the century and the advent of socialism.[2] The far left's disdain for the traditional party of the left—the Liberals—was even more marked in the 1890s during Gladstone's fourth and final ministry of 1892 to 1894.)

The Tories too were aware of the necessity to recruit the new voters; in this regard their most important new politician was Lord Randolph Churchill. He imitated, to an extent, the Liberals, most significantly Joseph Chamberlain who, taking the lessons of the second Reform Act of 1867 to heart, had formed organizations for the new voters. Lord Salisbury, the leader of the Tories, was aware of the importance of these new voters, despite his apparent disdain for them. In the hard bargaining that marked the passage of the Reform Act of 1884 he had been deeply involved in the redistribution of seats and the restructuring of constituencies. The suburbs were on their way to demonstrate their affection for the Conservative party. The game of politics was changing character.

It was against this background that William Morris plunged into a period of intense political activism, dating from his joining the Democratic Federation in 1883 until his comparative withdrawal from his many political activities in the early 1890s. Not uncoincidentally, in this period too, as we shall see, there was a great outburst of activity in the world of design. If it is an exaggeration to regard them as parallel, interacting events, I believe that they were connected, both reflecting similar dissatisfactions with the world as it was.

[2] Such was Beatrice Webb's opinion. See Helen Merrill Lynd, *England in the Eighteen-Eighties: Towards a Social Basis for Freedom* (New York, 1945), p. 155. This book is still a valuable discussion of the period.

Politically speaking, dissatisfaction was most intense among the workers and their supporters and sympathizers. There has been considerable historical debate as to whether there was a "Great Depression" starting in the late 1870s; whether or not it actually existed as such, many workers in those years felt they were worse off than they had previously been. In part this was a result of an increased awareness of their plight not only among the workers themselves but among concerned members of the middle and upper classes as well, who were coming to recognize their dependence on the workers who had helped create their prosperity. Arnold Toynbee gave his famous lectures on the Industrial Revolution, coining the term itself, in 1880-1881; Charles Booth published the first volume of his *Life and Labour of the London Poor* in 1891: in these years, too, Beatrice Webb was turning her shrewd, critical gaze on her own position as a privileged member of society as she would later record in *My Apprenticeship*; Andrew Mears wrote *The Bitter Cry of Outcast London* in 1883.

There was a growing recognition of the bitter poverty at the bottom of the pyramid in this richest and most powerful nation in the world. Robert Blatchford and his Clarion movement became a popular force for socialism. Blatchford, who devoted a page of his publication, *The Clarion*, to news of the Clarion Guild of Handicraft, founded in 1901, had been converted to the socialist cause in 1889 after seeing how the poor were forced to live in the Manchester slums. In the same year a Royal Commission on Sweating in Industry focused attention in its report on bad working conditions, particularly in many small workplaces, in the allegedly most advanced civilization the world had known. The workingman, newly enfranchised, had a new sense of his potential political strength, even as he felt more strongly the continuing injustices of his position at the bottom. Throughout the decade there was a growing tension between the workingman and the powers that be, marked by disorders in the center of London, most notably "Bloody Sunday" on November 13, 1887, by a series of major strikes at the end of the decade, the Matchgirls Strike

of 1888, and the great Dockers Strike of 1889. With the worsening economic situation skilled workers were eager to protect their position as the aristocracy of labor. But in the general discontent, unskilled workers—the great mass of the proletariat—were coming to a firmer sense of the need to take action themselves. It was against this background of growing labor unrest that Morris had his period of greatest political activity. As England itself was becoming a country where more and more participated in its politics, beginning with the acquisition of the franchise, so too the labor movement itself came to include and represent an increasing number of workers.

Middle-class and religious movements felt as well that they were under greater obligation to do something about the urban poor. Toynbee Hall, under the direction of Canon Barnett, became in 1884 the first important settlement house in London. Shortly thereafter no self-respecting college at either Oxford or Cambridge, and no worthy public school, did not feel that it must have a mission in the East End of London. The social conscience of the Church of England (and of other denominations too) was being stirred. In much that happened, in the religious area and otherwise, there was a continuation and intensification—even in the case of William Morris, hate it though he might—of the traditional English style: members of the upper and middle classes doing "something" for the poor.

The Church too shared in the radicalism of the period, for instance, in the career of the Reverend Stewart Headlam. As Peter Jones has remarked, "Many a priestly garb was seen in unemployment marches, and Headlam put himself at the head of more than one."[3] Headlam was in the vanguard both politically and artistically. His home was decorated by Arthur Mackmurdo of the Century Guild, and his church in Primrose Hill had decorations by C. R. Ashbee's Guild of Handicraft.

[3] See Peter d'A. Jones, *The Christian Socialist Revival, 1877-1914* (Princeton, 1968), for quotation, p. 130.

He officiated at the funeral of the radical worker Alfred Linnell for which Morris wrote the words of a famous death song, the music written by Malcolm Lawson, and published with a cover designed by Walter Crane. Robert Cunninghame Graham, William Morris, and W. T. Stead accompanied the coffin in the mass demonstration that was part of the funeral. Linnell's death had been caused by the blow of a policeman's baton, on November 20, 1887, during the sequel to Bloody Sunday. (Headlam also helped stand bail for Oscar Wilde. It was not necessarily true that those who were advanced in one respect would also be so in another, but Headlam certainly was, and his career serves as one indication of the ferment of the period.)

On the whole, however, traditional religions, despite the efforts of some of their leaders, were failing to satisfy not only the bulk of the population, but members of the middle class as well. The degree to which the activities of the left during this period were searches for an alternate religion can be exaggerated. Yet there was a labor church movement, and it is understandable that those raised in the atmosphere of nineteenth-century religion might think in terms of conversion, and it would be a mistake to ignore that aspect in William Morris. There was an intellectual (and physical) restlessness in him suggesting that he might have been looking for some sort of faith. He himself did use the phrase "the religion of socialism" in the manifesto of the Socialist League in 1885, and in his long poem, "The Pilgrims of Hope," of 1886 he writes about the conversion experience to socialism as a form of new birth.[4] In the 1880s large numbers of men and women were seeking for a new sort of solution. This intellectual, social, and political restlessness was central to the period. It was part of what Holbrook Jackson has called the "social earnestness" of the time.

Also important in the formation of the political atmosphere

[4] These ideas are from Stephen Yeo, "The Religion of Socialism," *History Workshop* 4 (Autumn, 1977), 5-57.

was the presence of exiles; England was well known for its comparative willingness to harbor political refugees, such as Karl Marx. Yet their being in England did not necessarily mean that radical causes prospered better there; both Marx and Engels disdained the English inability to exploit political situations and the ingrained respect that many of the proletariat had for authority. Marx died in 1883, but Engels kept a watching brief on the various political developments in England. He generally regarded Morris as a Utopian sort of socialist. Other influential foreign socialists and anarchists were living in England at this time, most notably Prince Kropotkin, and also Sergei Stepniak and Andreas Scheu who were quite close to Morris. (Poor Stepniak was run over by a train in Chiswick in 1895, and it was when speaking at his funeral in December that Morris caught a chill that eventually led to his death the following October.)

Although both the traditional political parties attempted in the 1880s to cope with the expansion of the franchise and to capture the new voters for themselves, new political movements came to the fore. The Tory party was attempting, and to a considerable part succeeding, in wooing the middle-class voter, particularly those resident in the growing suburbs, who were likely in the past to have voted Liberal.

Important Liberal mainstays such as those with great Whig names as well as businessmen who had been supporters of the Liberals throughout the nineteenth century were now moving over to the Tories. The great question (still subject to a continuing historical debate), and a major factor in politics on the left until after the First World War, was whether the newly enfranchised workers would vote Liberal or for the new political groups that were competing for their votes. Whatever the decision, the small but hyperactive organizations, most notably the Social Democratic Federation, which came into being in the early 1880s, were responding to and intensifying the political ferment of the period. The upheavals of the time and the fights for votes provided a background for the developments in the 1880s in the world of design.

William Morris is, I believe, an important link between the two movements. There is no question about his many activities in both areas. In his own mind they were intimately connected and one infused the other.

DESIGN

THE DEVELOPMENT of English design in the second half of the nineteenth century paralleled what happened in English society itself. Both became increasingly self-conscious, culminating in literary terms in the self-regarding nature of the 1890s, and abruptly terminating with Oscar Wilde's trial in 1895 when aestheticism became suspect, if not scandalous. As Yeats remarked in his introduction to the *Oxford Book of Modern Poetry*, in 1900 "everybody got down off his stilts; henceforth nobody drank absinthe with his black coffee; nobody went mad; nobody committed suicide; nobody joined the Catholic Church; or if they did I have forgotten."[5] The 1890s were the last flowering of an aesthetic movement that had been most active in the 1870s. It too represented a questioning of the dominant values of the earlier part of the century, the values by which most Englishmen and women, certainly those who dominated the country, lived. A sense of this sweep is conveyed by a remark of Helene Roberts': "The period began with the grand style, monumental history paintings and neoclassicism, and ended with the arts-and-crafts movement, aestheticism and art-for-art's sake. It began with the aristocrat and dilettante as patron and it ended with the middle class as the main support of the arts. It began with Joshua Reynolds and ended with Aubrey Beardsley."[6]

As writers, the English clearly have always been in the forefront, but in other arts they have frequently felt inferior

[5] W. B. Yeats, "Introduction," *The Oxford Book of Modern Verse* (Oxford, 1937), pp. xi-xii.
[6] Helene Roberts, *Victorian Periodicals Newsletter* 9 (July, 1970), 6.

vis-à-vis the achievements on the Continent. And they have tended to a strange mixture of feeling about this: a disdain for what they might consider the excessive concern for artistic matters across the Channel, along with a continual worry as to why they themselves have not achieved in art and design quite the level of other great European cultures. The nineteenth century was no different. Particularly in the world of design there was a constant concern about the French, and the ways in which they were ahead. Yet there were elements of xenophobic feeling: that the English must not, need not, commit themselves to worrying overmuch about a foreign country. The nineteenth century is marked by investigations by parliamentary committees into the teaching of practical arts for the stated purpose of improving trade and design in competition with other countries. (Today England may have the most elaborate and in many ways most effective art educational system in the world, even while the country still has some sense of inferiority when comparing its design to that in other countries.) For instance, in 1837, the last year of the reign of William IV, the government was disturbed by the growing popularity of French designs, and Parliament authorized an art education scheme at Somerset House in London. But ten years later the plan was condemned by a new parliamentary commission.

The conflict in attitudes would be characteristic throughout the century. The greater value of native products contrasted with the nagging feeling that artifacts from abroad were somehow more distinguished, better thought out and made. The government's reaction to this situation is one of the many examples of departure in the nineteenth century from laissez-faire tradition: there was a continual governmental interest in questions of design. Since such issues of course were vitally connected with British markets abroad, the government's concern was hardly surprising. Arguments in favor of better education in design were regarded as essentially practical by many politicians; and it is the practical strain that persists to this day in questions of art education. Design naturally con-

nected art and trade. It provided a way for artists to make a living and for government and manufacturers to support artistically valuable causes without losing their reputation for practicality. "Value for money" was an English vice and virtue; education in design, as a popular educational force, might even help calm a populace that was showing signs of becoming unruly. Such education also served a utilitarian end. Training in design might equip members of the growing population with a practical skill.

The Arts and Crafts movement of the later years did not arise spontaneously, but against the background of a concern with design, a recognition that too much English design through a good part of the century was deficient in quality, whereas, in the past, there had been the great accomplishments of Chippendale, Kent, and even in the nineteenth century of such furniture designers as Gillow of Lancaster. This tradition of practical design was very important in England both in itself and, indirectly, as an influence upon the philosophy underlying the new, modern design. In part at least, the Arts and Crafts movement came into being as a reaction against a tradition that put practicality first and did not share the Arts and Crafts disdain for the machine—in fact rather welcomed it. Yet the Arts and Crafts movement also drew upon this practical tradition, and the concern for useful design that it represented.

The ambiguities are suggested by such a figure as Henry Cole, a shaper of the Great Exhibition of 1851 and of the further extensive display of design in the International Exhibition of 1862. Cole was a founder of the Victoria and Albert Museum, as it came to be called, a civil servant, an editor, briefly a down-to-earth designer, and a manufacturer in his firm, Summerly Art Manufacturers. (He was also a friend of Charles Dickens, who parodied him nonetheless as the schoolroom visitor obsessed with fact in the first chapter of *Hard Times*. And Ruskin disliked him because of his belief that good design could be turned out for profit.) Even before the Great Exhibition Cole had been intrigued by the lucrative

potential of having eminent artists produce designs for manufactured articles. Thus, paradoxically, the Arts and Crafts movement and what it regarded as its chief enemy—ordinary mass design and manufacture of the nineteenth century—shared the same concern for design and for making worthy objects more easily available.

The inadequacies of art education in the course of the nineteenth century were a negative goad, so to speak, in the developments of the Arts and Crafts. And the changes in art education itself, as they gradually came about, were a different reaction to similar problems. At times the motives coalesced, as in the support that William Morris gave to building up the collections at the Victoria and Albert, the great teaching museum of art and design, and the use he himself made of its collections.[7]

The "Schools of Design" was a very English development. It started, in part, as a reaction against established institutions, most notably and as usual the Royal Academy. The schools grew into institutions themselves. Their development rapidly became inseparable from questions of class: for whom was the education intended? It almost seemed that the degree of the flexibility of the teaching depended upon the class of those who were taught. The Arts and Crafts movement could assert itself effectively, in part, because, despite the radical political concerns of some of its members, it was dominated by the middle class, who were determined to keep their class position. At the same time the elements of gentlemanly amateurism, inherent in the movement, hindered its effectiveness.

These problems of purposes and class arose very early in the history of art education in the nineteenth century. The need for the schools was seen as part of a concern for "useful knowledge," a concept that was the bridge between eighteenth- and nineteenth-century practicality. In 1835 a Select

[7] See Barbara Morris, "William Morris and the South Kensington Museum," *Victorian Poetry* 13 (Fall-Winter 1975), 159-177. For the education question see Stuart MacDonald, *The History and Philosophy of Art Education* (London, 1970), and also Quentin Bell, *Schools of Design* (London, 1963).

Committee on Arts and their Connection with Manufactures was established by Parliament on a motion by William Ewart, significantly, a member from Liverpool. He was a great friend of Gladstone's father, and godfather to the young William Ewart Gladstone. The Liverpool strain of practicality and concern for manufacture asserted itself throughout the century, most notably in the founding of the National Association for the Advancement of Arts and its Application to Industry in that city in 1888.

Gladstone himself—perhaps as a compliment to his godfather—thought along similar lines. In a speech at the opening of an exhibition celebrating art and industry at Dundee in Scotland on October 29, 1890, he declared:

> The industries of the country will derive enormous advantage from the cultivation of art. Beauty is an element of immense pecuniary value. The traditional cultivation of taste and production of beauty in industrial objects, is better known—best of all known, perhaps—in Italy, and very well known in France. . . . In the enormous commerce of France, the beauty of the objects produced counts from year to year for a great many millions sterling, and those millions sterling would fade into [thin] air were the apreciation of beauty and the power of producing beautiful objects taken away. . . . I assure you that it is hardly an exaggeration to say that at the time when I was a boy . . . there was hardly anything that was beautiful produced in this country. . . . [Now the] introduction of beauty is becoming a regular portion of the industrial art.[8]

The guidelines for the inquiry of 1835 were significant and reflected concerns that would persist throughout the century: "To enquire into the best means of extending a knowledge of the Arts and Principles of Design among the people (es-

[8] Arthur Wollaston Hutton and Herman Joseph Cohen, *The Speeches and Public Addresses of the Rt. Hon. W. E. Gladstone* (London, 1892), X, 303-305.

pecially the manufacturing population) of the country, and also to enquire into the constitution of the Royal Academy and the effects produced by it."[9] Nevertheless the Royal Academy, the established institution, managed as usual to win the day and to make sure that the new schools would only be concerned with ornament, and ornament of a routine kind. Work by rote and imitation was desired, and creative design for industry remained at a low level, dramatically decreasing the chances of success in "beating out" other nations.

The only art instruction previously provided by the government had been at the military training schools of Woolwich and Sandhurst. The report of the Select Committee did not establish schools for design; rather they arose as a result of the evidence given to the committee. Yet even before the report was published, the government decided that something needed to be done: a normal school of design was founded. "This was the small beginning from which so much was to spring, and from this grew a system containing the Royal College of Art, a multitude of municipal art schools, and the Victoria and Albert Museum."[10]

As so frequently before and since, snobbery entered in and kept designers from achieving the position they held on the Continent. The development of the Arts and Crafts movement, late in the century, occurred among other important reasons so that the "second-class" implications of the nineteenth-century teaching of design could be avoided. Until then, the teaching of design was limited mostly to imitation and it was largely aspiring members of the lower-middle class who took advantage of the opportunities of the schools. Design, like so many other aspects of nineteenth-century English society, had its class implications.

The middle class exploited the schools even though they were meant for artisans as a form of charity, despite their somewhat more exalted original purpose. Henry Cole in-

[9] As quoted in MacDonald, *Art Education*, p. 67.
[10] Ibid., p. 61.

tended that the curriculum in the schools of design should provide art masters trained by a national system who would go on to teach design in state schools. In this case drawing was not thought of as skill to be used for a trade, but as a matter of teaching technique. The training was more mechanical and less individual than that found on the Continent. It was this mechanical version of the "South Kensington" system against which the Arts and Crafts movement was later to revolt.

The Royal Society of Arts, founded in 1754 and to this day flourishing in its Robert Adam buildings off the Strand, was concerned with questions of industrial art. It was continually troubled that England fell behind other countries in industrial design and failed to train individual artists or artisans capable of raising national standards. Methods of teaching in England tended to be doctrinaire, encouraging uniformity and conformity. There was talk about the importance of individualism; in fact, it was not encouraged. As Stuart MacDonald mentions, the tradition in England was to support "useful ornamental and mechanical drawing, as opposed to an aesthetic atelier training in the French and Italian academic traditions."[11] Since the various purposes of art education were in conflict, the same themes and needs continued to manifest themselves throughout the nineteenth century, and even in this century as well. As Quentin Bell has observed, "It may be doubted whether we have ever decided just what it is that our art schools are to do." Bell suggests that class hierarchy permeated this world as well, and perhaps also an element of Victorian prudery: "The study of the human figure, . . . was of central importance in the whole scheme of academic teaching; it had assumed an almost mystical value and it was through this study and, one may almost say, through this study alone, that the historical painter was formed. It was for this very reason that it was to be forbidden; the purpose of the schools

[11] Ibid., p. 227.

was emphatically not to produce artists but rather to form the taste of artisans."[12]

Throughout the century the government, through the Science and Art Department, was active in art education. By 1861 there were 87 drawing schools, and by 1884 there were 177.[13] It is debatable, however, how successful these schools were, particularly as the complaints of English failure to match continental design continued throughout the century. But William Morris helped transform the situation. Pevsner has remarked about Morris's relationship to the schools for design, with perhaps some exaggeration: "Not one of the founders and principals of the schools of decorative or industrial art down to almost the end of the century had an idea of the organic inter-relation between material, working process, purpose and aesthetic form which William Morris rediscovered. It is therefore due to him and his indefatigable creative energy alone that a revival of handicraft and then industrial art took place in Europe. The Modern Movement in design owes more to him than to any one other artist of the Nineteenth Century." Pevsner goes on to state that the Municipal School of Art in Birmingham, founded in 1883, was the first to incorporate Morris's principles.[14] The Central School of Design, founded in 1896, with W. R. Lethaby as coprincipal, sought to follow Morris. At long last, a school provided craft education for the artisan: "[It] was the first of its kind to have teaching workshops for the crafts and was considered the most progressive art school in Europe until the foundation of the Bauhaus in 1919."[15]

The early schools of design, obsessed with ornament, had restricted their teaching to the decoration of objects, with little concern as to what the object might be, from kitchen stoves

[12] Bell, *Schools of Design*, p. 67.

[13] Figures from Nikolaus Pevsner, *Academies of Art* (Cambridge, 1940), p. 256.

[14] Ibid., pp. 259, 265.

[15] Edward T. Joy, "The Art Workers Guild and the Development of English Furniture," in *Art and Work* (London, 1975), p. 16.

to grand pianos. The absurd lengths to which this could go are depicted in the catalogues of the Great Exhibition of 1851. The later schools had a much more flexible approach to training and attempted to use the student's imagination, rather than to teach by mere mechanical means.

The influence of Morris in the direction of change could also be seen in 1898 when his disciple, Walter Crane, became principal of the Royal College of Art, the leading "school of design" in the country. Crane in his writing, teaching, and administration led the move away from ornament toward free design, a move toward freedom that made itself felt in other areas about the end of the nineteenth century. Crane offers a splendid example of Morris's influence in shaping changes in art education in England itself. The art schools no longer confined themselves to ornament but taught a whole range of the arts. Schools of art were founded in various parts of London: Camberwell, Camden, Clapham, Hammersmith, Lambeth, Putney, South London, Westminster, Battersea. They were supported by local rates and hence were free from the central direction of the Department of Science and Art.[16]

But why was English design so relatively bad throughout most of the century when there was so much activity in this area—perhaps more than in any other country? Pevsner may be right: there may have been, before Morris, an inability to think creatively about design. But some claim that Morris, although a brilliant patternmaker himself, was not the shaper of the English design tradition that Pevsner would have him. Whatever the resolution of that debate, there can be no question that Morris's own activities, and the activities that formed the Arts and Crafts movement, reflect in part the failures of artistic education earlier in the century.

Art education as a kind of forerunner for the Arts and Crafts movement is at the least equivocal. It reflected a concern for the same problems of design, but it solved them in ways verging toward uniformity that members of the movement

[16] MacDonald, *Art Education*, p. 298.

considered erroneous. More straightforward predecessors for the movement were the great ancestor figures: A.N.W. Pugin and John Ruskin. Thomas Carlyle's indignation too about the state of the nineteenth-century society made an important contribution. In 1892 Morris reprinted Ruskin's chapter "The Nature of Gothic" from *The Stones of Venice* as a Kelmscott Press book, saying of it in his preface that "in future days it will be considered as one of the very few necessary and inevitable utterances of this century." Political developments of the time, problems in artistic education, and these great figures, all were, in varying ways, beacons of discontent.

To Pugin and Ruskin, Morris owed his conception of workmanship, sharing with them a concern with the moral implications of work, a belief that work in and of itself could be either debasing or noble. (Its nobility was suggested in the famous picture *Work* of 1852-1863 by Ford Madox Brown, an original member of Morris's firm, that showed workers of various kinds building a road with the "brainworkers," Carlyle and F. D. Maurice, observing them.)

Pugin and Ruskin were also prophets of the Gothic revival, that belief in Gothic as the only truly Christian architecture, dominant throughout the nineteenth century not only for churches but for an increasing number of public buildings—indeed for some private buildings as well. For Pugin, and particularly for Ruskin, the Gothic style suggested a conception of workmanship. Whether or not it was an accurate representation of the Middle Ages is another matter, and not necessarily crucial to its significance for the nineteenth century. For Pugin, Ruskin, and Morris the style was important for its statement about workmen in the fourteenth century: their labor was undivided, they were skilled as stonemasons, carvers, and so forth rather than specialists on a small aspect of the job who were thus prevented from having a sense of the total endeavor. They were not mere mechanics, reduced to the level of the modern factory, doing the same routine job.

Modern eyes find Ruskin's, Pugin's, and Morris's fond at-

titude toward the Gothic a little perplexing. Clearly, they saw it as somehow "plainer" than we perceive it. As Pugin remarked in *The True Principles of Pointed Architecture* (1841), "The two great rules for design are these: *1st, that there should be no features about a building which are not necessary for convenience, construction, or propriety; 2nd, that all ornament should consist of enrichment of the essential construction of the building.*"[17]

No matter how nineteenth-century Gothic was produced, it suggested for these thinkers the virtues of irregularity, a defiance of what threatened to be the triumph of the machine. In the latter regard there has been a continual discussion about the attitude of Morris toward the machine. It should be emphasized at the outset that he was not against machines totally, and in his Utopian novel, *News From Nowhere*, he recognizes the usefulness of machines doing work that is tedious. True, in his own firm he did not always follow this dictum: his workers at Merton Abbey at times did do the sort of repetitive tasks that might have been better done by a machine. Work there tended to be divided up in a "modern" assembly line. Such inconsistencies seem not to have bothered Morris unduly. He recognized that he lived in an imperfect world, and that it was necessary to adapt to it in order to maintain a position that allowed him to campaign for the goals he held. Machines however useful, were in no sense virtuous in themselves. Regularity and the sort of "perfection" achieved by the machine had little appeal to him.

The vagueness of this ideal has been effectively pointed out by David Pye in his intriguing study *The Nature and Art of Workmanship*. Pye expresses his anger at Ruskin and Morris for leading many intelligent people to despise the machine products of their own time, thus impeding possible improvement of factory products: "Between them they diverted the attention of educated people from what was good in the workmanship of their own time, encouraged them to despise it,

[17] A. Welby Pugin, *The True Principles of Pointed Christian Architecture* (London, 1853), p. 1; first published 1841.

and so hastened its eventual decline."[18] It is true that what they meant by workmanship and craftsmanship could be irritatingly vague and contradictory. And there is a tendency in the Arts and Crafts movement to judge work by its intention rather than by its quality. As Pye remarks vehemently, "a workman who will not be judged by his work is contemptible. . . . [There] is no possible criterion of workmanship except the work. If that too is a dogmatic assertion, at least it has the backing of ancient tradition. 'The tree is known by its fruit.' "[19] But this position does ignore the question that was so important for the critics of the nineteenth century— no matter that the quality of the product that might well be "shoddy" in any case—what was the condition of the workman who produced it? In the last analysis, the worker was more important than the work; in that sense, Morris believed that the political problem needed to be solved before the aesthetical. It was thinking about that need which marked the thought of Pugin, Ruskin, and Morris. No doubt Pugin exaggerated in his *Contrasts* (1836), comparing a medieval town with a nineteenth-century one, to the vast detriment of the latter. Pugin, Ruskin, and Morris were less concerned with individualism in its Renaissance or modern significance, less concerned with individual "happiness," than other modern thinkers, but they had an intense awareness of the connection between labor and life. Where Pye is right, and where we must be careful neither overly to praise nor overly to denigrate the products of the Arts and Crafts movement, is that it does not necessarily follow that a greater concern with the nature of labor will mean that the product made will be of greater aesthetic value—indeed it may be worse. Ruskin and Morris were questioning the assumption that the aim of society was to produce the best possible product. Ruskin's ideal society was much more hierarchical and conservative than Morris's;

[18] David Pye, *The Nature and Art of Workmanship* (Cambridge, 1968), p. 66.
[19] Ibid., p. 68.

Morris's vision of a rural "communistic" society for the future is clear in *News from Nowhere*. It may be as unrealistic today as then, but the legitimacy of its comment has not diminished. Pye does recognize that Ruskin made an important contribution: "He saw, before Japanese aesthetics were known in the West, that free and rough workmanship have aesthetic qualities which are unique. He also saw that in manufacture and building there is a domain of aesthetic quality which is beyond the control of design, and insisted that architects with drawing boards could never have made Venice what it was. Thirdly, he described and understood the quality in things I have termed diversity and understood its importance in the design of ornament, though not in workmanship. The intrinsic importance of these ideas is not diminished by the fact that so much rubbish has derived from illegitimate extensions of them."[20]

Ruskin was a great commentator on art. He railed against the state of society and served as an instigator for many of those who found so much wrong in the nineteenth century. Yet at the same time he was intensely Victorian himself, possessing that most characteristic of Victorian attributes: a belief that all aspects of life have moral dimensions. Hence a product's greatest significance may not be its aesthetic quality but its morality in terms of the feelings of those who produced it and of those who use it. We can sense why there was such a reaction in later years against this Victorian reductionist way of judgment, so close an alliance of art and morality. A consideration of its production may be a ridiculous way to judge a painting, but to force those who use the goods to ask at what price those goods may have been produced may not be quite so ridiculous. There can be no question that this sort of moral concern with the conditions of the laborer was an important factor in the growth of the Labour party—and that Ruskin and Morris were essential shapers of that party.

Ruskin's vision made him dislike the piecemeal approach

[20] Ibid., p. 70.

of the government art schools: their notion that design and ornament should merely serve as an "adjunct to industrial enterprise."[21] Morris derived the idea from Ruskin that craftsmanship and the sort of society that produced it were intimately related. It was that assumption that he and his followers pursued.

The Aesthetic movement—which flourished in the 1870s—was important too in setting the stage for the Arts and Crafts movement, though at first glance one might not think that there were many resemblances between them. The aestheticism of the period was much more inward looking and "precious," less hearty. But both movements were serious about aesthetics; both were profoundly influenced by Ruskin. The young Oscar Wilde, for example, hearing Ruskin lecture at Oxford, was inspired, not only to work on the Hinksey Road outside Oxford, but to go to America in 1882 and enlighten the natives on the English Renaissance of taste in "House Decoration," and "Art and the Handicraftsman." (Later, writing *The Soul of Man Under Socialism*, Wilde was to be deeply influenced by the vision that Morris had put forward in *News from Nowhere*.)[22]

In revolt against Victorian clutter and advocating a more "rational" approach to design, the Aesthetic movement came under the influence of Japanese art, particularly its sense of sparseness and restraint.[23] Also important was the Japanese conception of a total view of the aesthetic experience. Whistler designed not only the frames for his pictures, the pages of his books, but even the rooms where his pictures were exhibited including the colors of the walls and the placement of the pictures. The Aesthetic movement shared with the Arts and Crafts movement a sense of the relationship of both the higher and lesser arts: that an aesthetic approach suffused all aspects of life. It was a view that laid its leaders open to parody, most

[21] Janet Minihan, *The Nationalization of Culture* (New York, 1977), p. 134.
[22] See J. D. Thomas, "The Soul of Man Under Socialism," *Rice University Studies* 51 (Winter, 1965), pp. 83-95.
[23] See Alastair Service, *Edwardian Architecture* (London, 1977).

famously in Gilbert and Sullivan's *Patience*, with its picture of Wilde as the "Greenery-Yallery, Grosvenor Gallery foot-in-the-grave young man." Wilde dallied with political views, but they were secondary to him and did not have the profound implications they had for Morris. Perhaps because of his homosexuality, his rebellion against the values of his period was less public than Morris's, until 1895 when he took a stand for "the love that dare not speak its name" rather than flee the country. Having violated the commandment of English society—"do not be found out"—he was broken and imprisoned, and the cause of aestheticism was discredited. In his way, though, he was as brave as Morris in fighting the shibboleths of English society.

As well as in politics, there were to be, as I have suggested, significant new developments in the 1880s in the world of design and architecture, a conscious departure from historicism and eclecticism—a search for a more "independent" style—with fewer references to past styles than had tended to characterize much of the artistic and particularly the architectural development, of the first three quarters of the century. Pugin and Ruskin had put the Gothic style in a special place in the hearts of many nineteenth-century architects and designers. In the 1880s, however, there was an attempt to achieve a more "vernacular" style, more loyal to the traditions and materials of a particular area, to local and national history with less attention to importations from abroad, yet without turning away completely from the traditional aspects of the work of architects earlier in the century. Even the "Jacobethan" style for public buildings had a historical connection with the English past, until it gave way to an adaptation of Baroque elements and eventually to the dominance of French Beaux-Arts style.[24]

Why was there such a development in the 1880s? Did it take that long for the influence of William Morris to mature, for the example of Philip Webb's highly original Red House,

[24] Ibid.

built for Morris in 1859, to be taken that seriously? The importance of Red House—built with a vaguely medieval feeling but not specifically or intentionally so—has been disputed, but it certainly presaged many of the houses to be built later in the century: "plain" buildings that did not have a clear-cut association with one particular period in the past. It took a number of years, or more, for the full implications of Webb's house to sink in, and so too for Morris and his influence. And, beyond Red House, there were obviously other forces at work that led to the extraordinary flowering of new sorts of buildings, new sorts of designs, new sorts of artistic organizations in the 1880s.

Very large country houses were still being built, even as large imperial political gestures were being made, but the exciting developments at the frontier of architecture were in the direction of the small country house, a dwelling still elegant and certainly luxurious yet more in keeping with what might be England's future. As James Kornwolf remarks in his study of the architect M. H. Baillie Scott and his contemporaries in the Arts and Crafts,

> Baillie Scott was almost exclusively concerned with the design of the smaller country house and its furnishings. This interest was typical of his generation in England: Voysey, Prior, Ashbee, Lethaby, Lutyens, and Barry Parker, like Baillie Scott, drew upon the achievement of the earlier generation of Pugin, Ruskin, Morris, Webb, and Shaw, who initiated and led what has often been called the revival of English domestic architecture. But if the older men laid out a new course for domestic architecture, the younger architects brought it to fruition. Rallying around the various Arts and Crafts organizations formed in the eighties, they created an architecture in the nineties and early years of the twentieth century whose freshness and purpose was truly prophetic. The passion for health, whether through sun and clean air, wholesome food, or adequate working conditions, hous-

ing and bathing facilities, was, of course, especially wide-spread in the eighties. It was an explicit message of Morris' writings, of French Impressionist painting, of the Arts and Crafts movement, of American Shingle Style architecture.[25]

It is also clear that in the intense political activity of the 1880s there was an attempt to seek new solutions to the political conundrums of the decade and beyond. Kornwolf does not claim, nor would I, that there is a necessary connection between innovations in the artistic and in the political world. Yet there is a striking similarity of impulse: "The Eighties in England and elsewhere witnessed a renewed, but especially vigorous, pressure from the working classes and factions of the intelligentsia for correction of the insufferable human, economic, and cultural ailments wrought upon the century by various revolutions. The Arts and Crafts might well be viewed as the cultural parallel, if not the actual organ, of the socialist movement. Many leaders of Arts and Crafts—Crane, Day, Mackmurdo, Ashbee, and even Lethaby—followed Morris' example of active participation in socialism or in the cause of the working classes. In part, at least, this explains why the Arts and Crafts did not become a 'national' movement, supported by established institutions, patrons, or publications of the arts. That the Arts and Crafts was not itself socialist is confirmed by the figures of Voysey, Baillie Scott, and Lutyens, all of whom remained quite aloof from this aspect, and were later outspoken politically in an opposite direction."[26]

MORRIS AND THE ARTS AND CRAFTS

MORRIS was not only an inspirer but a founder of the Arts and Crafts movement. His years of greatest activity as a de-

[25] Kornwolf, *Baillie Scott*, pp. xxiii, 6-7.
[26] Ibid., p. 13.

signer were in the 1870s and early 1880s. His firm had been established in 1861 and was refounded as Morris & Co. in 1875; during the 1870s it was at its most innovative. Morris's ideal for living was a simple one—one room with plain walls. As he remarked to Yeats, "I would like a house like a big barn, where one ate in one corner, cooked in another corner, slept in a third corner, and in the fourth received one's friends." Nevertheless, he also produced very elaborate furniture and fittings such as we see in the Green Dining Room now in the Victoria and Albert Museum. And he designed with great brilliance patterns for wallpapers and textiles. These had far less influence upon the Arts and Crafts, which was more concerned with objects. Its practitioners were, perhaps, more influenced by what Morris said about the worker's involvement with his work than by Morris's practice. The aesthetic home became known for Morris's wallpapers, which Osbert Lancaster, in an extreme judgment, considered "the only legacy of any artistic value bequeathed us by the whole movement."[27]

Morris's further contribution in the world of design is stated concisely by Peter Floud in the 1952 catalogue for the exhibition of Victorian and Edwardian decorative arts at the Victoria and Albert Museum. There, his individual importance was recognized, but he was also placed in a continuum of nineteenth-century design. "Morris's whole life" Floud writes, "was a crusade against the debased standards of mid-Victorian mass-production which he traced to the influence of machine manufacture and the disappearance of honest and satisfying hand-craftsmanship. His own particular contribution to design was in the field of flat pattern-making in which his fertility was prodigious and his genius unsurpassed. This he applied successively to embroideries, wallpapers, printed textiles, woven textiles, carpets and tapestries, in each case basing his designs on a thorough understanding of the processes of

[27] Osbert Lancaster, *Home Sweet Home* (London, 1939), p. 44.

production gained by intensive personal research and experimentation."[28]

It was in the 1880s that Morris's concerns and message were taken up by others, frequently organized in groups. Among the most important of the latter were the Century Guild, the Art Workers' Guild, and the Arts and Crafts Exhibition Society. To a considerable degree they spread his ideas and practices.

Morris did have a certain proclivity for groups and guilds, a tendency to think in terms of brotherhoods, in arts and politics if not so much in literature, who would work together. At the same time he had some sense of being an isolated character, even though much surrounded by others. When he was an undergraduate at Exeter College, Oxford, he and Edward Burne-Jones wanted to form a brotherhood that would reform the world. They thought first they would band together as priests in the Church of England. Then Morris took an approach through literature—he published and edited the *Oxford and Cambridge Magazine*—then, through architecture—he apprenticed himself to G. E. Street in Oxford—then, painting—he joined Burne-Jones as a follower of Dante Gabriel Rossetti. In short, Morris had, as did others of the period, a belief in some sort of brotherhood, fairly closely modeled on a religious one. Even as he was losing his faith, he was still bent upon improving the world.

Morris's marriage to Jane Burden, a daughter of a groom in Oxford, fitted into the pattern of his early life. She was painted by Morris in his one easel painting, *La Belle Iseult*, and painted and drawn many times by Rossetti. One of Rossetti's most famous models, she was probably later his mistress and in his paintings survives as the archtypical Pre-Raphaelite woman. She was—to use the group's term—a "stunner," and it is perhaps significant that Morris met her

[28] [Peter Floud] *Victoria and Albert Museum Exhibition of Victorian and Edwardian Decorative Arts* (London, 1952), p. 38. This invaluable catalogue contains brief biographies of most of the figures mentioned in these pages.

when he was one of those, including Rossetti, who went up
to Oxford in 1857 to paint murals in the Oxford Union. (The
paintings are now virtually invisible. Of that Oxford visit,
Jane remains the most visible survival.)

Their marriage in 1859 was important not only in his life
but in the history of design. Before then, Morris had been
living in Red Lion Square in London with Burne-Jones. Al-
ready he felt that the furniture commercially obtainable was
not acceptable; he and his friends designed and made several
large pieces, some of which had to be cranked up outside the
building to the flat. When Morris married, there was no longer
room to stay at Red Lion Square and he decided to build a
house for his bride, which would also be a sort of secular and
noncelibate monastery—an early-day "commune" in which
other families might live, most notably the Burne-Joneses. In
1860 Burne-Jones had married Georgiana MacDonald, one of
whose sisters would be the mother of Stanley Baldwin and
another of Rudyard Kipling. Land was found fairly near Lon-
don—an orchard in Upton, now Bexleyheath. There in 1859
Red House was built, designed by Philip Webb.

Morris had met Webb in Street's office and their association
lasted for the rest of their lives; Webb became one of the most
important and interesting architects and designers of the age.
Red House was a turn toward a building style simpler than
the heavy Victorian approach, a style already heralded by the
parsonages of Butterfield and Street. It has aged well and is
an unassuming and warm building. Morris lived there briefly
only, until 1865, and just with his own family. The impetus
behind Red House—Morris's recognition that if he were to
have a congenial place to live, he must build it himself; just
as he recognized that to have attractive furniture and other
appurtenances of living he had to design them himself, or
have them designed by his friends—led to the foundation of
one of the most important "brotherhoods" of all: the for-
mation in 1861 of the "firm" of Morris, Marshall, Faulkner
& Co., in which Rossetti too was a partner. The growing
success of the firm and the awkwardness of living away from

London forced Morris to give up Red House and move back to the metropolis. Brotherhoods are not all that easy to sustain, as communes in our own time have discovered. Not without irony, Rossetti in 1874 referred to Morris as engaged in "petty trade," and there was probably some latent feeling that a firm was not a proper activity for either artists or gentlemen.

Morris's own bitterness about the business situation is reflected in a letter to his mother on March 25, 1875, when he was reorganizing the firm: "My recalcitrant partners have behaved so badly that I felt half inclined more than once to throw the whole affair into Chancery. . . . 'tis a deal of money to pay for sheer nothing."[29] In 1875, with some pain and suspended friendships, the firm was restructured as Morris & Co. with Morris officially, as he had been largely in fact, the dominant figure.

But here I wish to emphasize the group activities that were so marked in Morris's career. As his daughter May Morris observed, "[In] the decorating of Red House we have a microcosm of all the activities that were to come. . . . And there it stood, 'the house that Top built', among the apple orchards of Kent, with the date 1859 turning in the winds on the vane about the roofs, fitted out, room by room, by enthusiasm and vigorous young invention, intimate, home-like, in its simple perfection the very pattern of a small English country dwellinghouse."[30] From the experience with Red House came a firm providing stained glass, wall-painting, painted tiles, furniture, embroidery, table glass, metalwork, later on chintzes, paper hangings, and woven hangings, and after the reorganization of 1875, tapestry and carpets. As Rossetti wrote to Charles Eliot Norton in 1862, the aim was "to give real good

<hr />

[29] William Morris to Emma Morris, William Morris Gallery, Walthamstow, J-15; hereafter WMGW.

[30] May Morris, "Introduction," in *William Morris: Artist, Writer, Socialist* (1936; reprint ed. New York, 1966), I, 11-13. Top or Topsy—Burne-Jones's nickname for Morris—which stuck through his life, because of his unkempt hair, from Topsy in *Uncle Tom's Cabin.*

taste at the price as far as possible of ordinary furniture."[31]
Whether it was actually possible to do this was another matter.

The firm represented an attempt to reform the state of
design by means of a group of like-minded souls with Morris
more than any other acting as an example and an influence.
It was characteristic of him that he thought in terms of groups,
but when they were formed, he grew dissatisfied with them.
There were parallel developments in his business and political
life. In business, he had reorganized the firm in 1875 and
broken with some old associates, most notably Rossetti and
Ford Madox Brown. Somewhat later, he reorganized his po-
litical life. From 1883 to 1890, he moved from the Democratic
Federation to the Socialist League, and then to the Ham-
mersmith Socialist Society. Similarly, though he was also
involved in the design groups formed in the 1880s, he had
ambivalent feelings about them. Could small groups, whether
concerned with design or politics, actually transform the state
of society? A thorough-going reformation, indeed revolution,
was needed. Yet his association with those who considered
themselves his disciples in art or politics was not totally un-
congenial. As his daughter remarked, "The busy and fruitful
years of the eighties [saw] my Father in association with men,
many of them younger than himself, who felt the time had
come to proclaim the importance of the arts to modern life,
and to that end to group themselves into a body that could
meet and discuss and find ways to forward the cause of Art."[32]
Practically none of these young men would follow Morris all
the way politically; most of those who considered themselves
socialists were so in a more limited way than he. But they
were attracted to him not only by his active life as a designer
but also by his "public" role as a proselytizer for his ideas
about art, and in some cases about politics.

The Society for the Protection of Ancient Buildings, affec-
tionately known as "Anti-Scrape," was founded in 1877, largely

[31] Ibid., I, 72.
[32] Ibid., II, 81.

under Morris's impetus, in reaction to what he considered mistaken ideas of restoration, particularly those practiced in that year by George Gilbert Scott at Tewkesbury Abbey. The Society opposed rebuilding a structure in its original style. Rather it advocated the preservation of the original old building with the minimum alterations, that is, historical accumulations were not to be scraped off. Morris saw heavy-handed restoration as a sign of the crass commercialism of a capitalist age, but he would join with all those who opposed it, no matter what their reasons. His political views did, however, form significant part of a talk he gave to the Society in 1884, and the concept of guilds he advanced in that talk is important in assessing the role of the groups that formed in the 1880s, varied as they were, and his influence upon them.

By the summer of 1884 the Art Workers' Guild was already in the process of formation, and Morris also knew of the Century Guild. By this time as well he had extensive experience as a manufacturer himself, making objects that might have been produced by some sort of guild system in earlier years. He now had a feeling for the political implications of what he was doing. Generally he was fairly careful in dividing his interests and not imposing his political views upon societies that did not have a political dimension. But the intensity of his political experiences in 1884—he had just joined the Democratic Federation the previous year—and the artistic activities that also characterized the period—made him aware of the political implications of his artistic work and willing to express his views to the Society for the Protection of Ancient Buildings. As he remarked at the beginning of his talk: "I am compelled very briefly to touch upon the conditions upon which handiwork has been produced from the classical times onward; in doing so I cannot avoid touching on certain social problems, on the solution of which some of you may differ from me. In that case I ask you to remember that though the Committee has ordered me to read this paper to you, it cannot be held responsible for any opinions outside the principles advocated in its published documents. The Society should

not be regarded as *dangerous*, except, perhaps, to the amusements of certain country parsons and squires, and their wives and daughters." He then went on to point out the difficulties faced by those who wished to reform the system, to argue why he believed that it was necessary to make far more fundamental reforms: "To expect enthusiasm for good workmanship from men who for two generations have been accustomed by the pressure of circumstances to work slovenly would be absurd; to expect consciousness of beauty from men who for ten generations have not been allowed to produce beauty, more absurd still. . . . The kind and quality of that work, the work of the ordinary handicraftsman, is determined by the social conditions under which he lives, which differ much from age to age." In his talk he offered a short historical sketch, in which he emphasized the importance of the lack of a division of labor in times past. (Morris himself, although primarily a designer, attempted to practice every craft in which his firm engaged—he was a living embodiment in his interests in crafts, and in all his other interests, of a lack of a division of labor.) The division of labor came about in the Tudor period: "Instead of all workmen being artists, as they once were, they were divided into workmen who were not artists, and artists who were not workmen." Morris felt that this system was completed in the eighteenth century, when the workman "was reduced to a machine, under that of the present day he is the slave to a machine." But in the crafts and architecture, he thought that the artisans were closer to what they had been in the eighteenth century, not yet slaves of the machines.

This important lecture reinforces the claim made for Morris as a founder of the modern approach toward art and architecture. Despite his identification with the Gothic Revival and his great affection for Ruskin's "The Nature of Gothic," and the ideal of workmanship he believed the Gothic period to stand for, Morris saw the defects of building in the Gothic style. A number of his designs look old-fashioned to us—and so they should, as they were done, in many cases, more than

a hundred years ago—but his wish was to move out of historical style, particularly the eclecticism that characterized the Victorian age, into a more ahistorical style. Naturally style would reflect the period but not in a deliberate way: the aim was loyalty to the material of the particular area of the country. "Surely," he declared, "it is a curious thing that while we are ready to laugh at the idea of the possibility of the Greek workman turning out a Gothic building, or a Gothic workman turning out a Greek one, we see nothing preposterous in the Victorian workman producing a Gothic one. . . . It is a strange view to take of historical knowledge and insight, that it should set us on the adventure of trying to retrace our steps toward the past, rather than give us some glimmer of insight into the future."

As Mark Girouard has pointed out in his history of the Queen Anne movement, *Sweetness and Light*, the Morris firm moved away from the tradition of the "ponderous" Goths, keeping some of the Gothic elements but attempting to combine them with more "timeless" features largely drawn from the seventeenth and eighteenth centuries. The result was a domestic style of architecture that might be somewhat eclectic but with a certain lightness and freshness of touch that gives it a strong justification to be seen as one of the major sources for the Modern movement.

Morris put forward in this talk a cardinal Ruskinian belief that art must produce pleasure for those who practice it:

> For, after all, what is it that we are contending for? The reality of art, that is to say, of the pleasure of the human race. The tendency of the commercial or competitive society, which has been developing for more than 300 years, has been towards the destruction of the pleasure of life. . . . Believe me, it will not be possible for a small knot of cultivated people to keep alive an interest in the art and records of the past amidst the present conditions of a sordid and heart-breaking struggle for existence for the many, and a languid sauntering through life for the

few. . . . Let us admit that we are living in the time of barbarism betwixt two periods of order, the order of the past and the order of the future.[33]

Here I believe we have Morris's attitudes stated very clearly. We can see why he welcomed, in a limited way, endeavors to recreate an artistic system that would resist using workmen as either machines or slaves of machines.

One of Morris's most influential ideas for the entire movement was his attempt to give equal status to the so-called "lesser arts" in the context of architecture, and to bring them up to the level of the established arts of painting and sculpture. In other countries a similar attempt was being made, but it is doubtful whether it conveyed elsewhere so many implications of class as in England: as the "greater" arts were dominant in the English artistic world, so the established classes were dominant in its political world. Morris's first public lecture—which started him on his way to becoming both an artistic and political missionary—was on "the lesser arts." So many of his followers were prepared to accept his upgrading of design, but in a traditional nineteenth-century individualistic way by raising individual craftsmen to a higher level, much as the class system was protected in England by allowing the particularly talented to get ahead. Although he was still a Liberal in politics, Morris had a far more total vision than many of his artistic followers. Indeed, it may have been his expansive view that put some of them off: "I believe all the change and stir about us is a sign of the world's life, and that it will lead—by ways, indeed, of which we have no guess—to the bettering of all mankind." Morris's followers would adopt his Ruskinian view—that objects should give pleasure *both* to the maker and user, but they would not necessarily follow him in his political position—that it was essential to change society totally in order to make this possible. If they were far less sweeping in their thoughts, they were

[33] Ibid., II, 128-145.

nonetheless important in bringing about modifications in their society. They advocated design of a new sort, traditional in its adherence to "nature" but freeing itself from the literal designs of conventional Victorian manufacture.

MORRIS AND POLITICS

THERE was always a deeply crusading spirit in Morris himself, but, as we have seen, it would not take political form until 1876 when he threw himself, as a Liberal, into the agitation against Disraeli over the question of whether England would support or attack Turkey. In a more generalized sense, he was a fighter, and a fighter against the complacent "spirit of the age"; the spirit that was represented in the Great Exhibition of 1851, which he refused to visit as an adolescent. He had, however, a crusading spirit of his own that tempted him to enter the Church, and although he quite rapidly had lost his religious faith, the remaining spirit led Morris and Burne-Jones to pledge themselves to the world of art, dedicated to fighting an age in which they felt that "shoddy is King." Burne-Jones continued to be his most faithful friend, although not in sympathy with him politically, and the major designer of stained-glass windows for the firm.

It was hard, in some ways, for Morris to work with others, and he was the dominant figure in the firm from the beginning; he also had excellent managers—first Warington Taylor and then George Wardle. The firm was not run very differently from other similar business and he was not moved in later years by his socialist beliefs to do much in this regard. Quite the contrary, he realized that such small-scale change would not materially effect the coming of the necessary revolution. He also feared that if he dramatically improved the lot of his own workers, he would simply reinforce the great doctrine of "getting on," and make of them men content to belong to the bourgeoisie, rather than workers anxious to help transform the world. There was, also, the paradox of

price. Morris, as a designer, was committed to quality, and as a businessman, to making a profit, not only to support himself and family, but to provide funds for his socialist activities. The expensiveness of much that his firm produced would seem inconsistent with the latter, though the firm did make some simple inexpensive objects.

Still, he was aware of the paradox of his position, as in his famous outburst about ministering to the swinish luxuries of the rich while working at the house of Sir Lowthian Bell. His private income, and then his later financial success, allowed him to devote time and money to political causes. Marx, we know, expected that certain members of the bourgeoisie, such as himself, would assist in bringing about political change, but he did not feel compelled, therefore, to give up the trappings of the bourgeois life. Such gestures are frequently pretentious. Yet social reformers can be uneasy in the bourgeois situation, particularly if they are manufacturing luxury goods as well. As Morris remarked in 1883, "We are but minute links in the immense chain of the terrible organization of competitive commerce, and . . . only the complete unriveting of that chain will really free us. It is this very sense of the helplessness of our individual efforts which arms us against our own class, which compels us to take an active part in the agitation which, if it be successful, will deprive us of our capitalistic position."[34] That he was quite self-conscious about his position can be seen in a further remark he made in Cambridge in 1884, that "he was one of a class that lives upon the labour of other people."[35] In the late 1880s when he was asked if, as a rich man, he would submit to a division of wealth, he replied "I am not quite a rich man, as rich men go nowadays, . . . but I am richer than I ought to be compared with the mass of my fellows; or rather, perhaps, I shall say they are poorer than they ought to be. I am more than willing that

[34] *The Standard*, November 23, 1883, quoted in Meier, *Marxist Dreamer* I, 43.

[35] *Justice*, February 23, 1884, quoted in Meier, *Marxist Dreamer*, Notes I, xii.

my riches, such as they are, should be put into the common stock of the nation; and I shall rejoice to work for the community, and give it the benefit of whatever talent or skill I possess, for the same wages that I demand for, and that the nation could afford to pay, under a proper economic and moral system, to every workman—dustman, blacksmith, or bricklayer—in the land."[36]

At the same time, as in the talk that he gave to the Society for the Protection of Ancient Buildings, he was aware of the importance of the nature of work, and the need to transform it. He felt as a later commentator has remarked, that "men had become unnaturally separated from the sources and ends of their productivity. . . . all the daily expressions of life revealed a reductive, mechanical tension between toil and weary idleness, rather than a life-giving alternation between useful work and refreshing leisure."[37] The nature of work was at the center of his concerns. The alienation of the worker from his work was the problem that the growing socialist movement and the Arts and Crafts movement were each attempting to resolve. Morris acted as an inspiration to both. But he regarded Arts and Crafts organizations with a somewhat jaundiced eye. He felt that, important though they were, they were too small-scale to do enough good. As they were not political, they did not go to the heart of the matter.

Morris's activities in the 1870s reveal how he arrived at his views on the position of the workman, and, by implication, the attitude toward Arts and Crafts groups that he put forward some years later. The younger men in the world of design were moving in a lively and important fashion in redesigning the world, while Morris, driven by some of the same needs, was becoming more and more involved politically, redesigning the world in terms of politics. Ever since his years at

[36] J. Bruce Glasier, *William Morris and the Early Days of the Socialist Movement* (London, 1921), pp. 109-110.

[37] Barbara J. Bono, "The Prose Fictions of William Morris: A Study in the Literary Aesthetic of a Victorian Social Reformer," *Victorian Poetry* 13 (Fall-Winter, 1975), 45.

Oxford, perhaps even earlier, he had felt that there was something wrong about the society in which he lived. As painter, as architect, as designer, as poet, he was anxious to better it. In the 1870s he was beginning to concentrate on the political and social environment. His sense of a need for a new sort of society is evident in a letter he wrote to Louisa Baldwin, one of the MacDonald sisters, the mother of Stanley Baldwin and sister of Georgiana Burne-Jones, even as he evokes the continual English dream of the world of the countryside, which would form such a vivid part of *News from Nowhere*: "Suppose people lived in little communities among gardens and green fields, so that you could be in the country in five minutes' walk, and had few wants, almost no furniture for instance, and no servants, and studied the (difficult) arts of enjoying life, and finding out what they really wanted: then I think one might hope civilization had really begun."[38] This was in the 1870s. Later on the very term civilization would come to stand in his mind for what was wrong about England.

Certainly Morris had led an active life up until 1876 in terms of his business and his considerable literary career. Then he was nudged into public life by his indignation about the treatment of the Turkish Christians, writing a letter of protest to the *Daily News* on October 24, 1876. He became active in the Eastern Question Association, for which he served as treasurer, and then in the next year in the formation of the Society for the Protection of Ancient Buildings. His commitment intensified and his beliefs moved further and further to the left, culminating in his joining the Marxist Democratic Federation, under the leadership of H. M. Hyndman, in January, 1883.

The years from 1876 to 1886 were marked by steps toward socialism. In the late 1870s, his total political conversion was still in the future; in that period both he and his disciples in design shared a reforming instinct to reshape the world. As the younger men demonstrated a greater intensity in their de-

[38] Morris to Louisa Baldwin, March 26, 1874 in Philip Henderson ed., *The Letters of William Morris* (London, 1950), p. 62.

sign activities, so too did Morris in his public activities. At the same time he maintained his business and design work. In the late 1870s he was at a plateau but ready to move in a new direction, this time political. He had accepted—more intellectually than emotionally, and it would always be a heartache for him—the relationship between his wife and Rossetti. The firm had been reorganized, he had a competent manager and did not have to cope with temperamental partners.

His increased political activity brought him in closer contact with workingmen. Before he had chiefly known them as employees; now, he was increasingly impressed by their qualities. Through Anti-Scrape he became more convinced that under the present arrangements of society, the primary motivation in the world would be economic and commercial— a commitment to economic gain, the sham of "restoration" to make something look new, with little fidelity to the inner quality of what the building had been before. For the experience of organizations, and a sense of the realities of nineteenth-century English life, his time in the Eastern Question Association and his continuing commitment to Anti-Scrape were extremely important. His indignation about the Turks and about the state of buildings in England marched hand in hand, political and artistic fury gathering force together.

During this period, too, he was expanding his manufacturing activities, and spent a lot of time with Thomas Wardle in Leek learning about the dyeing of textiles. Most of the surviving correspondence for 1876 is between himself and Wardle on technical questions. The intensity of his feeling about integrity in design is evident in a letter to Wardle at the end of 1875: "[It is essential] our having all our dyes the soundest & best that can be, and [I] am prepared to give up all that part of my business which depends on textiles if I fail getting them so."[39]

Undoubtedly he had always had ambivalent feelings about

[39] Morris to Thomas Wardle, November 26, 1875, Duke University Library.

trade. Perhaps some of these were the ingrained snobbism of the English gentleman, although in his case that seems less than likely. He was on a crusade to modify the aesthetic standard of his day; yet he had to work within the structure of English society. As he wrote as early as 1875 to Rosalind Howard, later the reforming Countess of Carlisle, about his working with Wardle, "I have been learning several very interesting things here, & love art and manufactures, and hate commerce and money making more than ever: I look forward very much to talking the whole matter over with you, though I daresay we shall differ on a point or two."[40]

Wardle and Morris agreed politically, as they both did with Wardle's brother George, the manager of the Morris firm. He wrote to Thomas Wardle the following June about the Eastern Question: "I have already signed the petition: my daughter Jenny brought it me; I have handed it over to G. Y. W[ardle] and he and I will be able to get a name or two I daresay."[41]

It was slightly later than this that the question of the protection of ancient buildings came to Morris's mind. With Wardle he went from Leek to a visit to Lichfield Cathedral and deeply disapproved of the restoration work being done there. In September, 1876, on his way to visit his old Oxford friend, Cormell Price, in Broadway in the Cotswolds, he saw what he considered the vandalism going on in the restoration of the parish church in Burford. At Price's house, Broadway Tower, he drafted a letter urging that a society be founded to fight such steps. The society actually did not come into being until the following March when his distress over Gilbert Scott's plans for Tewkesbury Abbey precipitated the formation of Anti-Scrape. Morris was beginning to overcome his reluctance to take public action. As late as January, 1876 he had written to Eiríkr Magnússon, his fellow translator from

[40] Morris to Rosalind Howard, July 30, 1875, Howard mss., Castle Howard, Yorkshire.
[41] Morris to Thomas Wardle, June 26, 1876, Duke University Library.

the Icelandic: "I was born *not* to be a chairman of anything."[42] It was hard for him to take the necessary conciliatory role of the chairman, and the changes in his political career were in some part reflections of his inability to get along with others. They were also motivated by ideological differences.

But he continued to plunge into political activities on the Eastern Question and was involved with A. J. Mundella, the prominent Liberal politician from Sheffield (Morris probably held most of its manufactures in contempt), in the agitation. He sent Mundella names of potential supporters for the Liberal position on the Eastern Question. That Morris's circle was still literary and artistic is reflected in his list: William Allingham, William De Morgan, F. S. Ellis, his publisher, such close friends as Charles Faulkner and Philip Webb and the artists W. B. Scott and Henry Wallis. The only name beyond his usual circle was the well-known journalist W. T. Stead, and it is indicative of his comparative unfamiliarity with that public world that he would get his initials wrong and call him W. S. Stead.[43] He threw himself into organizing a national meeting in London to take place in St. James Hall in December, and he was willing to contribute substantially to the association, as well as to write others urging them to do so.

His political commitments were beginning to rob him of time to work at his business, as when he wrote to Wardle that he was unable to come to Leek to continue his training as a dyer: "My political work, which I have taken up in such a way, that it is a matter of honour not to shirk it would prevent me getting away this week; . . . Our meeting was a very great success, and to me a very solemn & impressive affair: I could not have imagined people would have been so enthusiastic."[44] Morris was very impressed by Gladstone's speech at the meeting on December 8 of the National Con-

[42] Morris to Eiríkr Magnússon, January 24, 1876, National Library of Iceland.

[43] Morris to A. J. Mundella, November 15, 1876, Sheffield Public Library.

[44] Morris to Thomas Wardle, December 11, 1876, Duke University Library.

ference on the Eastern Question; he was now involved with the Liberal establishment as treasurer of the Eastern Question Association, an organization in which the Duke of Westminster was the president, and the Earl of Shaftesbury, vice-president. There is some indication, ironically, that business and politics happened to march together: in January 1877, Morris went to call on the Duke of Westminster at his country house, a great Victorian pile, at Eaton in Cheshire, about its chapel. Nothing apparently came of this possibility of work. Morris was not impressed by Eaton. As he wrote to his mother, " 'tis a huge place, but not at all a success, I think."[45]

His feelings about working-class activities displayed both a delicacy of feeling, and also a sense of what might be the proper role for a member of the middle class. There are a few letters that survive over the years to one Frederic Every, perhaps a craftsman, who introduced him to workingmen at the time of the Eastern Question agitation. Morris thought highly enough of Every to recommend him for a post as secretary of the National Liberal Land Company. Every solicited Morris's support for the Trades Guild of Learning, a nonpolitical cause. Morris was more than willing to subscribe, and be an associate member, but would not be a vice-president. Another time, although he was willing to attend a meeting, but was prevented from doing so by rheumatism, he remarked, "The only thing I have to say about the whole matter now is that I think it important, that your meeting if you hold it should be *purely* of working-men; in which I don't doubt you will all agree with me."[46] His relationship with the working class was still removed and somewhat abstract—in the future he might have welcomed such an opportunity. At the same time he revealed a considerable sensitivity to the need of working men to operate on their own, and not to allow their organizations to be taken over by the middle class.

[45] Morris to Emma Morris, January 13, 1877, WMGW.
[46] Morris to Frederic Every, December 13, 1873, Berger Collection, Carmel, California.

He had begun overtly to involve himself in politics. But his next great agitation, one he would continue for the rest of his life in the same form, while his political involvement would undergo an immense change, was, as mentioned, the Society for the Protection of Ancient Buildings. He was still a very respectable figure, and in February 1877 he had declined to stand as professor of poetry at Oxford. In 1892, after the death of Tennyson, Morris was a very serious possibility for the court position of poet laureate. Ultimately his politics would have prevented him from being a candidate and he never would have accepted. He wrote at the time to the Liberal politician James Bryce, "I am a sincere republican, and therefore could not accept a post which would give me even the appearance of serving a court for complaisance sake."[47]

In early March, 1877, he wrote to the *Athenaeum* objecting to Gilbert Scott's proposed restoration of Tewkesbury Abbey. He wrote to Wardle on March 7, "Next week I shall have parson & architect down on me, and may expect to finish in the work-house after all."[48] Morris was operating in consultation with F. G. Stephens, the art critic of the *Athenaeum*. His language was becoming increasingly political: "My eye just now caught the word 'restoration' in the morning paper, and, on looking closer, I saw that this time it is nothing less than the minster of Tewkesbury that is to be destroyed by Sir Gilbert Scott. Is it altogether too late to do something to save it—it and whatever else of beautiful or historical is still left us on the sites of the ancient buildings we were once so famous for?"[49] He felt that he was an amateur in organizing such an association; he solicited Stephens' help in telling him what to do, and what people to write. He attempted to organize the stage army of the Good, those worthy individuals

[47] Bryce to W. E. Gladstone, October 28, 1892, quoting Morris to Bryce, October 27, 1892, BL.
[48] Morris to Thomas Wardle, March 7, 1877, Duke University Library.
[49] Morris to Editor, *Athenaeum*, March 5, 1877 in Henderson, *Letters*, p. 85.

who supported such causes in Victorian England.[50] He was still on sufficiently friendly terms with Rossetti to try, unsuccessfully, to tempt him to join the organizing Committee of Anti-Scrape (although Rossetti may eventually have joined the organization): "Don't be afraid, 'tis not political this time. . . . Ned [Burne-Jones], Webb, Wallis, Boyce, Poynter, F. G. Stephens, Colvin are among the committee."[51] He wrote an elaborate letter to William De Morgan, to be shown to Carlyle, to achieve his cooperation. At the same time, the declaration of war by Russia in April against Turkey led to a revival of activity by the Eastern Question Association and the Labour Representation League, with which Morris was now involved.

As George Orwell said of Charles Dickens, Morris was full of generous anger, and his indignation increased during 1877. He complained that the protests on the Eastern Question were going badly and, amusingly enough, he also felt not only that Disraeli's policy, backed by the Queen, was a disaster in the East, but also that the Queen herself was presuming to compete with Morris & Co. in the manufacturing of tapestries through the support she was giving to works in Windsor. Morris wrote to Wardle, "The *Widow Guelph* has been enticing our customers from us & has got an order for tapestry that ought to have been ours."[52] He was clearly becoming more radical and rambunctious as in his remark about the Curragh, in Ireland, reporting on a trip he had taken there— "where our army of occupation sits."[53] The most momentous

[50] See Howard LeRoy Malchow *Agitators and Promoters in the Age of Gladstone and Disraeli* (New York, 1983).

[51] Morris to D. G. Rossetti, April 3, 1877, University of British Columbia Library.

[52] Morris to Thomas Wardle, October 24, 1877, Duke University Library. Morris won the competition. The Royal Windsor Tapestry Works operated from 1876 to 1890, finally closing in 1895. Morris started preparing himself for tapestry work in 1878, and from 1879 until the late 1930s tapestries were an important part of Morris & Co.'s production.

[53] Morris to Georgiana Burne-Jones(?), October 1877, in Henderson, *Letters*, p. 95.

event of these months was the preparation for his first public lecture, on design, a parallel event to the increasing public activity of the young men who felt that it was necessary to do something about the state of design. This began his career as a public lecturer on art and politics—those talks and the essays that would become highly influential in his own time and the years beyond.

He was accustomed to writing verse, but not expository, hortatory prose. He was quite nervous about it, and even went to try out his voice in the hall. As he wrote to his daughter, "I went with Wardle to the place, & read Robinson Crusoe to him to see if I could make my voice heard: which I found easy to be done: yet I can't help feeling a little nervous at having to face my fellow beings in public." He wrote to his wife: "I finished my lecture yesterday after very hard work at it: I deliver tomorrow in a dismal hole near Oxford St: I am not sanguine as to its reception."[54] The address was to be to the Trades Guild of Learning, Frederic Every's association. Presumably Every was responsible for persuading Morris to speak, and so can be credited with a decisive moment in Morris's life. The Trades Guild of Learning had been organized by Professor Warr, a positivist, and was intended to educate young carpenters, stonemasons, and apprentices.[55] It was more *de haut en bas* than Morris might have liked. Apparently the audience largely consisted of his own workmen and clients—both of whom may have come more out of loyalty than interest. Wardle reported: "I need hardly say there were very few workmen of any kind there, except the men from Queen Square and that the bulk of the audience was formed by Morris's *clients*."[56]

The lecture itself, delivered on December 4, was almost the

[54] Morris to Jane Alice Morris, November 29, 1877, BL, 45, 339 f.12, in Henderson, *Letters*, p. 100; Morris to Jane Morris, December, 1877, BL, 45, 338, f.78.

[55] E. P. Thompson, *William Morris* (New York, 1977), p. 247.

[56] George Wardle to Sydney Cockerell, August 24, 1898 in May Morris ed., *Morris*, II, 605.

pure milk of Ruskin. He was aware of the importance of pleasure in work, and the need for England to improve her decorative style in order to do better as a manufacturing nation: "England has of late been too much busied with the counting-house and not enough with the workshop: with the result that the counting-house at the present moment is rather barren of orders." He was not yet taking a position of the left; indeed it would take six years for him to cross at Oxford what E. P. Thompson calls "the River of Fire." But at the same time, the elements of the vast political change that would take place within him were there: "To give people pleasure in the things they must perforce *use*, that is one great office of decoration; to give people pleasure in the things they perforce *make*, that is the other use of it." He was already aware that social questions were extremely important: "How can I ask workingmen passing up and down these hideous streets day by day to care about beauty?"

So many of the ideas he developed later, that were to be so influential, were already present in this lecture in early form:

> Nothing can be a work of art which is not useful; that is to say, which does not minister to the body when well under command of the mind, or which does not amuse, soothe, or even elevate the mind in a healthy state. What tons upon tons of unutterable rubbish pretending to be works of art in some degree would this maxim clear out of our London houses, if it were understood and acted upon! . . . Simplicity of life, begetting simplicity of taste, that is, a love for sweet and lofty things is, of all matters most necessary for the birth of the new and better art we crave for; simplicity everywhere in the palace as well as in the cottage. . . . We have even now partly achieved LIBERTY, so we shall one day achieve EQUALITY, which, and which only means FRATERNITY, and so have leisure from poverty and all its griping, sordid cares. . . . Amidst renewed simplicity of life we shall have leisure to think

about our work. . . . Men will then assuredly be happy in their work, and that happiness will assuredly bring forth decorative, noble, *popular* art. That art will make our streets as beautiful as the woods, as elevating as the mountain-sides; it will be a pleasure and a rest, and not a weight upon the spirits to come from the open country into a town; every man's house will be fair and decent, soothing to his mind and helpful to his work: all the works of man that we live amongst and handle will be in harmony with nature, will be reasonable and beautiful: yet all will be simple and inspiriting, not childish not enervating; for as nothing of beauty and splendor that man's mind and hand may compass shall be wanting from our public buildings, so in no private dwelling will there be any signs of waste, pomp, or insolence, and every man will have his share of the *best*.[57]

Morris was pleased with his lecture, the first of hundreds that he was to give: "It went off very well, and I was not at all nervous, but made myself well heard."[58] It was promptly printed, first in *The Architect* for December 8, 1877, and then in the new year as a pamphlet. It is significant that his strong words about the nature of art and decoration, his boiling indignation about the foreign policy of the country, and his commitment to Anti-Scrape, all converged in his life at the same time. The same sort of juxtaposition was evident in the discontent felt by young designers, and their looking to Morris for inspiration. Morris's anger at the turn of politics increased, and he began to despair of the Liberal party, although he was far from ceasing to support it at this point. He complained to his wife, "the Jew wretch & *that* old Vic [are] forcing

[57] Quotations from William Morris, *The Decorative Arts: Their Relation to Modern Life and Progress* (London, 1878), 32 pp. reprinted as "The Lesser Arts," in May Morris ed. *Collected Works of William Morris* (London, 1915), XXII, 3-28.

[58] Morris to Jane Alice Morris, December 7, 1877, BL 45, 339, f. 14, in Henderson, *Letters*, p. 101.

us into the war." He was becoming accustomed to talking in public: "I even tried to flit a few words at a small meeting we had at Lambeth yesterday: I can't say I got on very well but I did manage to get a few words out & get to *the end.*"[59]

It is apparent that his political activity was cutting into his work for the firm. He wrote to Wardle, "We are all in a flutter here about our inspired prime minister's last stroke, which I expect will keep me busy for 3 weeks or so: after which I hope to get to work with my tapestry design."[60] Morris held the Queen, along with Disraeli, accountable for the war scare, and generally referred to her in his correspondence as the Widow Guelph or the Empress Brown. His indignation grew when he discovered that the "Widow Guelph is setting up a stained glass manufactory as well as a tapestry one."[61]

His political activities increased, and in January, 1878, he spoke at a meeting in favor of the free navigation of the Dardanelles and wrote a song for a meeting, "Wake, London Lads. Lest England's Glory Come to be Bond Servant to the Turk!" He was not aware of proper political usage, and that officially the Queen's name, despite the fact that Morris saw her as a political villainess and a trade rival, must be kept out of it. The report in the *Times* of January 17 of the meeting of the Workmen's Neutrality Demonstration held at Exeter Hall on January 16 mentioned that he was reprimanded for violating this convention. It was also reported that he had said: "Disraeli was a man without genius . . . but only a galvanized imitation of it." He was still full of praise for Gladstone.

Morris was being swept away by the excitement of politics. Writing to Sidney Colvin to arrange a talk he was to give in Cambridge, he admitted he was falling behind in his business: "I shall . . . be in no heart to do anything but the most humdrum part of my necessary business; in which to say the truth

[59] Morris to Jane Morris, December 20, 1877, BL 45, 338, ff. 84-85, in Henderson, *Letters*, p. 103.

[60] Morris to Thomas Wardle, December 20, 1877, Duke University Library.

[61] Morris to May Morris, January 4, 1878, BL 45, 341, f. 3v.

I am grieviously behind hand at present."[62] He was becoming increasingly distressed about politics. Gladstone had agreed to come to talk to a workingmen's meeting, but the Liberal planners felt that it was a mistake—to Morris it seemed that the Liberals were "funking."[63] He went up and down in his assessments of the political scene and the Liberals' perform-ance. He wasn't accustomed to the continual turns of politics. He wrote ironically to his daughter about the "veracity of Beaconsfield, the sagacity of Northcote, & the tenacity of Derby. With which 3 long-tailed words I will end politics, my dear. Tell Mama that business is fairly good . . . consid-ering the state of trade."[64] He was gaining increasing respect for the working class, an important ingredient in his move toward socialism: the workers would cease to be his employ-ees and become comrades: "Our working-men allies (who all along have been staunch and sagacious)."[65] He was excitable, and changeable: he wrote to the prominent Liberal politician James Bryce that "I can't think that a riot made by the war party would have hurt either us or Gladstone a bit, and now I am sure they will hold meeting after meeting, and triumph, as they well deserve to do."[66] He now seemed to feel that he would "give up reading the Papers, and shall stick to my work."[67] He turned to more restful activities, doing some fishing at Kelmscott and inveighing against Victoria: "The Empress Brown is hard at work at her rival establishment. I am sure she expects to get the whole of the ornamental up-holstery of the Kingdom into her hands. Let her tremble! I

[62] Morris to Sidney Colvin, January 30, 1878, Bodleian Library, Oxford, ms Autog d. 23, f. 73.

[63] Morris to Jane Morris, February 4, 1878, BL 45, 338, f. 98, in Henderson, *Letters*, p. 109.

[64] Morris to Jane Alice Morris, February 11, 1878, BL 45, 339, f. 25v, in Henderson, *Letters*, p. 111.

[65] Morris to C. J. Faulkner, February 5, 1878 in Henderson, *Letters*, p. 109.

[66] Morris to James Bryce, February 20, 1878, Bodleian Library, Oxford, Bryce Papers, Uncatalogued English Correspondence, Box 12.

[67] Morris to Jane Morris, February 25, 1878, in Henderson *Letters*, p. 112.

will under-sell in all branches."[68] He was involved in arrang-
ing the move from Horrington House in Chiswick to Kelms-
cott House, his London home for the rest of his life: it was
formerly the Retreat, then home of the fairy-story writer,
George MacDonald. He wrote to his daughter on March 18,
"As for politics, I am now out of it."[69] That same month he
remarked to Wardle, "Disaster & misfortune of all kinds, I
think will be the only things that will breed a remedy: in short
nothing can be done till all rich men are made poor by com-
mon consent."[70]

His public life in fact was kept on the boil. In April he
entered fully in the campaign for the Wren churches on behalf
of "Anti-Scrape." These activities were profoundly modify-
ing his way of life and his business.

Some years later he marked his final conversion to the so-
cialist view, and its significance for art, in his lecture "Art
under Plutocracy" delivered at Oxford on November 14,
1883, with Ruskin acting as chairman. The lecture was spon-
sored by Liberal undergraduates, the university, and the Rus-
sell Club and took place in University College, where his
friend and fellow socialist, Charles Faulkner, was a fellow.

It was appropriate that he announced his conversion to
socialism at Oxford, only the most recent of the crucial mo-
ments in his life that had occurred in that city and university.
Not only was Ruskin in the chair, but also lending their au-
thority, were the master of University College, the warden
of Keble College, and the warden of Merton College. Orig-
inally Hyndman himself was to give the talk; presumably that
was vetoed as he was too well known as a socialist. Perhaps
the veto served to spur Morris on. As he commented to Faulk-
ner the previous month: "As to Hyndman lecturing in your
hall I would ask you to lay before the Master the fact that I
am quite as much a Socialist as he is; that I am an officer of

[68] Morris to Jane Alice Morris, March 6, 1878, BL 45, 339, f. 27v.
[69] Morris to Jane Alice Morris, March 18, 1878, BL 45, 339, f. 29.
[70] Morris to Thomas Wardle, March 8, Duke University Library.

the same Association, and am distinctly going to lecture as a
delegate from it. . . . Hyndman is an educated man if Trin :
Coll : Camb : is capable of education (which is doubtful) . . .
[nor] will I allow him to blow up any *old* building in Ox-
ford."[71] Perhaps the Oxford authorities felt that one of their
own would not go too far. Morris had given fair warning,
but in fact his talk scandalized the authorities. Its title was
mild enough—"Democracy and Art"—but in it he declared
his belief that without a total change of society art could not
flourish. The relationship between art and labor urged him
to socialism: "Art is Mankind's expression of his joy in la-
bour."[72] When the talk was published, he gave it the more
provocative title of "Art under Plutocracy." At Oxford it had
attracted a lot of attention, including a public protest by the
Master of University College, the historian James Bright.
Perhaps the Master was particularly offended by Morris's sug-
gestion that the undergraduates should attack class barriers by
marrying beneath them (as Morris himself had done). There
were also reports in the press, and Morris wrote to W. T.
Stead: "I have to thank you very much for your sympathetic
report of the Oxford meeting and generally for the fairness
and generosity of your dealings with the Dem : Fed : as well
as myself."[73] He had now firmly and publicly committed
himself to the socialist cause. (There was a nice coda to this
incident in 1932 when Michael Sadler, then Master of Uni-
versity College, arranged for May Morris to give a talk to an
Oxford luncheon society, meeting in the Town Hall, on Mor-
ris and socialism, in order to make amends for the bad re-
ception Oxford had given her father some fifty years before.)[74]

[71] Morris to C. J. Faulkner, October 23, 1883 in Henderson, *Letters*, pp.
188-189.
[72] *The Collected Works of William Morris*, ed. May Morris (London, 1915),
XXIII, 173.
[73] Morris to W. T. Stead, November 16, 1883, Bodleian Library, Oxford,
dep 25, 1872-85, ff. 72-73.
[74] See M. E. Sadler to May Morris, September 10, 1932, Berger Collection,
Carmel, California.

From now on Morris's life was more public. His life and talks were powerful influences upon the careers of the young men in the Arts and Crafts who were just beginning their professional activities.

In his article, "The Revival of Handicraft," in the November 1888 issue of the *Fortnightly Review* Morris was explicit on both the evil and the benefit of the machine and the necessity for man to dominate and to avoid being either a part of the machine or its servant: "As a condition of life, production by machinery is altogether an evil; as an instrument for forcing on us better conditions of life, it has been, and some time yet will be, indispensable." To a degree the critics of Morris who see him as wishing to dispense with the machine are not without justification. He is convinced that the machine, with its commitment to producing utilitarian objects, is also likely to produce ugly objects. Yet he wishes to take a middle ground, and it is in this way that the crafts provide a sensible way to make goods that will be beautiful specifically because beauty is their secondary purpose (a "modern" view) and will have that beauty in large part because as much as possible they have scorned the machine (an "unmodern" view): "It is to my mind the very consciousness of the production of beauty for beauty's sake which we want to avoid; it is just what is apt to produce affectation and effeminacy amongst the artists and their following. In the great time of art conscious effort was used to produce great works for the glory of the city, the triumph of the Church . . . was the aim rather than beauty." Operating in such an indirect way is also how pleasure for the worker might be achieved: "But unconscious as these producers of ordinary beauty may be, they will not and cannot fail to receive pleasure from the exercise of their work under these conditions, and this above all things is that which influences me most in my hope for the recovery of handicraft. . . . So long as man allows his daily work to be mere unrelieved drudgery he will seek happiness in vain. . . . What on earth are we going to do with our time when we have brought the art of vicarious life to

perfection, having first complicated the question by a ceaseless creation of artificial wants which we refuse to supply for ourselves." Morris's analysis of modern civilization is attested to in the malaise that is presently gripping our society—our sense of alienation, of living our lives at a second remove through television, spectator sports, and so forth. He brilliantly depicts and anticipates the defects of the consumer society; he makes it clear why the world of the Arts and Crafts then and now serves as a possible way out of the dilemma posed by industrial society. Morris was able to place, far better than most of his contemporaries and disciples, the dilemmas society faced.

> Necessities . . . are at present driving us into luxury un-
> redeemed by beauty on the one hand, and squalor unre-
> lieved by incident or romance on the other. . . . We do
> sorely need a system of production which will give us
> beautiful surroundings and pleasant occupation, and which
> will tend to make us good human animals. . . . We do
> most certainly need happiness in our daily work, content
> in our daily rest; and all this cannot be if we hand over
> the whole responsibility of the details of our daily life to
> machines and their drivers. We are right to long for in-
> telligent handicraft to come back to the world which it
> once made tolerable amidst war and turmoil and uncer-
> tainty of life.

Morris is not here calling for the revival of the guild system, which was tied to its own time, but for a radical shift in the nature of manufactures. Things made by hand will prove to be better objects for those who use them, and more satisfactory to make for those who create them. There is a certain ambiguity and vacillation in his attitude; one suspects he would prefer to dispense with the machine. But he recognizes that that is probably impossible—in which case man must master the machine rather than be its "servant, as our age *is*." He puts the role of the Arts and Crafts movement in its place—

inferior to what must be done politically, but nevertheless highly important:

> We should welcome even the feeble protest which is now being made against the vulgarization of all life: first because it is one token amongst others of the sickness of modern civilization; and next, because it may help to keep alive memories of the past which are necessary elements of the life of the future and methods of work which no society could afford to lose. In short, it may be said that though the movement towards the revival of handicraft is contemptible on the surface in face of the gigantic fabric of commercialism; yet taken in connection with the general movement towards freedom of life for all, on which we are now surely embarked, as a protest against intellectual tyranny, and a token of the change which is transforming civilization into socialism, it is both noteworthy and encouraging.[75]

Hence Morris was able to support the work of the Arts and Crafts groups and place them in what he regarded as their proper political context.

In January, 1891, he published "The Socialist Ideal of Art" in the *New Review*. It reflects in part his involvement in the Arts and Crafts Exhibition Society. Morris was a man of faith, a hedgehog, who believed in a total controlling vision, yet who conducted himself as though he were a fox: "Socialism is an all-embracing theory of life, and that it has an ethic and a religion of its own, so also it has an aesthetic. . . . Inequality of condition . . . has now become incompatible with the existence of a healthy art. . . . To the Socialist, a house, a knife, a cup, a steam engine, or what not, anything, I repeat, that is made by man and has form, must either be a work of art or destructive to art." For Morris, socialism infused art with

[75] William Morris, "The Revival of Handicraft," *Fortnightly Review*, November, 1888, 1, 603-10. Reprinted in May Morris ed., *Collected Works*, Vol. XXII.

a special importance that to him seemed obvious and pre-
emptory, even though undoubtedly many, including socialists
and nonsocialists, did not share his views: "The Socialist . . .
sees in this obvious lack of art [in ordinary goods] a *disease*
peculiar to modern civilization." Morris saw art as the road
of subversion, as the way to defy and help change the system,
and to show an artist's attitudes toward the values of capi-
talism: "Under the present state of society happiness is only
possible to artists and thieves." Again Morris advanced his
view of the advantages of the Middle Ages in artistic terms:

> Art was once the common possession of the whole peo-
> ple; it was the rule in the Middle Ages that the produce
> of handicraft was beautiful. Doubtless, there were eye-
> sores in the palmy days of medieval art, but these were
> caused by destruction of wares, not as now by making
> of them. . . . Ruin bore on its face the tokens of its
> essential hideousness; to-day it is prosperity that is ex-
> ternally ugly. . . . If . . . we can manage, some of us, to
> adorn our lives with some little pleasure of the eyes, it
> is well, but it is no *necessity,* it is a luxury, the lack of
> which we must endure. . . . At present art is only en-
> joyed, or indeed thought of, by comparatively a few
> persons, broadly speaking, by the rich and the parasites
> that minister to them directly. . . . [Art] is helpless and
> crippled amidst a sea of utilitarian brutality.

For Morris art and the state of society were inextricably in-
tertwined. Although he felt that politics came first, he sup-
ported developments in the world of design which might
present some faint idea of what art might become in a socialist
society: "The Socialist claims art as a necessity of human life
which society has no right to withhold from any one of [its]
citizens. . . . The pleasurable exercise of our energies is at
once the source of all art and the cause of all happiness: that
is to say, it is the end of life." In a sense Morris is the prophet
of a new religion of the world of art, and he almost rises in
this essay to the language of incantation: "When people once

more take pleasure in their work, when the pleasure rises to a certain point, the expression of it will become irresistible, and that expression of pleasure is art, whatever form it may take." The point of politics, in an ultimate sense, is to prepare the way for art. "Our business is now and for long will be, not so much attempting to produce definite art, as rather clearing the ground to give art its opportunity. We have been such slaves to the modern practice of the unlimited manufacture of makeshifts for real wares, that we run a serious risk of destroying the very material of art; . . . [Socialists must see] that to condemn a vast population to live in South Lancashire while art and education are being furthered in decent places, is like feasting within earshot of a patient on the rack."[76]

In this essay, and elsewhere, one can sense Morris's ambivalence about organizations such as the Arts and Crafts Exhibition Society. He thought they were important at helping to create what the artistic future should be. But these groups were concerned with the state of art before that of politics had changed, and Morris felt that the first obligation was to change the world politically. He was sympathetic to these artistic groups, he participated in their activities and was a powerful force in helping them. At the same time he was intensely involved politically and continued his support of political causes even in the last years of his life—when much of his energy was given to the Kelmscott Press. His vision of the socialist world was one in which small groups would be extremely important; he was fearful of the implications of state socialism. In this sense he could accept these groups as the heralds of the artistic future, even though to his mind they were operating in a world that had not yet been politically reformed.

[76] William Morris, "The Socialist Ideal," reprinted from the *New Review* January, 1891 in May Morris, ed., *Collected Works*, XXIII, 254-264.

· CHAPTER II ·

The Century Guild

THE POLITICAL REVOLUTION Morris wished for did not take place in England, yet much of the design revolution did, premised on some of the same values of creating a better, more sensible, and more beautiful life for the ordinary person. It will not do to underestimate the importance of small-group design activities in changing the nature, style, and look of English life. In their ways they have been vehicles, along with the more obvious social and political changes—the widening of the franchise, the comparative decline of privileges, and growth of democracy—for the improvement of the quality of life.

One of the earliest groups to emerge in the outburst of design activity in the 1880s was the very loose association known as the Century Guild. Formed in 1882, it was dominated by Arthur H. Mackmurdo, with Herbert P. Horne and Selwyn Image as his principal associates. Its designs were imaginative and vivid moments of innovation which helped shape the future. In a number of ways the Guild summed up many tendencies of the period. Much more "aesthetical" than most of the other organizations that were to come into being then, it also had elements of the "proto-Art-Nouveau" in its style. There was always to be an extraordinary English "double think" about the relationship between Arts and Crafts and Art Nouveau: a verbal denunciation of the "style" coexisting with an unmistakable stylistic similarity. The similarity was

perhaps greatest in the Century Guild work, even though it was the earliest of the Arts and Crafts groups, and the most removed in time from the flourishing of Art Nouveau.

The Guild's most important design contributions were by Mackmurdo himself: the whip-line curve, as in the chair he designed and in the title page for his book on Wren's churches, and a sophisticated classicism as in the house "Brooklyn." Mackmurdo felt that designers must consider the total environment in which individuals live, that every aspect of a house should fit together, that life itself should be integrated. Mackmurdo tended to be an "organic" thinker, and this trait would be important in his ideas on city planning, and as the dominating force in his later social thought. It was also to this purpose that in 1882 he founded the Century Guild. In some ways, the Guild was a latter-day version of Morris's firm, particularly in the firm's first incarnation from 1861 to 1875: a group of partners. But the Century Guild was not a manufacturing group, but a group of designers loosely allied. It was inspired in its theory by Ruskin and in its practice by Morris.[1]

In its way, Mackmurdo's idea of the Century Guild was more realistic than that of the Morris firm and of some other Arts and Crafts organizations; he was far less worried than they about the role of the machine. Morris's firm did execute designs that were then sent out with some qualms to be manufactured, but the Century Guild did not hesitate about that practice. Mackmurdo recognized that good design could only become prevalent through the use of the machine. Morris was the prophet, but it was men such as Mackmurdo, and even more Voysey, who established close cooperation with manufacturing firms that led to a more sophisticated development of ordinary taste. Through manufacturers good designs were made available to those who would not have been able to afford them before, and a new and simpler taste created for the middle class. Mackmurdo was more hopeful than Morris

[1] See Sylvia Elizabeth [Lisa] Tickner, "Selwyn Image: His Life, Work and Associations," Ph.D. dissertation (Reading University, 1970) p. 26.

about the association of artist and industrialist as effecting some sort of marriage of convenience between the artist and the machine: "When for the Century Guild I was designing damasks, silk and woolen fabrics, printed cretonnes and wall papers, I remember how my soul wrestled with this demon of mechanics. I would fain have hand processes throughout. . . . After closer acquaintance with machine printing and weaving I was able more accurately to balance the possible gains and the inevitable losses. . . . Great and unimaginable things may in the future result from a more true marriage between art and industry, where hitherto it has been but an ephemeral and promiscuous union."[2] What he envisioned was a time when artists, acting as businessmen, in control of their own manufacturing, would be enabled to make decisions, from the first sketch to the final realization.

Mackmurdo believed that machinery could act as a liberating force that would free men to spend more time in pursuit of the idea of beauty itself. He saw himself as much more of a rationalist than Morris, more interested than he both in the theories of the Renaissance and in those of the period of industrialization. No worshipper of the machine, he recognized its limitations and acknowledged that one was more likely to achieve perfection through handwork than through mechanical means: "While recognizing the fact that we must all unfortunately rely, to a great extent, upon things made by machines, this fact should not to any extent, alter our estimate of the many advantages of handicraft. These advantages are not limited to aesthetic qualities in the thing done, nor to the pleasures in the doing; they inhere in the sheer perfection of workmanship; so much so, that a hand-made watch is today superior to a machine-made watch."[3]

Mackmurdo was conscious of being an extension of Morris. Though he disagreed with him on quite a few issues, he continued to believe in him as the example of how the artist and the manufacturer might cooperate.

[2] A. H. Mackmurdo "History of the Arts & Crafts Movement," p. 245, K1037, WMGW.
[3] Ibid., p. 147.

Morris . . . would spend days in the workshops where blocks were being cut and wall papers were being printed before he would design the simplest floral ornament for a wall paper. With our new mechanical facilities for multiple production, problems new to the world have to be solved; and if artistic principles are not to be sacrificed, nor taste violated, the artist who is conversant with the problem is the only man who can solve it. . . . No beauty can enter the toiler's home unless it be brought in by the artist and industrialist working in happy association for this unselfish end. . . . In every department of life's accessories we must for the moment accept the fact that mechanical processes will tend more and more to take the place of handicrafts in the production of those things which the homes of the millions must possess for their use.[4]

Mackmurdo in his own design work attempted to combine both the emphasis on the nonmechanical to be found in Morris with the need to use modern techniques of reproduction.

Arthur Heygate Mackmurdo was born on December 12, 1851, in London and was educated at the Felsted School in Essex. Much of his building would be in that county. The family had come from Dumfries in the eighteenth century. His father was a successful businessman, a chemical manufacturer, and was a member of the Fishmonger's Company in the City of London. Mackmurdo's mother was a D'Oyly Carte, of the family who produced the Gilbert and Sullivan operettas and would build the Savoy Hotel. Thanks to this connection, Mackmurdo himself was to play a part in the design and construction of the hotel in 1889.[5]

[4] Ibid., pp. 242-243.

[5] Mackmurdo appears to have misled Pevsner about his involvement in the building of the hotel. The major architect was Collings Beatson Young. Mackmurdo's contribution has been reduced to perhaps some designs for decorative details on some balcony fittings. See Margaret L. Walk, "A Note on the Architect of the Original Savoy Hotel," November 1, 1978, WMGW.

Another family connection was Herbert Spencer, an influence upon the young Mackmurdo, who had scientific inclinations, though no special gifts to reinforce them. He did attend lectures by T. H. Huxley and later in life wrote a series of philosophical-social disquisitions, among them *The Human Hive: its Life and Law; The Gold Standard and other Diseases*; and *A People's Charter*. These works are long forgotten, having failed to survive him—he died in 1942—while what he produced in design, in part under the influence of Morris, has become of greater and greater interest. But it was the vague sociological treatises that he mistakenly thought to be his significant contribution: "Personally I attach much more importance to my sociological works than I do to architectural works or designs for applied arts." Seldom can an artist more poignantly have misunderstood his rare gifts. He has emerged as a genius of design not of social theory, an important figure in the course of artistic events at the end of the nineteenth century.

Spencer was only one of his intellectual influences. Others were Matthew Arnold, Auguste Comte, and most importantly, John Ruskin. Significantly, four were critics of the Victorian age; but two—Spencer and Comte—criticized it for not being scientific enough; and two—Ruskin and Arnold—criticized it for its moral inadequacies. Mackmurdo remarked in an autobiographical fragment: "Not allowed to read til I was 7 I found my delight in building structures with wooden bricks. . . . Father was practically interested in the art movement leading up to the 1851 Exhibition of Mechanics, Science and Art—the absorbing interest at the period when the die of my life was being cast. . . . [My family had personal contact with] Thos. Carlyle, Herbert Spencer, John Ruskin and James Brooks. Later on I worked along side W. Morris, Philip Webb, and Madox Brown."[6]

Mackmurdo's friendship with Ruskin was clearly a decisive

[6] Mackmurdo, "Autobiographical notes for Eleanor Pugh," 1936, p. 2, WMGW. The last sentence may be an exaggeration.

influence upon him; he studied at his drawing school at Oxford in 1873 and accompanied Ruskin on a trip to Italy in 1874, the first of several such trips: "I travelled [in] Italy and France sometime in company with Ruskin & under his direction made studies of stones, insects, plants, mountains & buildings, by which I had a grounding in the Laws underlying all organic form."[7] Ruskin pointed him toward the formation of an organization that would further architectural and design aims. It was from Ruskin too that Mackmurdo gained a love of "natural" flowing forms that was a major motif in his designs, as in his famous chair (1882-1883) and in his title page for *Wren's City Churches*—forerunners both of the Art Nouveau style, though his architectural work tended to be somewhat more geometrical.

Spencer and Comte helped make Mackmurdo sympathetic toward a geometrical style while Ruskin made him receptive to irregularity and experiment. Mackmurdo writing about Gothic art years later in 1892, declared that "Gothic art . . . is, as ornament, felt to be imperfect, yet within each living line lies the suggestion of infinite possibilities and the anticipation of a more perfect maturity." Like Ruskin, he believed a building should be decorated with forms derived from nature, and that ornaments should, through imperfection, make it clear that they were designed by a human hand. And he echoed Ruskin in his belief that the teaching at the South Kensington Museum, later the Victoria and Albert, placed too great an emphasis on the geometrical.[8] Undoubtedly he also imbibed from Ruskin other aspects of his thought—he followed his advice and "tramped from East to West England to observe the country & nature, buildings & villages."[9]— and shared with Morris the Ruskinian emphasis on the importance of workmanship, and the pleasure that it can give.

[7] Ibid.

[8] Quotation from *Hobby Horse* used, and points made by W.M.P. Haslam, "A. H. Mackmurdo's Artistic Theory," M.A. Thesis Report (Courtland Institute, University of London, 1968), p. 14.

[9] Harry Sirr, "Notes for Mackmurdo's niece, Eleanor Pugh," p. 5, WMGW.

The visit to Italy was important to Mackmurdo for a number of reasons. It was there he developed a fondness for Renaissance architecture that would make him somewhat out of step, despite his tramps in England, with the "vernacular" traditions of so many of the architects of the time—and certainly out of step with Morris who detested the Renaissance. Mackmurdo was more an individualist than Morris and saw in the example of Italy the possibility of the union of the artisan—as in the earlier medieval tradition—with the artist: that there might be both cooperation and individualism. It was exactly at this time that Morris was becoming more political, more radical, and more an enemy of what he regarded as self-aggrandizing individualism: what might be called the Renaissance tradition.

Mackmurdo's visit to Florence was also important in the development of the new attitude toward preservation that led to the establishment of the Society for the Protection of Ancient Buildings in 1877. Mackmurdo, appalled at the restoration and the cleaning of the Duomo, reacted so vociferously—much as Englishmen are reputed to act when seeing cruelty being perpetrated on animals abroad—that he was harassed while attempting to sketch in the streets of Florence and had to leave the city. Upon his return to England he played an important part in the founding of "Anti-Scrape," though he may be somewhat overstating, as he frequently did in his memoirs, his own importance. The more persuasive explanation of the organization's origin turns on Morris's horror at Gilbert Scott's restoration of Tewkesbury Minster. The historian E. P. Thompson has pointed out how important this commitment was in Morris's becoming a socialist.[10] It exposed him to the conflict between property values and what might be good for society—the fight between rampant individualism, the notion that owners could do anything they wished with their property, versus the needs of the past, present, and future. One of the first causes the Society for the

[10] Thompson, *William Morris*, pp. 226-242.

Protection of Ancient Buildings took up was the preservation of Wren's city churches. Mackmurdo was probably a major force in persuading the society and Morris himself—who became secretary and treasurer, not president as Mackmurdo remembered—to take up the cause of the churches. It was at this time that Mackmurdo met Morris and he gives himself credit for persuading Morris to join the society: "I was requested to ask him to join the 'anti-scrape' society. . . . 'I suppose you want to preserve these cold naked city churches of Wren. No I'll have nothing to do with it' I got him however to join it & he became the first President."[11] As in politics, Morris might well have to make compromises. The result here, Aymer Vallance remarked, was that "thenceforward Morris had to lend his support, on principle, to defend many buildings which it is certain that he did not himself admire."[12]

Whatever were Morris's private views, he participated fully

[11] Mackmurdo, "Notes on Morris for Nikolaus Pevsner," ?1938, J361, p.2 WMGW. Meier (*Marxist Dreamer*, I, xxv, n. 129), reads this quotation, I believe incorrectly, as applying to Carlyle, which, as he points out, is improbable because of Carlyle's affection for Wren. William De Morgan, the potter, was instrumental in persuading Carlyle to support the society, and as he wrote years later when recalling his associations with Morris for J. W. Mackail, Burne-Jones's son-in-law and Morris's biographer, "I received a letter . . . from Carlyle to the Society accepting membership. It made special allusion to Wren, and spoke of his city churches as *marvellous works*, the *like of which we shall never see again*, or nearly that. Morris had to read this at the first public meeting, you may imagine that he did not relish it and one heard it in the way he read it—I fancy he added mentally, *and a good job too*." (A.M.W. Stirling, *William De Morgan and His Wife*, [New York, 1922], p. 113). Carlyle did join the Committee, with many others, including Ruskin, James Bryce, Lord Houghton, Leslie Stephen, Mark Pattison, and Holman Hunt. Carlyle wrote in support, "I can have but little hope that any word of mine can help you in your good work of trying to save the Wren churches in the City from destruction; but my clear feeling is, that it would be a sordid, nay, sinful, piece of barbarism to do other than religiously preserve these churches as precious heirlooms; many of them specimens of noble architecture, the like of which we have no prospect of ever being able to produce in England again" (quoted in W. R. Lethaby, *Philip Webb and His Work* [1935; reprint ed. London, 1979?], pp. 147-148.)

[12] Aymer Vallance, "A. H. Mackmurdo," *The Studio* 16 (1899), 186.

in the fight, even if a Wren church might mean less to him than a great medieval barn, such as the one at Great Coxwell. He wrote a powerful letter to the *Times* in April, 1878 protesting not only the neglect of the Wren churches, but the destruction of churches in the City of London in general. Quite a few by Wren were designated for destruction—St. Margaret Pattens, St. George, St. Matthew, and St. Mildred. In his letter Morris introduced a pleasant note of English patriotism in his discussion of St. Paul's:

> Many persons suppose that by preserving St. Paul's Cathedral, [Wren's] great masterpiece, enough will be left to illustrate his views upon ecclesiastical architecture, but this is far from being the case. For, grand as St. Paul's undoubtedly is [which Morris himself didn't actually believe], it is only one of a class of buildings common enough on the Continent—imitations of St. Peter's Rome. In fact, St. Paul's can scarcely be looked upon as an English design, but, rather, as an English rendering of the great Italian original, whereas the City churches are examples of purely English renaissance architecture as applied to ecclesiastical purposes. . . . Surely an opulent city, the capital of the commercial world, can afford some small sacrifice to spare these beautiful buildings the little plots of ground on which they stand. Is it absolutely necessary that every scrap of space in the City should be devoted to money-making?[13]

Both Morris's and Mackmurdo's argument represents a new attitude toward conservation.

Mackmurdo used the Wren churches for a vastly different purpose, however, when in 1883 he wrote a book about them with a title page that, as I have earlier suggested, has emerged as one of the masterpieces of the period, one of the great moments of the new design (Figure 2). In its swirls, its sense of fire and action, its anticipation of Art Nouveau, it is a

[13] Morris to the *Times*, April 17, 1878, in Henderson, *Letters*, pp. 120-122.

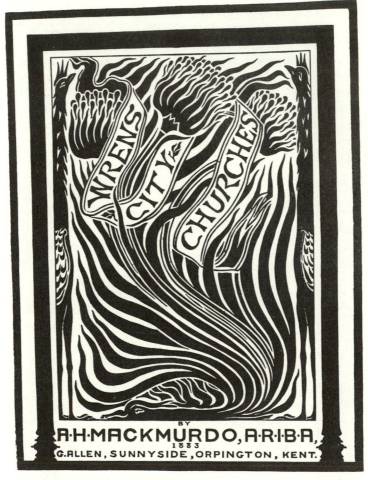

2. A. H. Mackmurdo, "Wren's City Churches title page," 1883.

remarkable work, and far more distinguished than the murky prose of the text itself. After the imaginative title page, there is a rather conventional frontispiece: a traditional engraving of St. Paul's itself, with the somewhat incongruous caption: "Soul striving from struggle into calm." Mackmurdo was

later ashamed of his prose, but not of the purpose to which it was put. As he wrote in 1938 to Harry Sirr, a retired inspector of ancient monuments, "As to my book on Wren's City Churches, its object was achieved when I saved over 30 from being pulled down. But I am ashamed of the stilted and artificial phrasing—a caricature of Ruskin before I had *literally* grown up. I *shan't let you read it.*"[14] The book and the early issues of the *Hobby Horse*, the Century Guild periodical, were issued by George Allen, Ruskin's publisher.

The chapters of the book had been given as lectures in an attempt to stop the destruction of the churches. Of the fifty churches now attributed to Wren, nineteen were torn down and the proceeds from selling the land used to build suburban churches; fifteen more were destroyed by German bombs in the air raids on London during the Second World War.[15] Mackmurdo begins his book with a confused philosophical introduction, then continues with a more straightforward description of the fifty-three city churches he attributed to Wren. The second section of the book consisted of notes on the towers of the churches.

In a passing reference to the Law Courts, designed by G. E. Street, Morris's architectural master and one of the great "Goths," Mackmurdo suggests one of his differences with Morris. The Law Courts themselves, built in the 1870s, were the last great Gothic revival buildings in England. "But surely," Mackmurdo remarks sourly, "to our children it will not seem strange that the age which designed the New Law Courts should have destroyed Wren's City Churches."[16]

In the 1870s he came to know Morris not only in connection with "Anti-Scrape" but also as a visitor at Hammersmith, where he heard him declaim his verse. But Morris was only "one among many," as it were. For Mackmurdo had a wide

[14] Mackmurdo to Harry Sirr, January 4, 1938, Manuscript Collection, Royal Institute of British Architects, London.

[15] John Betjeman, ed., *An American's Guide to English Parish Churches* (New York, 1958), p. 251.

[16] A. H. Mackmurdo, *Wren's City Churches* (Orpington, Kent 1883), p. 63.

range of acquaintanceship. For instance, some years later he decorated the rooms at 31 Upper Bedford Place of the Reverend Stewart Headlam, the radical parson who founded the Guild of St. Matthew, had lots of friends in the theatrical profession whom he organized into the Church and Stage Guild, and was a firm advocate of Christian socialism. Mackmurdo also managed the almost impossible feat of maintaining friendships with both Ruskin and Whistler. He painted his Century Guild exhibition stand yellow as it was Whistler's favorite color; and Whistler's concept of total design, the importance of placement, the use of quiet background colors, had a considerable effect on him. He had met Whistler through the D'Oyly Cartes, and helped him arrange an exhibition, in the course of which he was much impressed by Whistler's attention to details, his lightness of touch: "Drawings were in white frames on white matting. The slightest touch of colour in a drawing shone out and caught the eye at once."[17] There was a general "lightening" of mid-Victorian style in the latter part of the century, notably in the growing popularity in the 1870s of the "Queen Anne" style buildings, the modifications in the work of the Morris firm itself, and the growing influence of the designers and writers who were gathered about Whistler in Chelsea, which would come to include not only Oscar Wilde—actually a rival of Whistler's, who also wrote and lectured on decoration—and later, on Ricketts and Shannon as well as Aubrey Beardsley. Beardsley and Wilde were not sympathetic figures for Morris, but Mackmurdo was able to see their virtues and Morris's too; his designs suggested what was to come at the end of the century while he was also part of the more solid qualities of the Morris tradition.

Morris provided the "platform" necessary for Mackmurdo; indeed for much of modern design, Morris brought together previous tendencies of innovation and helped make them better known. As Mackmurdo wrote about Morris, "He it was

[17] Mackmurdo, "Notes on Whistler for Pevsner," J848, WMGW.

who consolidated the vagrant aims and proved the practical possibilities of a vital domestic art. . . . At first he must confine himself to the middle-class home; so ugly, stuffy & crowded with meaningless bric-a-brac. But he had a vision of a future when it would be possible for beauty to enter the humblest home."[18]

In the notes on Morris that Mackmurdo made years later we can see what a profound influence Morris was upon him, even though he was able to look back with some dispassion: "His tremendous energy had to find an outlet in handicraft. The making & shaping of things had a charm for him. But the thing his hands had made must find a place in everyday life. Not a thing to sit in a cabinet or . . . to be looked at." Mackmurdo was much more interested in systems of a Herbert Spencer variety, and he rather misrepresents Morris as being totally without a world view, ignoring his well worked-out political ideas: "The Renaissance with its science & its philosophy was the curse of all the modern hateful things [Morris thought]. And so he hated science & he hated philosophy. These subjects were banned at his table. This is your damned science he would say to me. . . . He liked and praised my work as much as he disliked and opposed my views. He knew nothing of science or philosophy. I as a pupil of Herbert Spencer was nurtured on these. . . . He had no hope in the world except through Revolution. I had great hope in the world through Evolution & we crossed swords upon this many a time. I always left him impressed with his immense vigour."[19]

Whatever their disagreements, Mackmurdo recognized that it was from Morris, as from Ruskin, that he received the impetus for his own important work. Largely under their influences he held a conception of the artist as the custodian of moral values. As he wrote in 1892 in the *Hobby Horse*: "Having a more generous gift than their fellows of that which

[18] "History," pp. 153, 163, WMGW.
[19] "Notes on Morris for Pevsner," pp. 1-3, WMGW.

is in its measure, common to all men, artists see more clearly and feel more intensely the grip of forces at work upon the affairs of the world. . . . The disease of competition . . . has cankered the heart, preventing for the present the establishment of such conditions of labour as might not disgrace an age that has made of all its people citizens; and to all its children given a free education. But to hasten the advent of such conditions, no influence is more potent than that the artist may exercise through his poetic anticipation of a future legitimately sprung from the loins of a traditional past."[20]

Mackmurdo also shared with Morris the compulsion to bring decorative arts up to the level of fine arts. He agreed with Morris's statement about the dangers of separating the decorative arts in a category apart from architecture, painting, and sculpture: "The lesser ones become trivial, mechanical, unintelligent, incapable of resisting the changes pressed upon them by fashion or dishonesty."[21] Yet he was anxious to differentiate himself from Morris, at least politically:

> An instance of an artist entering the circle of social politics, consequently advocating what we believe to be dangerously narrow-sighted remedies of existent evils, is given in the case of William Morris—one who had been and is still considered by us chief among the leaders of to-day's art movement, one who perhaps more than any has raised the tone and character of industrial art to the high rank it attains in this country. As an art craftsman he is our master: but we hesitate to follow him in his endeavor to agitate for state intervention as possible panacea for poverty; or to accept his belief in parliament as an apportioner of property.

This was a misunderstanding of Morris's position, for it implies that Morris had faith in the present state to solve the

[20] *Hobby Horse* 7 (1892), 16-18.
[21] William Morris, "The Lesser Arts," in *Collected Works*, ed. May Morris, XXII, 3-28.

social and economic problems of society, while instead he had finally come to the position that a totally new society was necessary to achieve the elimination of property and poverty. His ideas may not have been fully developed along these lines at the time that Mackmurdo was writing or it is possible that Mackmurdo may not have been aware of them. Mackmurdo went on, "Poverty, injustice, and crime are to us the natural result of class character." Morris agreed with this position. But Mackmurdo had a rather imprecise and aesthetical solution for the state of the world: "As character develops both in individual and class by gradual growth from the heart's centre, old evils become impossible because distasteful, and the whole world is happier." Mackmurdo in fact wished largely to dispense with the state, without bothering to consider what would happen to society in the meantime: "The State's function is to protect property and see that all individuals have fair play: and this is sum of its 'power.' . . . [Morris] in his splendid industries and as a considerate employer of labour caring for heads and hearts as well as hands, is with other like workers doing more to better the conditions of every class, than the united governments of all the world could do."[22]

Mackmurdo's official training was as an architect with T. Chatfield Clarke and James Brooks. He was dissatisfied with Clarke to whom he was apprenticed in 1869 and persuaded Brooks, an architect influenced by Pugin, a builder of churches, who ordinarily did not take students, to train him in 1873. At least in looking back, Mackmurdo saw his design and his work with Brooks as part of a social purpose: "In my social work in the East End of London, in a district distinguished for its ugly squalor and resultant crime, I had become acquainted with the churches built by James Brooks. . . . I recognized the temperament of the artist and the hand of the craftsman. With this live soul I must get in touch."[23] Brooks

[22] A. H. Mackmurdo, "The Guild's Flag's Unfurling," *The Century Guild Hobby Horse* No. 1 (April, 1884), 2-12.

[23] "History," p. 196, WMGW.

was interested in design and decoration but was frustrated by his inability to have them done as he wished for his buildings. He assigned to Mackmurdo the task of coordinating the ornamental details for his designs, an experience that strengthened the apprentice in his opinion that architects could not depend on "decorators" from outside, with no sympathy, or understanding, for the essential design. He was impressed by the craftsman aspect of Brooks and his wide-ranging design activity—eventually he would design every detail of his buildings. The effect upon Mackmurdo was tremendous. As he later wrote, "[Brooks's] difficulty in getting the work executed in days when there were no craftsmen led me to found the Century Guild of Artists—a body of craftsmen or artists working in a variety of media."[24] He was impressed too by the work of Benjamin Woodward—with Thomas Deane he was the architect of the University Museum in Oxford in 1855 in which Ruskin took such an interest—who "was the first architect to gather round him a group of artists and craftsmen to design and execute the decoration of his buildings."[25]

Mackmurdo first established offices in 1875 at 28 Southampton Street, and then at 20 Fitzroy Street—the latter eighteenth-century house became quite well known as a center of artistic and musical activity and was a sort of early "commune." Mackmurdo's importance as an architect can be seen—and his significance as a "modern"—by comparing two buildings he did next to one another in Enfield, outside of London, but some years apart. The first, Halcyon, 6 Private Road, built around 1873 before he established his practice, is a perfectly pleasant "busy" but interesting combination of Gothic and Queen Anne elements (Figure 3). It was contemporary and has some resemblances to Norman Shaw's famous New Zealand Chambers in the City of London. The second, Brooklyn, 8 Private Road, probably built a decade later, one

[24] Mackmurdo, "Manuscript autobiography," p. 1, WMGW.
[25] "History," p. 93, WMGW.

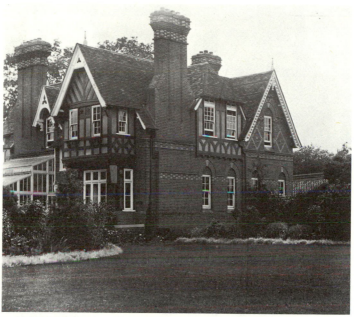

3. A. H. Mackmurdo, "Halcyon House, Enfield."

year after the founding of the Century Guild, is startlingly different in its plainness and its geometric feeling (Figure 4).

This house, Brooklyn, is in fact to my mind one of the most exciting houses of the nineteenth century. With its somewhat Renaissance look it might well have been built years before, yet in its comparative simplicity it has the feel of a modern house. Unfortunately, Halcyon, the older house—both are rather mysterious in terms of their dates—no longer exists, but Brooklyn is well maintained and is a striking thing to see, though its classic simplicity is somewhat undercut by the decoration. Halcyon was built for Mackmurdo's mother; Brooklyn, for his brother; and between them there is a sense of transition to modern architecture that parallels the advance

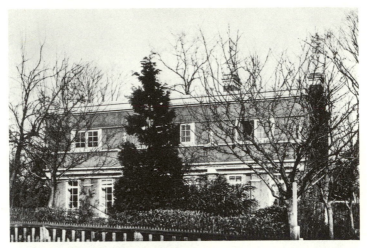

4. A. H. Mackmurdo, "Brooklyn, Enfield."

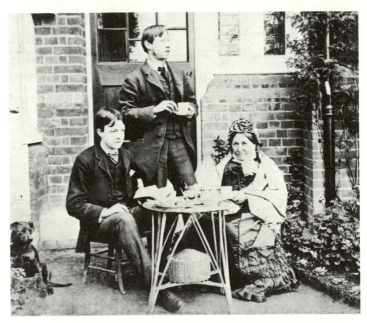

5. "A. H. Mackmurdo and Herbert Horne with Mrs. Mackmurdo, Halcyon House, Enfield."

between the two landmark houses built by the modernist architect Otto Wagner in Vienna, the first Villa Wagner of 1886-1888 and the second of 1912-1913. There the number of years separating the two buildings was much more striking, and both of the Wagner buildings are much grander structures. The English emphasis on being "small scale" and "domestic" is obvious in the two Mackmurdo buildings—but the search for an arrival at a new Modern style is evident in the contrast between them.[26] Brooklyn may have been built as late as 1887 when it was painted bright yellow (a Whistlerian color?) in contrast to its presently more traditional white.[27] The house has affinities to Godwin's austere design for Whistler's White House of 1878, though its decorative touches are somewhat fanciful with coy statues of little boys skipping rope, and a frieze of putti faces. (Structurally, it has to be acknowledged, the house was not too well built.)

Brooklyn is similar in feeling to the plans of a simple house presented in the *Hobby Horse* and commented on favorably in the *British Architect* in January, 1889. The house was in the manner of those designed in the period for an artist or lover of art, such as those in the 1901 Darmstadt competition, notable for the plans submitted by Baillie Scott and Mackintosh.[28]

[26] For the Wagner buildings see Heinz Geretsegger and Max Peinter, *Otto Wagner the Expanding City: The Beginning of Modern Architecture* (London, 1970).

[27] See Edward Pond, "Mackmurdo Gleanings," *Architectural Review* 128 (1960), 429-431.

[28] *The British Architect*, January 4, 1889, p. 26. The journal commented: "This is an example of what may be accomplished in the design of a detached house to cost only £600, including a studio some 32 feet by 20 feet, sitting-room 15 feet by 12 feet, kitchen, scullery, offices, four bedrooms, bathroom, and last, but not least, ample hall and staircase space. Excepting the position of the sitting-room door and the plan of the kitchen, the whole appears to work very harmoniously. The elevations are marked by a pleasing simplicity and style, which though perhaps more fitted for a summer clime than ours, affords useful suggestions to the architect. It will be noted that the weight of the building is carried on the piers placed at needful intervals with a wall veil of brickwood covered with cement rough cast."

There was some idea that the Bush Hill Park project—of which Brooklyn may have formed a part—in Enfield at the Essex end of Greater London might be a rival to Bedford Park. There was even to be a pub, comparable to the Tabard, to be designed by E. J. May who had done much work in Bedford Park. The full project was not successful, however, although some houses were built. It may have been one reason that Mackmurdo had moved to Enfield, established a workshop, and organized an Arts and Crafts exhibition there—but very little is known about these details.

When thought of in the context of Mackmurdo's large and strange house started in 1904—Great Ruffins—near Colchester, also in Essex, it has been maintained that Brooklyn's "striking originality is convincingly explained not so much by his pioneering of the modern movement as his highly eccentric personality."[29] But that is seeing the building in too isolated a way—its "rogue" elements are no doubt in part a reflection of the self-motivated and rather egocentric character of Mackmurdo. But it is also legitimate to view the building as a great and exciting leap forward into a new sort of simplicity and rationality, a contrast to what had gone before. Also we would not want to underestimate the possible influences of his younger colleague, Herbert Horne, who became a full associate in 1885, in the designing of Brooklyn. Horne's design ideas may well have reinforced Mackmurdo's move toward simplicity, and certainly the heyday of both men as designers was when they worked together. As Pevsner remarks, "Now he [Mackmurdo] had found a style all his own. Where did those proportions originate, or the plain wall of the upper storey with its three horizontal windows placed on top of the pilastered ground floor? Where can he have seen anything resembling these clear-cut cornices, or the ornamented bands that run along the windows? There is no doubt

[29] Alan Johnson, "Notes," Victorian Society Walk: Bush Hill Park and Enfield, April 21, 1979, p. 2. ?Copy in Victorian Society Library, Bedford Park, London.

some faint recollection of the North Italian Renaissance in it, but it is ingeniously re-shaped. The feeling of this first floor design is that of Frank Lloyd Wright if anything, and it was well over twelve years before Wright started work."[30]

He did several other extremely striking buildings, one with Japanese interiors for the artist and friend of Whistler's, Mortimer Menpes, at 25 Cadogan Square, in 1889, that fortunately has been preserved as a staff building for the Peter Jones department store. His other building in the area, 12 Hans Road, done in 1891, is overwhelmed by standing opposite Harrod's and is almost too small and too close to the corner to be noticed. But it is an effective building, demonstrating a new sort of purity of line—straight lines that nevertheless suggest power and look as if they might be about to expand into whiplash lines. The house at 12 Hans Road is next door to a Voysey house, and both have recently been restored; the two make a splendid combination.

Mackmurdo officially retired as an architect in 1904, but before doing so he designed Great Ruffins in Wickham Bishops, near Colchester, for himself and his wife, Eliza D'Oyly Carte, whom he married in 1902. He started to build the house in 1904; it was not completed until 1926 and then for another owner as Mackmurdo could no longer afford to live in it. He now spent the greatest part of his time spinning his economic theories, although he did do a few buildings in and around the village of Wickham Bishops. Perhaps the most successful is a handsome simple building designed to serve as the servant quarters and garages for Great Ruffins, and now are very pleasant private residences. He also did a cottage for himself around 1920, in which he died, a store around 1925, and the simplest of village halls around 1930; these last three are comparatively nondescript.

On the more social side there was some possibility of build-

[30] Nikolaus Pevsner, "Arthur H. Mackmurdo" (first published 133 *Architectural Review*, 1938) *Studies in Art, Architecture and Design* (New York, 1968), II, 134.

ing a settlement house with which Mrs. Humphry Ward was involved. More interesting and more elaborate was Mackmurdo's involvement in a plan for a community project in Ealing, which went as far as the issuing of a prospectus in February, 1892, for college-like buildings "providing comfortable Residential Chambers for those engaged in the arts and professions." The plan for the buildings, called Hogarth Cloisters, was to allow the residents, to a considerable degree, "to dispense with the superintendance of domestic servants etc., and to extend the principles of co-operation to all details of domestic life." There would be 144 private residences, 80 rooms for students, studios, a cottage hospital, and a club that would contain public and private dining halls, as well as a dining room for children. It took some of the aspects of Bedford Park, built twenty years before fairly nearby, and intensified them. All the residences would be off a covered arcade "about one-third a mile in length, and [it] will contain exhibits of statues, and palms, flowers, ferns, etc. and will form a pleasant promenade both in Summer and Winter." Mackmurdo had gathered together an interesting cross section of the Army of the Good to support the venture, ranging from the Whistler wing—Mortimer Menpes and the Pennells—to such figures as Stopford Brooke, the famous preacher and man of letters (to whose classes Mackmurdo had delivered the lectures on the Wren churches that formed the basis of his book), Oscar Browning, the snobbish Fellow from King's College, Cambridge who had done much to promote the study of history, to friends of Morris's, such as T. J. Cobden-Sanderson, Walter Crane, and Henry Holiday, as well as Frederic Harrison, the positivist, the painters Hubert Herkomer, G. F. Watts, Frederick Leighton, the novelist Eliza Lynn Linton, and even an aristocrat, Victoria, Countess of Yarborough. The prospectus claimed that many of these sponsors had agreed to become residents in the cloisters, and in any case they would have the responsibility to nominate tenants.[31]

[31] Quotations and details from Hogarth Cloisters Prospectus. 194/78, WMGW.

Elizabeth Robins Pennell wrote about this scheme: "A little covered passage-way at the back of the houses, connecting them, will be reserved for the use of the servants, who therefore need never appear in front with buckets and brooms." From the central kitchen the residents could be served at home. "Socially they may hold themselves entirely apart from their nearest neighbors. If any enforced intimacy were to enter into such a scheme of life, it would ruin it altogether, no matter how charming might be the people by whom you were surrounded. That the little settlement will include no objectionable social elements, Mr. Mackmurdo is determined. Every tenant must be introduced by one of the supporters of the undertaking." The project was also progressive from the feminist point of view: "There will always be women naturally who will prefer running their own houses, being mistresses of their own servants, and supreme in their own kitchens. But for women who work, who have any professional or business occupation, I can imagine no more delightful way of living."[32] And the promise was held out of finer food than could be prepared in private kitchens: "Dinners will be obtainable of a 'recherché' description on the most reasonable terms, and such as would not be possible in ordinary lodging."[33]

Although this scheme for Hogarth Cloisters had social implications and attraction for the middle class, Mackmurdo was also involved with a scheme for the working class—The People's Cabin Company that intended to build a workingman's club in Birkenhead: "This Company has been formed with the object of providing the working men and lads of Birkenhead with a Hall for meeting, rest, recreation, and refreshment under conditions the most favorable to the interest of the enormous numbers needing such a place of resort, and to

[32] Extract from Elizabeth Robins Pennell, "The Women's World in London," *Chautauqua Literary and Scientific Circle* (February, 1892), pp. 210-212. 194/73, WMGW.
[33] Residential Chambers Company Corrected Proof Sheet. 194/74, WMGW.

establish a higher type of public-house."[34] He was involved, too, with a plan to establish a set of resident chambers in Manchester, which would have a shared dining room. As far as one can tell, none of these buildings ever got beyond the prospectus stage. They were all representative of rather mild social planning. For instance the Birkenhead Club, where no political or religious meetings were to be allowed, would be managed by a committee of workingmen, elected every six months by the directors of the organization, who, presumably, were solid members of the middle class. But if these projects do not suggest too advanced a social conscience, they do show a concern for the quality of life in late Victorian England.

There were two other major figures in the Century Guild: Herbert P. Horne and Selwyn Image. Horne was even more universal in his interests than Mackmurdo. In his minor way, he was an aesthetical version of William Morris. Despite his loathing for his own time, Morris was a creature of his period—a great Victorian with all the energy, the wish to get on, associated so readily with more philistine Victorian figures. In contrast Herbert Horne was an aesthete of the 1890s, whose interests belong more to the Beardsley period than the world of Morris. He was an important designer and art historian, and as the main editor of the Century Guild's journal, *Hobby Horse*, which concerned itself with all aspects of its design, he was also an influence on Morris in the "typographical adventure" of the Kelmscott Press.

Horne was raised in a very proper aesthetical way, being a resident of Bedford Park, the "Queen Anne" suburb in Chiswick where the Yeatses lived, and which Morris found rather fantastical. He was born in 1864, the son of a not especially successful architect, Henry Horne. When very young he was articled to a surveyor, but in 1880 he saw some drawings by Mackmurdo and decided that he wished to study with him. His father arranged this, and so in 1883, the year after the

[34] "Prospectus." 194/73, WMGW.

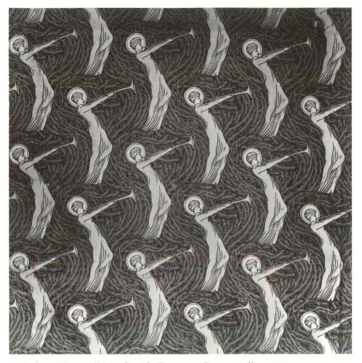

6. Herbert Horne, "Angel with Trumpet Cretonne," c. 1884.

founding of the Century Guild, he was articled to Mack-murdo, and in 1885 he became his partner, for £50 a year and commissions on work that he brought in. Clearly Horne was something of a prodigy, not that Mackmurdo was that well established as an architect at that date. Horne may have con-tributed some of the ideas as to how the front of the Savoy Hotel was to be executed. He was the architect for the Church of the Redeemer on Bayswater Road, Brewhouse Court at Eton, and the Baptistry of St. Luke's Camberwell. He de-signed some of the most interesting textiles and wallpapers executed by the Century Guild (Figure 6). But by 1900 he

was no longer primarily interested in architecture and the partnership was dissolved. In fact probably he and Mackmurdo were estranged by the early 1890s.

His interests were various. When Bernard Berenson met him in London in 1888, he saw him specifically as the successor to William Morris: "the great man of the next generation, an architect, painter, poet, fine critic, and editor of the *Hobby Horse*."[35] In 1891 he published a short book of poems—*Diversi Colores*—and in 1894, *The Binding of Books*. His work as editor of the *Hobby Horse*, which will be considered later, was quite important. He designed a number of title pages and in the first decade of the twentieth century, three typefaces for private presses. He was also a collector and with small resources managed to acquire a valuable group of English watercolors most of which were eventually sold to Edward Marsh. Then in Florence, where Horne settled in 1900, he built up a considerable Renaissance collection. He left it at his death in 1916 to the city of Florence along with the Palazzo Fossi, now the Museo Horne. Undoubtedly the major source of his income, as with Bernard Berenson, was his increasing activity as an art expert, and he was a follower, as were Berenson, William Martin Conway, and Roger Fry, of the methods of Giovanni Morelli: the establishment of attributions through repetitive physical details to be found in paintings claimed to be by the same painter. His most important art historical study was of Botticelli, published in 1908. Botticelli is now so well established as one of the great figures in the history of art that it is hard to remember that this is a fairly recent development and Horne, following Ruskin and Pater, is partially responsible for this considerable reevaluation. John Pope-Hennessy has remarked in his introduction to the 1980 edition that it is "the best monograph in English on an Italian painter. . . . As an interpretation of Botticelli and his work it has never been surpassed."[36]

[35] Berenson to Senda Berenson, March, 1888; quoted in Ernest Samuels, *Berenson* (Cambridge, Mass., 1979), p. 62.

[36] John Pope Hennessy, "Introduction," in H. P. Horne, *Botticelli* (Prince-

thetic movement of the 1890s. In that sense they were a link between the earlier aesthetic movement of the 1870s and its fin de siècle version. Their poetry was rather nondescript and weakly romantic. But they were sympathetic to the new in the world of design and literature, and in the context of their time they were certainly progressive. Image was friendly with Ezra Pound; in his fragmentary diary he noted for March 27, 1909, that "*Ezra Pound* called. . . . He speaks of America as a country in the raw, and thinks Walt Whitman the most native product she has given to literature."[39] Yet in later years both Image and Mackmurdo were uninterested in modern art. They were unable or unwilling to make the transition to the avant garde of the new generation. Image did not care for the Impressionists. He recorded in his diary in 1914 his hatred of the Grafton Group of painters, singling out Duncan Grant's *Adam and Eve*, and also Picasso's *Head of a Man* as "all vulgar, indecent, insolent gibberish."[40] So too some years later Mackmurdo violently attacked Paul Nash in a letter to Image.[41] But progressives of one era are not under obligation to like what happens in the generation that follows.

Quite early on in their friendship Mackmurdo and Image discussed design and questions of art and asked for Morris's opinion. In October 1880 Image remarked to Mackmurdo in a letter, "I am very glad you showed [my] drawings to Morris—and very glad indeed that he seemed pleased."[42] The correspondence between the two was primarily concerned with questions of design, color, and other artistic matters. Image's main activities were as a designer, particularly cartoons for stained glass, and also for embroidery. He became a member of the Art Workers' Guild in 1887, and its master in 1900. He wrote many poems, to be found in manuscript

[39] Ms. Eng. misc., d. 349, f. 33, Bodleian. Pound wrote of him in " 'Siena Mi Fe; Disfecemi Maremma' ": "Image impartially imbued/With raptures for Bacchus, Terpsichore and the Church."

[40] Ibid., f. 60.

[41] June 4, 1927, Ms. Eng. lett., d. 141, f. 156, Bodleian.

[42] October 16, 1880, Ms. Eng., e. 38, f. 24, Bodleian.

versions in his handsome calligraphy; he designed a Greek typeface for the Kelmscott Press that was also used by the publishing house of Macmillan. He published a few poems, including one volume in 1894, *Poems and Carols.* Mackmurdo edited another volume of his poems and one of his letters in 1932, two years after his death. Probably his most famous single work was his cover for the *Hobby Horse.*

These three young men—in 1882 Mackmurdo was 31, Image 33, and Horne only 18—came together as the main figures in the Century Guild, an organization dedicated to providing a total design, which looked at the world in a new way, yet built on Morris's accomplishments. Morris had managed more than any other designer to combine in himself and in his firm the skills of an executor (with the able assistance of business managers), a designer, and a craftsman. He had a total vision (ultimately including politics) and it was on that experience (politics excepted) that these young men were able to build. It was his integrated approach that they adopted.

It is tempting, though perhaps unfair, to suggest that these middle-class men, wishing to engage in the decorative arts, were concerned, whether consciously or not, with keeping their class position. In a quite idealistic way, Ruskin had alluded to the dangers of the divisions of labor. "We want one man to be always thinking and another to be always working, and we call one a gentleman, and the other an operative; whereas the workman ought often to be thinking, and the thinker often to be working, and both should be gentlemen in the best sense. . . . In each several profession, no master should be too proud to do its hardest work. The painter should grind his own colours; the architect work in the mason's yard with his men; the master-manufacturer be himself a more skillful operative than any man in his mills."[43] If the members of the Century Guild were to be designers, then designers

[43] Ruskin, *The Stones of Venice,* II, VI, #21; quoted in Meier, *Marxist Dreamer,* I, 143.

were to be gentlemen and to have the same social position as those who were painters or architects.

Ruskin had suggested to Mackmurdo the idea of a guild, having earlier applied it (despite or because of its medieval echo) to his unsuccessful popular organization—the Guild of St. George. Again there was that English affection for the markings of distinctions: members of the Century Guild could put M.C.G. after their names! Membership in the Guild was very ill-defined, and Mackmurdo and possibly Horne may have been the only official members. Perhaps they were the most important figures as they were architects—following the Morrisian precept of the dominant role of architecture, which kept the fine arts in their place. Mackmurdo certainly agreed with Morris that the designer or architect, not the manufacturer, should be in charge. As Image pointed out in a lecture, "Ruskin and Morris [brought] art out of dilettante connoisseurship . . . into touch with daily life. . . . Their teaching expanded and made practical and wide by [the] Arts and Crafts Movement and [the] Art Workers' Guild."[44] But for Mackmurdo it would be a more cooperative venture than Morris's conception of the relationship. Indeed, the designer and craftsman were exalted. The aim of the Century Guild was "to render all branches of Art the sphere, no longer of tradesmen, but of the artist. It would restore building, decorating, glasspainting, pottery, wood-carving, and metal-work to their rightful place besides painting and sculpture. By so placing them they would once more be regarded as legitimate and honored expressions of the artistic spirit, and would stand in their true relation not only to sculpture and painting but to the drama, to music, and to literature. In other words, the Century Guild seeks to emphasize the *Unity of Art*; and by thus dignifying Art in all its forms it hopes to make it living, a thing of our own century, and of the people."[45]

[44] Notes for lecture on Arts Schools, Ms. Eng. misc., c. 310, f. 18, Bodleian.
[45] Mackmurdo, "Prospectus." K 339, WMGW.

A good sense of how important the conception of the unity of art was for the Guild can be seen in a piece Herbert Horne wrote about it in the *Art Journal* in 1887: "The Century Guild was formed, now some four or five years ago, by a few workers in the various branches of Art, who, feeling that want of its greater homogeneousness, thought that by working together, and so becoming conversant with the theory at least of the other arts beside that particular one which each individually was practising, they might attain to something of the largeness and fitness of the old Italian Art of many parts."[46] Horne is not specific as to how this worked in practice. The house at 20 Fitzroy Street did become a place where the artists of the Century Guild congregated and where they may have done some work. Although there was not a common workshop, nevertheless a certain shared style did emerge.

In 1884 Mackmurdo wrote a manifesto for the first issue of *The Century Guild Hobby Horse*: "The Guild therefore, provides a part song in which many voices may show their fullest harmony and make that harmony as complete as enchanting, by the firmness with which each insists on his individualized part." He was also aware of the need to move away from the literariness that characterized so much of the nineteenth century: "[We will give] our work a more abstract, or mood-made character, than the more popular forms of art possess."[47]

A similar conception of the unity of art, central to the Guild, is also reflected in an article by Selwyn Image in the *Hobby Horse*. Image points out the need in a design to "produce a whole effect, which is complete. . . . It makes no difference to the man, *as a designer*, whether the object in front of him is a flower, or a shell, or a mountain, or a bird, or a human body. What are the lines it suggests, and the masses? That is everything: whether they form Venus or a toadstool does not at the moment matter: all that matters is abstract line and

[46] *The Art Journal* 39 (1887), 296.
[47] See Note 22.

mass."[48] This emphasis on abstraction and design had interesting implications for the future course of art, even if Image and Mackmurdo rejected them.

The notion of a "design group" was something new. The more common practice, and of course it was one that continued, was that the designer was on his own or an employee of a particular firm. The group represented a new conception about the importance of art and design. In terms of the Arts and Crafts movement, Morris was the first and probably always the most significant. William De Morgan's pottery workshop in Chelsea was founded in 1872, the following year the workshop of the Martin Brothers in Fulham was established. This first flush of activity was largely part of the Aesthetic movement of the 1870s. But the 1880s were the time of the greatest excitement, when artistic needs and social and political pressures began to coalesce:

> [It] has [been] argued that the enthusiasm for art workmanship, especially at South Kensington, in the 1860s and 1870s, was the really creative phase, and that the Arts and Crafts Movement represents simply the late petrification of this enthusiasm. There is a good deal of truth in this, and the early history of the Art Workers' Guild and the Arts and Crafts Exhibition Society reflect concerns matured in the 1870s—the Unity of the Arts, art workmanship vs. commercial workmanship; but the feeling was also growing in the 1880s, inspired by Ruskin's writing and Morris's lecturing, that alternative groups had to be set up, as a challenge to commerce, industry and the educational system at South Kensington.[49]

In an issue of the *Hobby Horse* a list was provided of the various designers and services provided by the Guild, and a reminder that the work was on display at the showrooms at

[48] Selwyn Image, "On Design," *Hobby Horse* 2 (1887), 117-120.

[49] Alan Crawford and Lynne Walker, "Arts and Crafts Organizations" unpublished paper (delivered at Victorian Society Conference on the Arts and Crafts, Birmingham, 1978), p. 4.

28 Southampton Street. It was a collective of designers. In some instances it acted as an agent in providing the services of other firms, such as Morris & Co., the Chiswick Press, and the Royal School of Art Needlework. But in other cases individual designers operated through the Guild, such as the cousins Rhoda Garrett and Agnes Garrett (Agnes was the sister of Elizabeth Garrett Anderson, the first English woman doctor, and of Millicent Garrett Fawcett, leader of the moderate suffragists. She was the first woman officially to be an interior designer). In these cases the Guild simply provided the address of art workers recommended. But such men as Benjamin Creswick, the sculptor, who did carving and plasterwork, worked through the Guild itself, as of course did the architects Mackmurdo and Horne. Names were also given for wrought ironwork, J. Winstanley; beaten and chased brass, pewter, and copperwork, George Esling; W. H. Hopper did designing and engraving upon wood; J. Powell, glass; while Selwyn Image provided painted glass, and painting applied to architecture and furniture. William De Morgan painted pottery and tiles. These names were "those workers in art whose aim seems to us most nearly to accord with the chief aim of the magazine." Also Clement Heaton was associated with the Guild; he revived the art of cloisonné method of enameling and indeed was one of the few Englishmen of his day to do so. In the same issue was provided a brief note about the house already alluded to—which resembles Brooklyn—estimated at a cost of £620, stating that "the Century Guild lays stress upon the fact that all Art makes for the needs of an entire people, and more particularly does it recognize this fact in the case of Architecture." The plainness of the house and its classicism are striking, in contrast with the rather more "homely" Queen Anne style that we might have expected—the use of piers providing a certain dignity. And there is an interesting note of functionalism: "This frank treatment of the construction produces a pleasant effect in the elevation. . . . In this building, imperfect as it is, it may be seen how practical the principle of the unity of the arts, and how easy

it is to introduce colour and sculpture into the simplest architecture."[50]

What was the purpose of what might be called the first of the Arts and Crafts "design groups"? It was to create "simpler" designs, that would not be mass produced and would be dramatically "lighter" than the furniture of the period. These were to be objects for a new sort of individual, more concerned with what would be the design of the world, and less anxious, through the ostentation of surroundings, to indicate status. They were designs for a society that was beginning to be more reflective about itself.

Artists acting as businessmen, in control of their own manufacturing, could make their own decisions. But also, as noted before, there was a desire to emulate the so-called "finer" arts. The Guild believed in presenting its work in a cooperative way, so that it was not possible to tell in the assemblages shown at various exhibitions who exactly had done what. The decline of the Guild is indicated by the breaking down of this unity. At the first Arts and Crafts Exhibition Society show of 1888 the Guild showed as a group; at the 1889 exhibition its members exhibited individually. There were various executed decorative schemes: for instance, a music room frequently displayed—at the Health Exhibition in London in 1884, at the Inventions Exhibition in 1885, the Liverpool International Exhibition in 1886, at the Manchester Jubilee Exhibition in 1887—and a design scheme for the interior of the house of Henry Boddington: Pownall Hall, Cheshire.

Victor Plarr, in his biographical sketch of the poet Ernest Dowson, provides a picture of the Century Guild headquarters, 20 Fitzroy Street: "The sacred house, about which a volume might be written, had, from about the year 1891, been the home of the *Hobby Horse* writers, and of at least one outsider. My dear friend Professor Selwyn Image still lives there, and will he forgive me if I remind him that the house was at one time referred to as 'Fitzroy' and that 'Fitzroy' was

[50] *Hobby Horse* 7 (July, 1887), n.p., at back of issue.

a movement, an influence, a glory? There were several Fitzroy institutions—notably what was known as 'Fitzroy silence' at our austere dinners and lunches. Lionel Johnson, when I left 'Fitzroy,' declared that it became full of strong mysterious men, who clamoured for large chops and steaks at meals. They are probably very eminent persons by this time. The original dwellers in 'Fitzroy,' before my time, were Mr. Herbert Horne, who with Professor, then Mr Selwyn Image, edited *The Hobby Horse*, Mr Galton, editor of Matthew Arnold and Lionel Johnson, Mr Arthur Macmurdo, [sic] and Lionel Johnson himself. Professor Image at that time kept a studio there. . . . Mr Randall Davies studied design under Mr Macmurdo and the late Hubert Crackanthorpe was for a time a pupil of Professor Image. Numbers of other distinguished people visited this artistic colony. This list of them would include Mr Mortimer Menpes, Mr Frank Brangwyn (a constant visitor), Mr Walter Crane, the late Oscar Wilde, Mr. Dolmetsch, Mr Ernest Rhys, Mr W. B. Yeats, Mr Will Rothenstein, Father John Gray, the Rev. Stewart Headlam, and a host more. Ernest Dowson had lunched there in the earliest days and had made me emulous to enter the sacred precincts."[51]

Mackmurdo's friend, Harry Sirr, wrote a more precise description of the appearance of the building for Elinor Pugh, Mackmurdo's niece, in 1942: "An entrant was greeted by a circular white Della Robbia relief let into a wall of the warm tinted vestibule. . . . Happy colouring of the wall covering secured brightness for two large rooms which could be thrown into one on the first floor, enhanced by lustre of its fitments, brass wall scones & hanging candelabra, & long low mantel mirror with reflecting facets in richly gilded framework."[52]

The Guild had a considerable influence on the course of design. Mackmurdo himself saw it as part of his continual campaign for the improvement in design, and in life. As he

[51] Victor Plarr, *Ernest Dowson* (New York, 1914), pp. 67-68.
[52] Harry Sirr to Elinor Pugh, May 6, 1942. 192/50, WMGW.

remarked in the Preface to his unpublished "History of the Arts & Crafts Movement," written many years later: "The citadel of the Philistine we attacked upon every side & here I have endeavored to give some account of the knights who led the crusade."[53] Mackmurdo saw his design work as part of his social purpose, to make the world more congenial and less sordid. The world was uglier than it need be because so many workers who might have been in the studio had left for the factory. Such organizations as the Century Guild might be able to do something to reverse this situation—not by pretending that the factory did not exist but through attempting to infuse better design into goods that were handcrafted as well as into those which were manufactured, "his wallpapers which were printed by Jeffrey's and Essex's, his textiles by a Manchester firm."[54] The political role on Mackmurdo's part was rather subdued. Yet the Century Guild was assumed to be on the left. In 1891 when the Guild had more or less ceased to exist, a Bostonian wrote to Horne, "I am commissioned to write to you on behalf of a society of young men in this city who are anxious to form an organisation on somewhat the same lines as the 'Century Guild.' Our [number] is of a somewhat varied character but we are all agreed upon seeking a revival of Art solely by means of a revivication of life: hence many of our number are Socialists."[55]

Mackmurdo, with his interest in an organizational basis for the Arts and Crafts movement, contributed to that extraordinary flowering of groups determined to spread the gospel of art, one example of the social concern so evident in the 1880s. According to his memoirs, he organized an Arts and Crafts exhibition in Enfield in 1883, and Ruskin societies in London, Manchester, and Birmingham.[56] He had a firm sense of the possible relationship between these organizations and

[53] "History," Preface mss., p. 3. K 1037, WMGW.

[54] Pevsner, "Mackmurdo," p. 135.

[55] F. Watts Lee to Herbert Horne, February 28, 1891; quoted in Tickner, "Selwyn Image," p. 191.

[56] "History," p. 204.

their attempt to influence the manufacturing process. As these "associations are formed to bring the influence of the artist to bear upon the manufacturer we shall see that man makes his attack now upon one fortress of the mechanical system & now upon another . . . man will not cease to make use of such a useful servant as the automatic power machine."[57]

Mackmurdo was also aware of the social purpose of such organizations, and the way in which the arts might be used to ameliorate the economic situation in the country and to improve the lot of the poor. But there hovers about his efforts some element of "social control": of diverting sources of possible trouble, particularly among the young. There were both aspects—amelioration and control—in one of the largest organizations of the time: the Home Arts and Industries Association. It had been founded around 1881 by Mrs. A. T. Jebb of Ellesmere, Shropshire, apparently inspired by an American example of C. G. Leland who had started classes in crafts for poor children in Philadelphia. Mackmurdo wrote about the association with some lyricism: "This object was one very near my heart, and I was glad to be one of the working committee. This 'Home Arts and Industries Association' has done much in the byways of life to reawaken the sense of beauty which the frost of mechanized production has numbed. . . . In 1889 we had 450 classes, about 1000 teachers and 5000 students."[58] Mackmurdo saw the organization as a precursor of the Art Workers' Guild—the more amateur organization giving a sense to the professionals that they too should organize, that there might be a growing interest in the world of the Arts and Crafts. The 1880s were certainly the organizational period: "Hence, let us pause to pay a tribute of thanks to those workers—mostly women—who in the eighties toiled to revive in the homes of the people the old cottage crafts."[59]

[57] Ibid. mss. no pagination.
[58] Ibid., pp. 206-207.
[59] Ibid., ch. 11, p. 3.

In his discussion of the Home Arts and Industries Association Mackmurdo depicts the classical English pattern of private endeavor beginning an activity that then becomes more public, although in the case of design the government all through the century maintained an interest in it: "Had it not been for the work done by this association it may be questioned whether the Art Workers Guild, or these Council craft schools, would have yet been established. Personal and private initiative is always the forerunner of corporate and public institutions. . . . It had done more to keep rural art & industry alive than any other body."[60] Free classes were set up, and the main office of the Home Arts Association supplied designs and money if needed. The work tended to be rather simple, and for a while there was an annual exhibition in London— the movement was certainly not commercial. Mackmurdo's involvement reflects his belief in the social purpose of art.

There was one other small organization to which Mackmurdo was connected. It demonstrates his relentlessly educational endeavors. The Fitzroy Picture Society was founded in 1891 and continued for a long time to provide pictures for schools. It had originated in yet another organization—the Arts for Schools Association that supplied "enlarged reproductions of [artists'] studies, . . . to schools at very low prices."[61] The Picture Society, in which G. F. Watts took a particular interest, was a similar organization that commissioned artists to provide drawings that could be enlarged and purchased by schools, as well as chromolithographs of well-known pictures. Selwyn Image was the most active of the Guild in designing these pictures—they were intended to demonstrate principles of design and provide examples that students might imitate.

These organizations had a didactic purpose and were to demonstrate both good design and worthy subjects. Biblical scenes were particularly favored; Heywood Sumner did a se-

[60] Ibid.
[61] Ibid. mss. p. 2.

ries of "Mighty Men of the New Testament." As the brochure for the Fitzroy Pictures expressed its aims: "If the next century is to withstand the ugliness which has mastered the present one, such education must begin early, as a matter of daily life, independent of exhibitions, museums and connoisseurship. . . . The method adopted in these pictures is intentionally direct and simple."[62]

One of the most significant accomplishments of Mackmurdo, Image, and Horne was the organ of the Century Guild originally called *The Century Guild Hobby Horse*. The great typographer Emery Walker was adviser to the *Hobby Horse*, and later to the Kelmscott Press, and then founder with Cobden-Sanderson of the Doves Press. Mackmurdo was not above suggesting that it was his having shown Morris a copy of the *Hobby Horse* that stimulated Morris to turn to printing.[63] As Gillian Naylor has remarked, "The *Hobby Horse* was the first of the art-oriented literary magazines of the 1880s and 1890s."[64] It was committed as was the Century Guild itself to total design—a belief that print, page, margin, illustrations, are all in a vital relationship to one another. The theory behind the name was that all views could be expressed. As Herbert Horne wrote in 1887, "The editors hold with Uncle Toby that the true translation of 'De gustibus non est disputandum' is 'there is no disputing about Hobby Horses.' And so they endeavor to make it a quiet garden of literature, kept free from arguments, 'for the setting forth of high principles.' "[65] The journal had only about five hundred subscribers, but the comparatively small number does not mean that it was uninfluential. Its careful approach to design was its most innovative aspect; most of the articles were quite tame. The most famous illustration, of course, was Image's design for its cover (Figure 7). He wrote about it to Mackmurdo with typical diffidence:

[62] Image papers, Ms. Eng. Misc. c. 310 f. 311 [?1891], Bodleian.
[63] "History," p. 171. Mackmurdo quotes Morris as saying to him, "Here is a new craft to conquer and to perfect."
[64] Gillian Naylor, *The Arts and Crafts Movement* (London, 1971), p. 119.
[65] Herbert Horne, "The Century Guild," *The Art Journal* 39 (1887), 298.

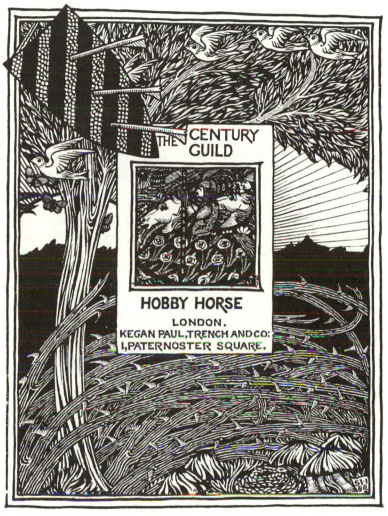

7. Selwyn Image, "Front cover of *Century Guild Hobby Horse* 1884."

"I will bring thee the drawing of the Hobby Horse—Curse it and fling it into the fire if thou are so disposed—by no means reject it."[66] Aymer Vallance, perhaps with some exaggeration, claims that until the *Hobby Horse* "never before had modern printing been treated as a serious art."[67] The first issue of April 1884 was known as the *Century Guild Hobby Horse*, and it was in that issue that the banner was unfurled; but there was not another issue until 1886. George Allen, who had published *Wren's City Churches*, was the first publisher. (Allen was a link with Ruskin. He had been a carpenter, and then had studied drawing under Ruskin and Rossetti at the Working Men's College. He had been asked to be a partner in Morris & Co. to be in charge of furniture. But he remained Ruskin's assistant and Ruskin transformed him into his publisher in 1871.)[68] *Hobby Horse* thereafter appeared until 1894, printed by the Chiswick Press, published by Kegan Paul in 1886 and 1887 and in its last years by the Bodley Head. Emery Walker continued as its consultant for design.

Not until the issue of 1888 did the *Hobby Horse* reach its full typographical eminence, in its paper, its larger typeface and new designs for initial letters and tail-pieces. It was this issue in particular that may not only have influenced William Morris but also helped inspire Charles Ricketts and Charles Shannon to start their publication, *The Dial*, in 1889 and form the Vale Press in 1896. The issues of the three years through 1890 were the most distinguished typographically; by 1891 the magazine was not as well focused, perhaps reflecting some tension between Mackmurdo and Horne.

As Peter Frost remarks about the influence of the journal, "It certainly sired a whole decade of magazines of art and literature that hankered after the unity of the arts without quite knowing why: *The Quarto, The Savoy, The Evergreen*

[66] Image to Mackmurdo, postmark December 29, 1883, f. 111, ms. Eng. lett. c. 38, Bodleian.

[67] Aymer Vallance, *Studio* 16 (1899), 187.

[68] See F. A. Mumby and Frances H. S. Stallybrass, *From Swan Sonnenschein to George Allen & Unwin Ltd.* (London, 1955), pp. 55-57.

(in its own Northern fashion), *The Pageant, The Dial,* and
The Dome all have clear and recognizable links with it. . . .
But perhaps the most important thing about it was this: it
was the first magazine to become self-conscious, and to see
itself as a work of art. So the design of the typeface itself, and
its distribution on the page, the size of the margins, the re-
lationship of illustration to typeface, the texture of the paper
on which all this appeared—all of these became matters of the
first importance, with the result that the magazine not only
aspired to present art in all its forms, but became a work of
art in its own right."[69] In this sense it came to be taken as
emblematic for the Century Guild itself as well as for what
the Arts and Crafts movement was concerned with—to make
a matter of art questions of design that had not been so con-
sidered before, and to create a whole new approach to the
artistic dimensions of the world.

Its articles, despite their mildness, were important in terms
of literary history. It was from the Guild and the *Hobby Horse*
that "the Rhymers probably grew, mingled among its mildly
Pre-Raphaelite, Ruskin-Morrisian, arts and crafts oriented
leaders, H. P. Horne, Selwyn Image, and Arthur Mack-
murdo, such literary and artistic notables as Wilde, Ernest
Rhys, Walter Crane, Will Rothenstein, Laurence Binyon, Lio-
nel Johnson, John Gray, and Arthur Galton."[70] For instance,
Ernest Dowson's famous "Cynara" and his poems on the eve
of conversion to Catholicism originally appeared in the *Hobby
Horse* in April 1891.

All parts of the *Hobby Horse* were treated with equal seri-
ousness. Horne was probably the major figure in the actual
putting together of the journal. (The same sense of care is
evident in the slim little volume of *Diversi Colores,* which
Horne published himself in 1891 at the Chiswick Press, ded-

[69] Peter Frost, "*The Century Guild Hobby Horse* and its Founders," *The
Book Collector* 27, no. 3 (Autumn, 1978), 357-360. See also Julie F. Codell,
"The Century Guild Hobby Horse, 1884-1894," *Victorian Periodicals Review*
16 (1983), 43-51.
[70] James G. Nelson, *The Early Nineties* (Cambridge, Mass., 1971), p. 151.

icated to Selwyn Image, and the parallel volume *Poems and Carols*, by Image, dedicated to Horne, three years later.) Yet Pevsner, relying on Mackmurdo's self-flattering account, attributes most of the credit to him, and certainly he was the senior figure in the Century Guild: "While engaged in the Guild work, Mackmurdo thought out another plan and again hit upon an idea of far-reaching influence. There was at that time no journal of artistic distinction in existence. Mackmurdo resolved to start one. He looked round and found in the Chiswick Press a printing press of unusually high standard and in Emery Walker a man to whom the reproduction of drawing and other works of graphic art could be safely entrusted, and ideal book-decorators in Selwyn Image and Herbert Horne. By printing the *Hobby Horse* . . . on hand-made paper, by carefully choosing a good traditional type, and by conscientiously setting and spacing the type, a production was achieved far above anything available at the time."[71] In 1892 Horne was replaced as editor by Mackmurdo, Image, and Lionel Johnson. Then in 1893-1894 Horne returned as editor for the three last issues.

There were seven volumes in all. The first issue contained illustrations by, among others, Ford Madox Brown, William Strang, Image, William Blake, a dominating figure, Rossetti; poems by Image and Horne; and essays by Image, Rossetti, and Oscar Wilde. Mackmurdo wrote a series of essays on painting in the National Gallery, paying particular attention to those of the Renaissance. The second volume, of 1887, had a similar mixture of pictures and essays. There was also a project mooted, but nothing more is heard of it—that there should be a library as a memorial to the men of letters of the Lake District.

This was the same year that the workshops of the Guild closed, but its influence was far from over. In 1888 the *Hobby Horse* page became somewhat fuller and there was a larger type. The volume contained an article by May Morris on

[71] Pevsner, "Mackmurdo," p. 136.

chain-stitch embroidery, and various historical pieces: on Florentine prints of the early sixteenth century and on medieval title pages. In the fourth volume of 1889 one can see that Mackmurdo is moving further from the sort of social concerns felt by Morris to a more "art for art's sake" position of the sort we associate with the 1890s.

There is one other area in which Mackmurdo, Horne, and Image were particularly active, and for which 20 Fitzroy Street was a center: the revival of ancient music, led by Arnold Dolmetsch. William Morris, although he enjoyed rousing songs, and wrote poems to be set to music, particularly political ones, was not especially musical. But he became increasingly intrigued by Dolmetsch's work (Dolmetsch played for him on the virginals while he was dying in October of 1896). The growing interest in English music of earlier times was part of the same impetus from which the Society for the Protection of Ancient Buildings arose, and of the historicism of the period, a growing interest in "roots," and in approaching the development of society in a more respectful way, without the profound conviction that the world as it is, rather than as it was, was bound to be superior. Morris encouraged Dolmetsch to make a harpsichord in 1896 for the Arts and Crafts Exhibition Society. With Roman lettering by Horne, it was decorated by Image and Helen Coombe who shortly was to marry Roger Fry. Dolmetsch gave quite a few concerts at Fitzroy Street, and in fact it was there that he gave his first English lecture and concert on December 19, 1891—an important date in the history of English music. Horne assisted Dolmetsch in his research. Dolmetsch's great achievement was not so much his recovery of ancient music, but his belief that the music should be played on the instruments of the time, many of which he reconstructed. Morris wished to publish a song book of three hundred songs from the time of Henry VIII, edited by Dolmetsch at the Kelmscott Press, but the project did not materialize.[72]

[72] See Margaret Campbell, *Dolmetsch: The Man and His Work* (Seattle, 1975).

Mackmurdo was also a very important influence on one of the most interesting architects and designers of the period and beyond: C.F.A. Voysey. An early building of his, a proto-modern house in Bedford Park, of 1891, with its white stucco defied the ubiquitous redbrick of Norman Shaw's houses and others influenced by him all around it. Mackmurdo helped Voysey learn how to work out patterns for carpets and wall-papers, and made a point of introducing him to wallpaper manufacturers. Voysey took many of the elements of the Century Guild, and preserved some of its more attenuated characteristics along with continuing Arts and Crafts tradi-tions. Voysey shared with Mackmurdo, and indeed with Morris, a belief in the necessity to be involved with the total design. This concept was present elsewhere, in such later groups as the Werkbund, the Wiener Werkstätte, the Bauhaus, but it had its first modern statement in England in the Arts and Crafts movement. Voysey was in the tradition of Pugin and Ruskin and acquired from them a belief that nothing was too insignificant to be designed by an individual. Voysey also admired Morris intensely, but he was reluctant to see too much of him as he felt that his own style would become too imitative.[73] He had no sympathy for Morris's political and religious views.

The difficulty with the Guild is that there was something of a void at its center. It was not an excessively centralized organization, and records, as far as I know, have not survived to indicate how it operated. It lacked the institutional vitality of the Art Workers' Guild and the Arts and Crafts Exhibition Society. The surviving objects, drawings, and manuscript material provide some evidence of the important innovative work of the Guild but not enough information about its inner workings. One suspects a lot of its activities may have been figments of Mackmurdo's imagination. That Mackmurdo largely abandoned his design career in order to spin his eco-nomic theories inadvertently suggests the social motivation

[73] See John Brandon-Jones, *C.F.A. Voysey: A Memoir* (London, n.d.).

behind his work—to move toward a cleaner, clearer life out of the muddle and complications of the nineteenth century. Mackmurdo himself is not exactly to be trusted in his descriptions and assessments, and in any case he does not tell very much about the actual procedures of the Guild. Yet its remnants are impressive.

By 1888 its various members, who still continued to cooperate, were more preoccupied with their own work. In 1890 the architectural partnership of Mackmurdo and Horne was dissolved, and there was some estrangement between the two men, as reflected in the changing editorship of the *Hobby Horse*. Image and Mackmurdo continued to work closely together. Horne left for Italy in 1900.

Mackmurdo aimed at a total style—a style that would be the same in all media: a unity of art. The barriers were to be broken down between the various art forms, there would be a great attention to detail, and collaborative efforts—all of which tended to be characteristic of the Arts and Crafts movement, and also of Art Nouveau.[74] The Arts and Crafts did have a certain respect for traditions that Art Nouveau lacked. But like Art Nouveau it aimed at a certain timelessness, to rise above tradition. Both movements were opposed to excessive historicism and eclecticism. As one historian has remarked, Art Nouveau meant "the road back to historical

[74] Mackmurdo had an interesting relation to Art Nouveau. Many elements of his style, and that of the Guild, could be called proto-Art Nouveau, with its "swirls and bobs." Ironically many of the Arts and Crafts practitioners protested vehemently at the time of the George Donaldson gift to the Victoria and Albert of important French Art Nouveau furniture exhibited at Samuel Bing's display at the Paris Exhibition of 1900. Figures associated with the Arts and Crafts, such as Image himself, Walter Crane, C.F.A. Voysey, Mervyn Macartney, Reginald Blomfield, Lewis F. Day, E. S. Prior condemned Art Nouveau. Yet they might well be seen as having some elements of Art Nouveau in their own work. (The most vivid example of this was the condemnation of the gift by the sculptor Alfred Gilbert, now seen as one of the greatest Art Nouveau artists in England). See Martin Battersby, *The World of Art Nouveau* (New York, 1968), p. 127.

styles had been closed for good."[75] Art Nouveau and the Modern movement had different attitudes toward nature, but both can be seen in the Arts and Crafts movement, most particularly in the work of Mackmurdo: "To a certain extent Art Nouveau and the rational attitude of the Modern Movement . . . had their *points de depart* in an attitude to Nature—one trend developing the flower, the stem and the rhythm, i.e. the ornament, the other the fitness, the logic and the structure, i.e. the construction."[76] Mackmurdo's designs and those of the Century Guild moved in the Art Nouveau direction and away from Morris. Comparing Morris to Mackmurdo, Gillian Naylor, the art historian, has written, "As with Morris, nature is the source-book—flowers, leaves, animals, and birds predominate . . . but although the ingredients are similar, the structure of Century Guild patterns is completely different from that of Morris. Mackmurdo's designs, with their flaring leaves and petals, are almost expressionist in their harshness, vigour and movement; the colours, too—yellow ochres, coral pinks, purples and acid greens, are rarely found in Morris's palette."[77]

The work of the Century Guild played a major part—despite its comparative scarcity of production—in redesigning the world, having its roots in the work of William Morris, and being heavily influenced by him, yet stretching forth toward the Modern movement. Nikolaus Pevsner may have overly schematized this concept when he wrote to Mackmurdo in 1938, "In a lecture up at Glasgow next month, I want once more to show you as the fountain-head of all that came later through Voysey to Glasgow."[78] Yet there is a great deal of validity to this concept. One can see how Mackmurdo influenced Voysey, and both of them were influential beyond Glasgow and Mackintosh on the Modern movement: Van de

[75] Jan Romein, *The Watershed of Two Eras: Europe in 1900* (Middletown, Conn., 1978), p. 560.

[76] Madsen, *Art Nouveau*, p. 171.

[77] Naylor, *Arts and Crafts Movement*, p. 118.

[78] Pevsner to Mackmurdo, November 27, 1938, J841, WMGW.

Velde remarked that upon seeing Voysey's work he felt "as if Spring had come all of a sudden." Hermann Muthesius put it more directly: "The whole of our movement is based on the results England achieved from 1860 up to the middle of the 1890s."[79] At the same time these English artists had not, perhaps in contrast to their European counterparts, forgotten the past, and it is not surprising that Cyril Connolly should mention meeting the "gentle Voysey" in the 1930s with his latest disciple, the connoisseur and even reviver of fondness for Victorian styles, John Betjeman.[80]

Advanced work in England at this time looked both ways and contributed to the future while not neglecting the past. It provided some of the sources of the Modern movement yet it has also given comfort to those who have found the Modern movement sterile. Perhaps they were limited but the Arts and Crafts practitioners maintained a sense of humanity and humaneness. Mackmurdo and Voysey had no use for Morris's socialism, but in their different ways all three were concerned with the human implications of their art. They wished art and design might better serve future needs. Their attitudes might provide some solace in coping with the defects of so much of modern architecture, design, and planning.

With the end of the Century Guild, never a very formal group, about 1888, Mackmurdo's greatest work was done. The aims of the Guild continued to flourish in the activities of the Art Workers' Guild—its motto was "Art is Unity"— and in the Arts and Crafts Exhibition Society. These groups shared in the English characteristic of understatement. That must not lead us to underestimate their importance in shaping how our world looks, and how we think about it. The Century Guild aimed at that special and highly attractive combination of group activity and individualism that characterized so much of English life. England is, it might be said, a nation

[79] Quoted in John Allgrove, *British Sources of Art Nouveau* (London, 1969), pp. 11, 13.

[80] Cyril Connolly, *The Evening Colonnade* (London, 1973), p. 435.

of intense but highly cooperative individuals. The Guild wished
to achieve an "unbroken sentiment and strength of individ-
uality guaranteed by a guild of fellow-craftsmen."[81] Its work
built on Morris's. Its designs were among the earliest in cre-
ating the look of the modern world as we now know it.

[81] Guild Prospectus, WMGW.

The Art Workers' Guild

THE ART WORKERS' GUILD was perhaps the most important of the various organizations to come into being in the 1880s under William Morris's influence. Founded by a group of young architects in 1884, it was intended to bring together a variety of artists and craftsmen and to facilitate their assisting one another in their individual specialities.

Ruskin and Morris had long believed in breaking down barriers in the arts, not least because such barriers could be used as indications of class and ways of making social distinctions. The Arts and Crafts movement challenged the snobbery inherent in this sort of thinking and sought to establish a more rewarding relation of the worker to his work and ultimately to society. The Art Workers' Guild and groups like it in effect institutionalized the genius of Morris. As Mackail, Morris's biographer, remarked of the Arts and Crafts movement as a whole,

> On the one hand it aimed at a new organization of work within the single workshop, so that the manager, the designer, and the artificer should cease to be three distinct persons belonging to different social grades, differently educated and differently employed, working without mutual sympathy, or even each in active hostility to the others. On the other hand it expressed itself to the co-ordination of these workshops, hitherto isolated units of productive energy, whether by means of formal guilds

and associations, or through more intangible links of common ideas and kindred enthusiasms, into the beginnings of a trained organism of handicraftsmen, with a mutual intercommunication, and a cumulative force of trained intelligence. What Morris himself had, in earlier days done by the mere unassisted force of his own genius, was now being attempted on all sides with a conscious purpose.[1]

The Art Workers' Guild encouraged a sense of its own importance as an organization, but it had no wish to create new hurdles and barriers. The fight against professionalization in architecture, although it occurred some years after the founding of the Guild, exemplified its values. From the first, the Guild had opposed the more technical sort of professionalization, even though it believed, as Morris did, that architecture was the queen of the arts. In the early 1890s a newly organized group, the Society of Architects, lobbied for a bill in Parliament that would require the certification or registration of architects. The Royal Institute of British Architects was not prepared to go as far as that, but it was sympathetic to the idea of certain examinations to insure that individuals were competent in technical matters. In effect, certifying architects would form a kind of "guild." But the Royal Institute was interpreting the concept of a guild in a restrictive way, whereas the impetus behind the formation of the Art Workers' Guild had been for something more open, more artistic, and less "professional." The Guild believed in the unity of all the arts—the "lesser" and the "finer"; so, in a rather similar way, did those architects—Norman Shaw, for example—who were opposed to rigorous professionalization and had no wish to see their field divided from painting and sculpture. It was notable that Shaw, a leading architect of the period, chose to be a member of the Royal Academy rather than the Royal Institute of British Architects. A memorial to the Royal In-

[1] J. W. Mackail, *The Life of William Morris*, 2 vols. (London, 1899), II, 197.

stitute published in the *Times* on March 3, 1891, signed by
seventy eminent names—including architects who were mem-
bers of the Royal Institute, some who were not, and other
prominent figures—spoke out against professionalization. In
their view "no legislation [could] protect the public against
bad design; nor could legislation help to prevent bad con-
struction unless builders were required to pass the test of
examination as well as Architects, inasmuch as Architects are
not employed in the majority of cases."[2] Among the signers
were several who in 1884 had been closely involved in the
founding of the Art Workers' Guild—Mervyn Macartney (who
actually drafted the memorial), Edward Prior, W. R. Lethaby,
and Gerald C. Horsley—and a number of figures associated
with the Arts and Crafts wing of the architectural world—
E. J. May, J. J. Stevenson, A. H. Mackmurdo, Halsey Ricardo,
Herbert Horne, and Philip Webb. Among others who signed
the memorial were such supporters of the Guild as Ford Madox
Brown, Selwyn Image, Edward Burne-Jones, Walter Crane,
and William Morris himself. Within a year, Norman Shaw
and T. G. Jackson would edit a collection of thirteen essays
under the general title, *Architecture: A Profession or an Art?*
(1892), in which they argued in favor of the latter, pointing
out that the architect belonged in "his proper place, namely
at the head of the arts, where he should be, and there should
not be an endeavor to thrust him to the tail of the profes-
sions."[3]

Registration of architects was to prove the wave of the
future; but this particular controversy put off the eventuality
for another forty years. On February 6, 1891, the Art Work-
ers' Guild carried a resolution against registration, which was
not surprising.[4] Although the Shaw and Jackson collection
appeared seven years after the foundation of the Guild, it was
imbued with its spirit, and indeed, among the thirteen essay-

[2] Quoted Barrington Kaye, *The Development of the Architectural Profession
in Britain* (London, 1960), p. 138.

[3] Ibid., p. 140.

[4] Minutes, Arts Workers' Guild Archives, Queen Square, London.

ists were the principal founders of the Guild: Mervyn Macartney, Ernest Newton, Edward S. Prior, Gerald C. Horsley, and W. R. Lethaby. The antiprofessionalism note was sounded by G. F. Bodley, a distinguished architect and mentor of C. R. Ashbee, the founder in 1888 of the Guild of Handicraft. "The more we make the practice of architecture the practice of a fine art, the more we shall raise it to its legitimate position," Bodley wrote. "On the other hand, the more we make it, if we may use the expression, a sort of professional business, the more we lower it. And what should architecture be, if it should ever again take its fitting place, but the queen and mistress of the arts? It is the most ideal, the most creative, the most imaginative, and the most comprehensive of them all." Norman Shaw entitled his essay, "The Fallacy that the Architect who makes Design his first Consideration, must be un-practical." Lethaby wrote on "The Builder's Art and the Craftsman," emphasizing the importance of actually doing the work and of a "natural" style that would not be committed to historical precedent.

The Arts and Crafts movement was a means for the period to achieve a style of its own—one that would look "historical" in the future, not in the present, and hence be more than an echo of some borrowed past. As Lethaby wrote: "Architects already begin to realize that calling their work by the name of an historical style is proclaiming it dead. . . . These names are nothing but the epitaphs on the tombs of dead arts."[5] He felt it essential that an architect know all crafts—what could be a more emphatic indication of the pervasive influence of

[5] Norman Shaw and T. G. Jackson, eds., *Architecture: A Profession or an Art?* (London, 1892), pp. 57, 169. Pevsner commented on this book, "The artist-architects, inspired by the Morris idea of the artist-craftsman or the medieval masterbuilder stood on one side, the architect-professional men on the other, often more businesslike but often a little less uncompromising in their attitude to clients. I need hardly add to this that the whole conception of architecture as a profession is a Victorian conception and a concomitant of nineteenth-century liberalism." Nikolaus Pevsner, "The Late Victorians and William Morris," *Listener*, August 9, 1951, p. 218.

William Morris? The point of the enterprise of these architects and the Guild itself is summed up in the title of the essay by Gerald Horsley, "The Unity of Art." This had been the motto of the Century Guild, and on the badge of the Master of the Art Workers' Guild is emblazoned: "Art is Unity."

This particular controversy, centered on the work of the architect, suggests the general atmosphere and concern out of which the Guild arose, as does the lecture "Art and Socialism" that William Morris delivered on January 23, 1884, in Leicester, two months before the founding of the Guild and shortly after he himself had joined the Democratic Federation.[6] Morris was committed to the ideal of an integration of the arts, along with a change in the political structure of the nation. As Robert MacLeod has remarked, his aim was to reform art by reforming society, in contrast to Pugin who hoped to reform society by reforming art.[7]

It was frequently not the case, as I have said, that those who were influenced by Morris's views of the state of the arts were willing to accept his political analysis of the state. But it is significant, nonetheless, that these Arts and Crafts organizations should have come into being just at the time when politics was being subjected to increasingly radical pressure through the formation of small political groups, such as the Democratic Federation and the Fabian Society. The Art Workers' Guild arose out of a sense of a lack of a satisfactory role for the arts in society. Obviously, its members were not ordinary laborers. Yet the young men of arts who founded the Guild felt a dissatisfaction similar to that underlying the rise of the labor movement. Organization was now necessary by the so-called "lesser" figures.

Morris believed that the crafts—the minor arts—should be particularly joyful for those who practiced them. It was commonly assumed that pleasure—pleasure of a special sort, for

[6] Manuscript version, Ms. don. c. 29, Bodleian Library; also in *Collected Works*, ed. May Morris, XXIII, 192-214.

[7] Robert Macleod, *Style and Society* (London, 1971), p. 62.

not every moment of creativity consists of what we would ordinarily call pleasure—was chiefly to be found in the finer arts of painting, sculpture, and architecture. Even if medieval guildsmen and craftsmen were not as happy as Morris might have believed (or as he has been assumed to believe), their lot was less downtrodden, deprived, and unrewarding than that of the workers of the 1880s in England.

Reading his lecture, one sees that Morris was not foolishly romantic about the past nor sweepingly dismissive of the machine. One also sees why he should have been so important a shaping force on such organizations as the Art Workers' Guild. Although Morris did not allow himself to be made the Master of the Guild until 1892, his acceptance of the mastership indicates that despite his remarks to the contrary, he was willing within limits to assist in such Arts and Crafts endeavors even though they were not likely to bring about the sort of total change in society that he believed essential. Even today, the Guild recognizes its indebtedness by giving Morris's bust pride of place over the chair of its Master in its present meeting room.

In his lecture of 1884 Morris remarked that "while men labour no less painfully than they have always done, they have lost the solace of their labour which popular art once gave them." An organization like the Guild might provide an opportunity for at least a few to have a sense of pleasure— or "solace"—in their work and offer an example that might be extended. And he could foresee a time when machines might make laborers more, not less free, even though at the time he was speaking they had reduced workers into a further state of slavery: "The wonderful, the astonishing progress of mechanical invention which is the special mark of our age has done nothing to lighten the daily work of those who have to live by toil."

Aware though Morris was of the limitations of such organizations as the Century Guild and the Art Workers' Guild, he was not opposed to their formation. But in the long view he was deeply pessimistic about the effectiveness of such groups.

As he remarked elsewhere, politics must provide the real solution: "I do not believe in the possibility of keeping art vigorously alive by the action, however energetic, of a few groups of specially gifted men and their small circles of admirers amidst a general public incapable of understanding and enjoying their work. I hold firmly to the opinion that all worthy schools of art must be in the future, as they have been in the past, the outcome of the aspiration of the people towards the beauty and true pleasure of life."[8] Robert MacLeod in his incisive study *Style and Society* (1971) remarks on the problem that Morris, Philip Webb, and the Art Workers' Guild faced: "If the very existence of art depended on a vital communal tradition and enterprise that was at that time non-existent, what solid achievement could the solitary practitioner hope for? It was a problem incapable of resolution, and produced a sense of frustration."[9] Craft groups, however, might provide an important intermediate solution.

Yet for all the good intentions of organizations such as the Guild, Morris doubted that they could affect much: "An intellectual revolt had sprung up against the degradation of the arts . . . [and] had achieved the temporary and outward success on a limited scale: but I hinted to you that this revolt carried on these lines could never be lastingly or widely successful because it was an intellectual revolt only and expressed the hopes and fears of a small body of men only."

As K. L. Goodwin has pointed out, "hopes and fears" is a very characteristic Morris phrase—indeed it was used for one of his earliest collections of essays, *Hopes and Fears for Art* (1882). Goodwin has argued how much similarity there is between Morris's designs and his poetry. Much of the latter is full of expectation and then disappointment—"hopes and fears"—the moment itself is somehow of less importance than what comes before and after. Morris's object was to apply design to life, in order to make it rational, harmonious, and

[8] Ibid., no source given, p. 45.
[9] Ibid., p. 50.

beautiful. Goodwin argues that Morris had concluded by 1876 that he could not do this successfully in his poetry; he then turned his primary interest back to his business as a designer.[10] But of course he did not stop writing, and it also could be claimed that his turning to politics, which he did in 1877, was a new way of continuing the search. The pattern of search and disappointment continued as he joined one political organization, the Democratic Federation, then left it to help form the Socialist League, and left that to found the Hammersmith Socialist Society.

In his lecture of 1884, Morris went on to enunciate his recently acquired socialist beliefs: "I conclude by appealing to you not to think that limited success of the intellectual revolt worth gaining if it has to stop there, but to aim as the only chance of a real success, a real new birth of the arts, at a change which should embrace all, which should give out, that is to say, the pleasure of life, to all men." The lecture also modifies the accepted view that Morris was against individualism. He would be sympathetic to the individual aspirations of the members of the Guild and approved of these aims in the context of group activity:

It is true that all art springs from cherishing individuality of mind, that is to say freedom of thought and imagination: it may also be true as some people think that the whole tendency of civilization is to extinguish individuality of mind, in that case it must be true that it is the tendency of civilization, of progress as 'tis called by some, to extinguish art. Once more I will assert that art is the visible expression of man in the Pleasure of Life. . . . It is right and necessary that all men should have work to do which they are each of them specially fitted to do:

[10] See K. L. Goodwin, "The Relationships between the Narrative Poetry of William Morris, His Art and Craft-Work, and His Aesthetic Theories," D.Phil. dissertation (Oxford University, 1969). It is significant, as Joseph Dunlap has pointed out (personal communication, August 8, 1982), that Morris in his political poem, *Pilgrims of Hope* (1885) wrote: "But now are all things changing, and hope without a fear/ Shall speed us on through the story of the changes of the year."

that this work should be worth doing, pleasant to do of itself.

He went on to make clear both the virtues and the defects of improvement in the world of art and design—that it would help, but the ultimate solution for the problems of English, and world, society, would be political: "By simplifying our lives, and raising the standard intellectually (and the two things go together) we shall clear our vision, and not resist the necessary change when it comes—and who knows how near it may be."

The Arts and Crafts organizations were being established at the time when Morris was at his most political, and when he felt most keenly the necessity of political revolution. It was the previous year that he had affiliated with the Democratic Federation. That year he had given a powerful speech entitled "Art and the People: A Socialist's Protest Against Capitalist Brutality; Addressed to the Working Classes." In it he showed an intense awareness of the class implications of art. Indeed this was one reason he supported the new movements in the world of design. He hoped that they might remove some of the false divisions that marked the increased professionalization in the Royal Academy, and the growth of divisive organizations not dedicated to the conception of the unity of art: "In those times when art flourished most, the higher and the lower kinds of art were divided from one another by no hard and fast lines; the highest of the intellectual art had ornamental character in it and appealed to all men, and to all the faculties of a man; while the humblest of the ornamental art shared in the meaning and deep feeling of the intellectual; one melted into the other by scarce perceptible gradations: or to put it into other words, the best artist was a workman, the humblest workman was an artist. Well, let us see how it fares with art today: those who practice the purely intellectual arts, and who are technically called 'artists' are all by virtue of their occupation conventionally of the class of gentlemen."[11]

[11] May Morris, ed., *Willaim Morris*, II, 386-387.

This sort of discontent was felt by architects in their rela-
tions with the Royal Academy—to a considerable degree they
felt excluded from it, as if their work lacked the standing, the
sort of aura, attached to painting and sculpture. Yet mem-
bership in the Academy was a highly attractive honor. Their
discontent helped inspire the establishment of the Art Work-
ers' Guild as well as other organizations. Mackmurdo, an
architect, was the dominating force behind the Century Guild.
The architect C. R. Ashbee was the motivating force for the
Guild of Handicraft. Morris himself had only briefly trained
as an architect—it was one of the few skills that he did not
practice—but he believed in the primacy of architecture. His
meeting with Philip Webb, "the best man he ever knew,"
that architect's architect, in Street's office resulted in one of
the closest friendships in his life. So, although not an architect
himself, he was well aware of, and respected its important
place in the hierarchy of the arts.

As we have seen, architecture appeared to be going through
some sort of identity crisis toward the end of the century: was
it an art or a profession? It was a pursuit requiring much more
planning and coordination than was necessary for painting or
sculpture. With the growing complications of nineteenth cen-
tury society, with the increasing involvement of the state, the
complexity of sanitation and other technicalities, the aesthetic
considerations of architecture were frequently at hazard. It
was not surprising that the theory of functionalism should
have evolved, for it provided a way of making an aesthetic
virtue out of necessity. This was the direction in which Eng-
lish architects were moving, but they did not carry it to its
logical conclusions as happened on the Continent. Architects
believed in the unity of the arts and the importance of their
being in charge of that unity. They were also anxious to have
at their command a group of craftsmen able to assist them in
their work, capable and certified in some way as being so,
but not quite in the same professional class. The cult of the
golden amateur assuring its practitioners status as gentlemen
was and is highly important in England. This value was in

conflict with the increasingly strong demands for profession-alism—that building, as with so many other endeavors, was too important and expensive to be left in the hands of ama-teurs. The older apprentice ways of being trained, in archi-tects' offices, lacked objective certification.

One way of coping with the issue might be to try a new approach emphasizing the unity of the arts, a message that Morris had been preaching for some time. It also might serve to help English architects move toward a new and more "nat-ural" style that would free them of the historicism of the nineteenth century, even from the Gothic revival that was so important to so many of them. As Dennis Farr has written, "Architects and designers, faced with more tangible prob-lems, grappled with the conflict—some would say outright contradiction—between historicism (or revivalism) and the challenge presented by the machine age and new materials. Their restatement of fundamentals was largely determined by severely practical considerations, and not the least of the ben-efits this brought was the breaking down of the old barriers between artists, designers, and architects which had been cre-ated in the nineteenth century."[12]

It was difficult for architects to be in touch with craftsmen of various sorts sympathetic to and interested in their ap-proach. Reginald Blomfield, an architect and an early member of the Art Workers' Guild, was not unusual in pointing out that architects were "separated from the craftsmen by the barriers of trade."[13] The time seemed ripe for some sort of lowering or even the total removal of such barriers.

Most of the founders of the Art Workers' Guild—at least the architects—were members of a small informal discussion group, the St. George's Art Society. They came together to form the Art Workers' Guild with the Committee of Fifteen, the greater number of whom were craftsmen and artists such as Walter Crane and Lewis F. Day. Almost all of the members

[12] Dennis Farr, *English Art 1870-1940* (Oxford, 1978), p. ix.
[13] Reginald Blomfield, *Memoirs of an Architect* (London, 1932), p. 55.

of the St. George's group worked in the office of Norman Shaw, undoubtedly one of the great architects of the period.

Yet the feeling of the Art Workers' Guild would ultimately be more sympathetic to Philip Webb. This counterpoint between the two architects is a very interesting rhythm of the period.[14] Both men, like Morris himself, had trained with one of the greatest of the Gothic Revivalists, G. E. Street, Shaw replacing Webb in Street's office. Both marked a culmination—in some sense a breakthrough—of moving beyond particular styles, beyond the eclecticism that had marked so much of the century, to a style of their own times—Shaw on the whole was the less adventuresome and the more joyful: his most common style rather fancifully called "Queen Anne." Webb was the creator of Standen, Clouds, and other houses that were a triumph of a seemingly "natural" styleless architecture.

It was odd that the founding members of the Guild should have been workers in Shaw's office, and yet ultimately prove to be more under Webb's influence. This was especially true of Shaw's chief assistant and Webb's biographer, W. R. Lethaby, one of the most potent figures in the generation to follow Morris and one of the founders of the Guild. He was also the first Principal, along with George Frampton, of the Central School of Arts and Crafts, founded in 1896, which tried to conduct itself along Arts and Crafts principles: craftsmen did the teaching. As Mark Girouard has remarked, Webb "only employed one assistant, took on comparatively few jobs, and executed them with meticulous thoroughness. . . . Webb was the acme of rectitude and carefulness about money and lectured and bullied his clients mercilessly, for the good of their souls. . . . Shaw was a little lacking in principle, a little too

[14] See Andrew Saint, *Richard Norman Shaw* (New Haven, 1976), and Mark Girouard, *The Victorian Country House* (Oxford, 1971). As Pevsner remarked, "One can indeed say that the Arts and Crafts Movement was spiritually the work of Morrisites though physically of Norman Shavians." Nikolaus Pevsner, "Architecture and William Morris," *Studies in Art, Architecture and Design* (New York, 1968), II, 114.

facile, and with a streak of coarseness; but he had amazing creative abundance and zest for living. Webb was an honourable man; but there are times when one wishes that he could have enjoyed himself a bit more."[15] Both these architects, and also Voysey some years later, were concerned with building houses not exclusively for the rich, a notion comparatively new among major architects. Much as England itself was beginning to be forced to reassess her economic position, so too architects had to show somewhat more concern for needs such as new Board schools called for by W. E. Forster's Education Act of 1870, and for middle-class and lower-middle-class homes such as those for the aesthetically inclined to be found in Bedford Park in Chiswick, built by Shaw, E. J. May, and others in the 1870s. Of course it was also true that more members of the middle class could now afford to hire architects and that there were more architects available to be hired.[16] There was some decline of pretension, and the plain style was simply less expensive than the historical styles that had dominated much of the century. Aspects of this development can be traced back to Red House, which Webb had built for Morris in 1859. Lethaby claimed it to be the first nineteenth century building to abandon past styles.[17]

Before the revival of monumental architecture in England— the neo-Baroque Edwardian of the early twentieth century or the French Beaux-Arts style—there seemed to be a special moment marking a search for English roots as well as part of the beginning of a modern style: modernism itself. As Henry Heathcote Statham wrote in his article on modern architecture in the famous eleventh edition of the *Encyclopedia Britannica* (1910-11), "All had been copied that could be copied, and the result, to the architectural mind, was not satisfaction but sa-

[15] Girouard, *Victorian Country House*, p. 51. This picture may be a little overly gloomy: Webb's letters, at least to the Morris family, present a happier figure of a man.

[16] I owe these points to Alan Crawford.

[17] See John Physick and Michael Darby, *Marble Halls* (London, 1973), p. 60.

tiety. . . . To reduce architecture to good sound building and good workmanship seemed to promise at any rate a better basis to work upon than the mere imitation of classic or medieval detail: it might conceivably furnish a new starting point. . . . The building artisans, in fact, were collectively to take the place of the architect and the form of the building to be evolved by a natural process of growth. This was a favorite idea also with William Morris, who insisted . . . that in fact it was the modern architects who stood in the way of our having a genuine modern architecture of the 19th century."[18] It is unlikely that the architects went as far as this in submerging their own importance. But certainly at the end of the century there was an emphasis on cooperation. Morris, that supreme individual, was nonetheless in the vanguard of supporting those who believed in more joint ventures, groups of craftsmen such as the Art Workers' Guild.

Of the young men from Norman Shaw's office who were the most dynamic figures in the forming of the Art Workers' Guild, John Summerson has written, "There is an easy-going air about this group, reflecting the easy-going genius of their master but reflecting also that they came of well-to-do families and mostly had public-school educations. They were more literate than most architects, and they and their circle produced the best architectural books of the period."[19]

The most important figure in the group—certainly in terms of his ultimate influence—was W. R. Lethaby (1857-1931). But all of them were interesting architects, even though none quite achieved the eminence of Norman Shaw or Philip Webb. There was Ernest Newton (1856-1922), a "modest, practical man,"[20] who had gone to Uppingham, an interesting and innovative public school, where he would do some work toward the very end of his career in a spare style that tended to characterize all these architects. He had entered Shaw's office in 1873, was there three years as a pupil, three years as

[18] Quoted in Edgar Kaufmann, Jr., "The Arts and Crafts: Reactionary or Progressive?" *Record of the Art Museum Princeton University* 34 (1975), 6.

[19] John Summerson, *The Turn of the Century* (Glasgow, 1976), p. 19.

[20] Saint, *Richard Norman Shaw*, p. 186.

an assistant, and then, before Lethaby, was Shaw's resident clerk. In 1879 he had launched out on his own. Newton shared with other architects in the arts and crafts tradition a belief in the importance of local character in his buildings and the use of traditional building methods.[21]

Another member of the original group was Edward Prior (1852–1932), "Scholar and 'angular' intellectual,"[22] the son of a barrister who received a fashionable education at Harrow and Caius College, Cambridge, and from 1902 to 1917 served as secretary of the Arts and Crafts Exhibition Society. He came to Shaw's office in 1874. He built intriguing buildings and was intent on using local materials. Two architectural historians have gone so far—too far—as to call "The Barn" that he built in Exmouth in 1896 "probably the most important house of its date in Europe."[23] Politically he was a follower of the Tory implications of Ruskin's thought. There was E. J. May (1853–1941), who had not been a pupil of Shaw's, although he was associated with him in the building of Bedford Park. Gerald Horsley (1862–1917) was a member of the group who joined Shaw's office in 1879 and became the first secretary of the Art Workers' Guild. Mervyn Macartney (1853–1932) was a more active figure. In the wake of the dispute some years later over the registration of architects, he resigned as a fellow of the Royal Institute of British Architects, although he rejoined in 1906. Macartney was interested in the possibility of a gallery for exhibitions, an idea that helped lead to the founding of the Arts and Crafts Exhibition Society four years later. Macartney came to Shaw's office in 1878. In his work he was the pupil of Shaw who was the most "classically inclined."[24] He was also politically conservative.

Under Lethaby's influence, the young architects in Shaw's

[21] See William Godfrey Newton, ed., *The Work of Ernest Newton* (London, 1925).

[22] Saint, *Richard Norman Shaw*, pp. 186, 320.

[23] Geoffrey Hoare and Geoffrey Pyne, *Prior's Barn and Gimson's Coxen* (Budleigh Salterton, 1978), no pagination.

[24] Saint, *Richard Norman Shaw*, p. 269.

office were thought to be left-wing thinkers. As Gillian Nay-
lor has remarked: "Norman Shaw's office, while Lethaby was
there, gained such a reputation that fathers were loath to allow
their sons to associate with the staff."[25] Lethaby came to Shaw's
office in 1879 as chief clerk. He was the son of a carver and
gilder—a Liberal and an Evangelical—in Barnstaple, Devon.
There Lethaby first trained with Alexander Lauder and then
with Richard Waite of Derby. He came to Shaw's attention
when drawings of his were published in the *Building News*.
He was given great freedom by his employer. In 1879 he
received the Soane medal for study abroad, and then in 1881,
the Pugin studentship. He became primarily a teacher, almost
a sage, rather than an architect; he was central in transmitting
the tradition of William Morris—to whom he became very
close, particularly when he joined the Society for the Protec-
tion of Ancient Buildings. After committee meetings of the
Society, Lethaby had many conversations over supper with
Morris at Gatti's Restaurant. He established himself in inde-
pendent practice in 1889, but his period of active building was
comparatively short. He made considerable contributions to
New Scotland Yard, one of Shaw's most important buildings.
His first independent building was a country house for Lord
Manners, Avon Tyrrell, in 1891. He did several good size
country houses and a very interesting small business building
with J. L. Ball in Birmingham, in 1898-1900. His building
career was virtually over in 1901. He also was a furniture
designer, and with Ernest Gimson, probably the greatest fur-
niture designer of the post-Morris period, and some others,
he formed in 1890 Kenton & Co., which lasted only a few
years because of under-capitalization. He was concerned with
various aspects of architecture, with a particular interest in
Santa Sophia and the medieval period, as well as with some
of the broader implications discussed in *Architecture, Mysticism
and Myth* (1891). He wrote definitive works on Westminster
Abbey after he became its surveyor and applied to the abbey

[25] Naylor, *Arts and Crafts Movement*, p. 109.

the Anti-Scrape doctrines of maintenance rather than restoration. As much, if not more, than the others of the Shaw "nursery" or "the family," he attempted to achieve a sort of "free" architecture not caught in a historical style. In effect, he believed that each period should seek its own style and not give in to the eclecticism of historicism. The moment was brief. In fact, it was partially undone by Reginald Blomfield, a close friend of the Shaw group, but eventually a highly influential believer in the return to more self-conscious historical styles.

Lethaby was advisor to the Technical Education Board of the London County Council, drawing up a plan for art education, which he was able to implement at the London County School of Arts and Crafts, later known as the Central School. In 1901 Lethaby became Professor of Design at the Royal College of Art. Through his experience at the Abbey and elsewhere, he was a dominant authority on the proper treatment of old buildings. He agreed with Morris that art should enter into every aspect of life.

Through his involvement in the founding of the Art Workers' Guild, Lethaby continued the tradition of Ruskin and Morris into the twentieth century. He was characterized by a kind of mystical common sense, a sort of transcendent practicality. Lethaby was more welcoming to machines than Morris; he had a strong sense of the importance of art to industry, of the need to make good design and workmanship widely available.[26] Lethaby declared his debt to Ruskin and Morris often, as at an occasion in his honor at which he remarked that "the best way to think of labour is as art. That was Ruskin's and Morris's great invention. By welcoming it and thinking of it as art, the slavery of labour may be turned into joy. Art is best thought of as fine and sound ordinary work. So understood it is the widest, best, and most necessary form of culture. . . . Life is best thought of as service: service is

[26] See A.R.N. Robert, "The Life and Work of W. R. Lethaby," *Journal of the Royal Society of Arts* 105 (March 29, 1957), 355-372.

common productive work; labour may be turned into joy by thinking of it as art, art, thought of as fine and ordinary work, is the widest and best form of culture: culture is a tempered human spirit."[27]

Lethaby became a great friend of Philip Webb's, in part because he lived near him in Gray's Inn for many years. He imbibed Webb's more austere version of Morris's teaching. Both were socialists, Webb perhaps more devotedly so than Lethaby. Both furthered the conception of the affiliations of socialism and the Arts and Crafts. Such an affiliation was not essential: Ruskin was both a Tory paternalist and a progenitor of the Arts and Crafts movement. Yet the interest in the Arts and Crafts in the importance of the quality of the laborer's experience almost inevitably led to a more socially conscious approach to art and its relation to the quality of life.

Lethaby shared this concern. Ironically, Webb did not have any students to speak of in his office, but he became more of a master to these young men than Shaw himself, particularly in their aim of a "free" style. As Andrew Saint, Norman Shaw's biographer, points out, Shaw came more and more to diverge from his pupils. Shaw saw the architect as "the isolated designer of masterpieces in the mould of Inigo Jones or Wren, whereas the others spoke at every stage of the interdependence of the crafts."[28] The group of young men, most of them barely 30, wished to expand the work and horseplay of Shaw's office into a group for discussion. Therefore, in 1883 they created the St. George's Art Society, named after the nearby church and not as an echo of Ruskin's guild. It met in Ernest Newton's room at 14 Hart Street, Bloomsbury Square, once a month to listen to a talk.

The minutes of the Society reflect the preoccupations of these vital young men.[29] They felt removed from the dominant groups at the two ends of the spectrum—on the one

[27] W. R. Lethaby, *Scrips and Scraps* (n.p., n.d.), p. 6.
[28] Saint, *Richard Norman Shaw*, p. 317.
[29] The Minutes of the St. George's Art Society (May 1883-February 1886), Art Workers' Guild Archives.

hand, the Royal Academy, the home of "fine" artists, and on the other, the Institute of British Architects, an official body. These organizations appeared to stand for the disparity of the arts, whereas the "St. Georgians" aimed to achieve unity of the arts, which impelled them to establish the Art Workers' Guild the next year.

The first meeting of the St. George's Art Society recorded in the minutes took place on May 5 and consisted of Newton, Prior, Macartney, Lethaby, E. G. Hardy, and Reginald Barratt. Newton was elected president, and a committee was formed consisting of all those present, as well as E. J. May. Macartney was designated treasurer and Barratt, secretary. The number of elected officers demonstrates the English fondness for forming organizations no matter how few the members. (One feels that it would happen if there were two Englishmen on a desert island.) The first paper, given at the June meeting, was Lethaby's on comparing Early French with English Renaissance architecture. At this meeting on June 1, two more members were elected: Arthur Keen and Charles Honnibook. In July Macartney talked on the right training of an architect, in September, E. J. May on concrete construction, and in October, Prior on the use of terracotta. Even at this early date, a dispute arose about the training of architects, and these young men took a position contrary to that which they held eight years later in the debate on this subject. At the meeting on July 6, before hearing the paper, they voted—perhaps surprisingly—5 to 2 that there should be an examination for architects. At the October meeting a leave of absence was granted to Reginald Barratt for as long as he was abroad, and the stipulation made that there could be honorary members at a payment of 10/6. There was no mention of what dues, if any, the regular members paid. There was also a discussion, by the committee—Newton, Prior, Macartney, Horsley, Lethaby, May—as to whether the Society might expand its activities.

On October 22 there was a committee meeting of the Society. We begin to see the genesis of the Art Workers' Guild.

There was a formal report from the treasurer, Macartney, and from the secretary, Horsley, of a "visit to Mr. R. Norman Shaw R. A. The Treasurer having informed the meeting of the opinions of Mr. Shaw R. A. the future state of the society was discussed." Shaw had pointed out that in France painters, sculptors, and architects were trained in common: "If architecture in England was missing its way, it was for the young men to bring her back from professionalism. The architects of this generation must make the future for themselves and knock at the door of Art until they were admitted."[30] The cooperation would be invited, by means of a prospectus, of eminent artists, sculptors, and architects to form with the committee a new society for promoting more intimate relations between painters, sculptors, architects, and those working in the arts of design, and with a view to advancing the arts of painting, sculpture, architecture, and of design: "It was decided, if possible, to still carry on the St. George's Art Society in a similar manner as heretofore." The rest of the surviving minutes record the attempt to preserve the Society, but indeed the decision of October 22 more or less meant its approaching demise—it had served its purpose, and there was a limit to how much time busy men could spend on such activities. In November Prior, Newton, Macartney, and Lethaby wrote statements to Horsley calling for the unity of the arts.[31] Interestingly enough in their concern with architecture, painting, and sculpture, they were still thinking in somewhat Royal Academy terms. The attention to craft that would become the main thrust of the Guild emerged later from Morris's shaping spirit. The members of the Society still regarded Shaw as an important father figure. He took an indulgent interest in the doings of his students and his friends. Apparently he did not attend the meetings of the Society, nor indeed of its successor, the Guild.

[30] E. S. Prior, "The Origins," in H.J.L.J. Massé, *The Art Workers' Guild, 1884-1934* (Oxford, 1935), p. 7. Prior's talk was given in 1895.
[31] Ibid., p. 8.

It is worth noting the subsequent history of the Society. At its meeting on November 9 Ernest Newton read a paper on planning and reported on a viewing of Dorchester House in Park Lane; on December 7 Hardy spoke on restoration. At the meeting on January 4, 1884, Morris was elected a member. Perhaps because of declining attendance it was decided that the fine for nonattendance might no longer be remitted. At this meeting Lethaby read a paper on beauty in art. On February 1 Reginald Barratt spoke on London architecture. There was a visit announced for February 23 to Alma-Tadema's house. At the tenth meeting, on March 7, Macartney spoke on plasterwork, and there was a trip planned to the Brompton Oratory. It was noted in the minutes that about seven members generally attended the meetings. On April 4 Prior spoke on tombs, and a visit was planned to Osterley Park. Clearly there was a growing concern about attendance; it was decided to write to E. J. May and ask why he shouldn't be fined for nonattendance. Like many such groups, these young men seemed to take a certain pleasure in passing rules and regulations.

On May 2 four new members were elected, and Barratt read a paper on a tour to Italy. On June 6 there was a paper on painted glass by Honnibook (read by the secretary), and two members were fined for nonattendance. On July 18 Keen spoke on vaulting, on October 17, Belcher on spires, and on November 21, Beresford Pite on the western facade of Lincoln Cathedral. The society met eight more times, into February 1886. There were so few in attendance that at least once a paper was repeated at another meeting. On January 16, 1885, E. J. May gave a report on a visit to Northumberland, on February 19, Cyril FitzRoy, a pupil of Shaw's, spoke on Venice. On March 19, with an audience of four (Newton, FitzRoy, Lethaby, and Horsley), Hardy spoke on early Christian art. At the next meeting on May 16, the fine rule was abolished; clearly it was not having much effect. On June 18 Boney spoke on ironwork, on October 18, the treasurer, Macartney, on landscape gardening, on November 19, Newton on fur-

niture, and on January 21, 1886, Macartney and Barratt spoke about Rome; at the final meeting on February 21 Keen spoke on Wren, as recorded in the twenty-seventh Report in the minute book. If one of the reasons behind the organization was a feeling that there was a drifting apart of architecture, painting, and sculpture, there was little purpose in architects spending their time talking to one another, even if the topics, on the whole, were of a highly practical nature.[32] In any case the last two years of the existence of the society were somewhat unnecessary. It had helped give birth to the Art Workers' Guild, which was specifically designed to hear papers and to provide a community for artists of various kinds which the Society—being only architects—could not do. There was hardly any point for it to continue to exist, even though the St. George Art Society took some time to die.

The Fifteen, founded in 1881, was another progenitor of the Art Workers' Guild. The dominant figures in it were the designer Lewis F. Day, whose idea it was, and the painter and illustrator Walter Crane. Crane shared Morris's politics, which Day emphatically did not. The membership consisted of painters, sculptors, architects, and designers. George Simonds, the sculptor, who was the first master of the Guild, was also a member of the Fifteen, as were Henry Holiday, Hugh Stannus, T. M. Rooke, G. T. Robinson, James D. Linton, E. F. Brenthall, Sacheverell Coke, J. D. Sedding, H. Arthur Kennedy, H. M. Paget, Henry Page, T. Evert Harrison, and J. T. Nettleship. It met once a month from October to May—the host having to provide both a paper and refreshments. The title was taken from a puzzle of the time and not from the number of members.

Some years later Walter Crane wrote about the English revival of decorative art and the origins of the Art Workers' Guild. He also made a reference to his belief—even more important in the founding of the Arts and Crafts Exhibition Society—in the unsatisfactory character of the Royal Acad-

[32] See John Brandon-Jones, "Architects and the Art Workers' Guild," *Journal of the Royal Society of Arts* 141 (March, 1973), 192-206.

emy: "Up to about 1880, artists working independently in decoration were few and far between, mostly isolated units, and their work often absorbed by various manufacturing firms. About that time, in response to a feeling for more fellowship and opportunity for interchange of ideas on the various branches of their own craft, a few workers in decorative design were gathered together under the roof of Mr. Lewis F. Day, on a certain January evening known as Hurricane Tuesday, and a small society was formed for the discussion of various problems in decorative design and kindred topics, meeting in rotation at the houses or studios of the members. The society had a happy if obscure life for several years and was ultimately absorbed into a larger society of designers, architects, and craftsmen, called 'The Art Workers' Guild.' . . . Owing to the revived activity and demand arising for design of all kinds, the feeling grew stronger, among men of very different proclivities, for some common ground of meeting. . . . We have, of course, our Academy, or, as it ought to be called, guild of popular picture painters, always with us; but its use of the term 'arts' applies almost exclusively to painting, although sculpture, architecture, and engraving are on the programme; and, while absorbing gifted artists from time to time, generally after they have done their best work, it has never, as a body, shown any large conception of art; although it does a certain amount of educational work, chiefly through its valuable exhibitions of old masters, and its lectures in the schools, its influence in the main has been to encourage an enormous over-production of pictures every year and to foster in the popular mind the impression that there was no art in England before Sir Joshua Reynolds, and none of any consequence since—outside the easel pictures. Nevertheless, the work of such fine decorative artists as Messrs. Albert Moore, Alfred Gilbert, Harry Bates, and E. Onslow Ford, is seen there occasionally, and once even it was said a picture by Mr. E. Burne-Jones appeared there."[33]

[33] Walter Crane, "The English Revival of Decorative Art," *Fortnightly Review* 58 (July 1892), 815-816.

The fusion of the designers of the Fifteen and architects of the St. George's Art Society was the logical parentage of the Art Workers' Guild and made it truly something different and a much larger version of the Century Guild. As the papers delivered to the St. George's Art Society tended to be mostly architectural, so papers to the Fifteen were mostly concerned with the decorative arts.[34] The Fifteen too went through the ritual of making Morris an honorary member. These were not empty gestures, however, but indicate Morris's role as a progenitor. No matter that at the same time he had already become increasingly involved in politics and was turning more and more to the left. He wrote to Catherine Holiday, "Will you thank him [Henry Holiday] & say that I am much flattered by being elected an hon. member of the '15 but that I fear I shall seldom or ever be able to attend, as I am getting too old to go out in the evening after my day's work."[35] Morris was now only 49, but he was leading an exhausting life, trying to maintain his business while being deeply involved in socialist politics. His lack of direct participation in these two groups should not be construed as a lessening of his decisive influence. It is entirely logical that both groups should have elected him an honorary member. He had preached the interconnectedness of the arts, and these two groups—one primarily architectural, the other primarily concerned with design—were coming together to create a new organization that would represent the united approach Morris repeatedly urged. The Guild was an unaggressive organization, yet it represents in its subdued way a decisive moment in the spreading of a new approach to design, and a new way of looking at the world.

The more crucial steps in the foundation of the Guild came from the St. George's Art Society. The aim was to bring about the organization they had originally visualized their

[34] Prior, "The Origins," pp. 8-10.

[35] Morris to Catherine Holiday, March 17, 1883, Berger Collection, Carmel, California. She did a great deal of embroidery for Morris & Co., and her husband, Henry, also was active in designing for the firm, particularly stained glass.

own now failing group to be. The object was summarized on November 2 by Newton. "A Society composed of Painters, Architects, Sculptors, and other Artists would tend very much to improve Art, and to found a School of Artists in touch with one another. Architects have much to learn from Painters and Sculptors, and vice versa." (It is notable that designers were still grouped together as "other Artists" when in fact they were what became special about the Guild.) As Macartney remarked on November 13, "a programme of cohesion is needed such as the Royal Academy [only 5 of its 70 members were architects] hardly now suggests, and which the Institute of British Architects [with surveyors as the largest element in its membership] has deliberately rejected."[36] The St. George members spoke to those of the Fifteen as well as to such artists and decorators as W.A.S. Benson, Heywood Sumner, H. H. Macartney. The idea spread, and there was an informal planning meeting in the Charing Cross Hotel on January 15, 1884 which 21 persons attended. Various schemes were considered, such as having exhibitions selected by judges elected by the exhibitors. (Reform of jury systems was a continually considered but rarely achieved aim.) Lethaby was concerned that the society help in the area of decorative arts, particularly in bringing back forgotten handicrafts. He also felt the society should discuss current art and help institute a collection of modern painting. Architects wished to have decorators at hand sympathetic to their work, who would be able to assist them, and to attest to the unity of art. The Guild was also a product of the idealism of comparative youth: a hope that cooperation would triumph over the possible frictions of potentially temperamental people working together. The members—the brothers—could become a source of appointments for one another, and election would be a form of certification, a judgment passed without a need for examinations.

The ideas grew: lectures, tracts, pamphlets, a social club,

[36] Prior, "The Origins," p. 8.

dinners. The architect, J. D. Sedding, who joined in with the younger men far more than Shaw did, fond though Shaw was of them, pointed out that, in his view, architecture was going downhill and needed to be helped by such an organization: "The contents of the Building papers showed how drains and quantity-surveying had usurped among Architects the place of Art." Another architect, Basil Champneys, moved that "it is desirable that an Association should be formed for promoting greater intercourse among the Arts." The motion was seconded by the sculptor George Simonds and was carried unanimously.[37]

A further decision was taken that would have serious repercussions. It was moved by Edward Prior and seconded by Walter Horsley, "that at present the proposed Society shall not aim at publicity." Rather arbitrarily, but emphasizing the architectural theme of the organization, it was decided to exclude musicians, which, considering the exciting development and rediscoveries in English music at the time, somewhat parallel to the work of the members of the Guild, was something of a mistake. Apparently it was never discussed whether or not women were to be members. Since this was to be a professional organization and there were very few women professionals, the issue did not arise; and the organization continued exclusively male until fairly recently. Lewis Day moved that the organization "should consist of all Artists and Handicraftsmen worthy of the name of Artists." Interestingly this was amended in a way that appears to rule out those in the fine arts, although they did to some limited degree become members. The amendment, by Prior, was that the organization "should consist of Handicraftsmen and Designers in the Arts." This statement sounds as if architects were being excluded although that was never brought up. Rather it suggests the members held a nonprofessional view of architects. But it is significant that the original impulse of the St. George's

37 Ibid., p. 10.

Art Society—suggesting a possible rivalry with the Royal Academy—was here curtailed.

William Morris was inevitably the dominating background figure. Horsley suggested that Morris be consulted. Presumably he would have been both mildly encouraging and mildly discouraging: his great interest was now in politics, and he was not hopeful about the effectiveness of such an organization. The idea was never actually put to him, but it was significant that it should have been an early consideration. Those younger men would always be conscious of the man to whom they were considerably beholden for the very idea of the Guild. Restless as he was and not directly active in such plans, Morris was nevertheless a major force behind them. Although he himself never built a building and only studied architecture for nine months, the importance of architecture as the encompassing art dominated the origins of the guild as it dominated Morris's decorative thought.

The next organizational step was the formation of a sub-committee to consider what was to be done. It consisted of John Belcher, who had chaired the meeting, Benson, Day, Lethaby, C.H.H. Macartney, Mervyn Macartney, Newton, Simonds, Thornycroft, Wirgman, with Horsley acting as secretary. The committee, with Simonds as chairman, met on January 28 and February 8 and 15. Belcher suggested that it be an organization of younger men, with older men as advisors. But that would be rather futile and might have too much the suggestion of tutelage. A second formal meeting was held on March 11, with Simonds as chairman. The first name suggested for the group was "Society of Art-Craftsmen." The organization was to honor craft but the hyphenated term was regarded as too restrictive. Sedding suggested that it be called a guild. Given his religious nature, he probably liked the medieval echo.

There had already been the Century Guild, and Mackmurdo would almost certainly try to claim some sort of credit for this new development. Although not involved in its plans (nor present at the early meetings), he nevertheless wrote in

his memoirs, "On the 15th of January 1884 these architects and craftsmen met together, and in a serious mood but festive manner they took the oath of allegiance to the Sovereignty of Art, banding themselves together after the fashion of the medieval arts works into a Guild. . . . The central idea dominating this association of architects, painters, sculptors, metal workers, decorators, etchers, lithographers, etc. was an idea identical with that which had led to the banding together of the architect [sic], the artists and craftsmen who worked around William Morris as a brotherhood. It was also identical with the idea which led to the working association known as the Century Guild of artists."[38] This was not quite an accurate presentation of how William Morris operated. But such a statement suggests how present was the cooperative way of thinking about artistic endeavours.

"Guild" sounded a responsive note in the group, and Belcher, supported by Somers Clarke, suggested the name "Guild of Associated Arts." This would have the broadness and brotherhood desired. Benson gave the title a more antique ring by suggesting the "Guild of Art-Workers," while Day, more modern and practical, suggested simply "The Art-Workers." Finally the imaginative Prior (his houses tended to have a rhythm of three) put forward the title that was adopted and that has lasted until this day: "The Art-Workers' Guild." (The title has been somewhat simplified, perhaps to be made typographically more pleasing, and it has now lost its "the," its hyphen, and its apostrophe.) The society was to consist of "Handcraftsmen and Designers in the Arts"; there would be practical demonstrations of various arts, social gatherings, papers, and small exhibitions; the purpose would be a free exchange of information and views. With the selection of a name the Guild had now come into formal existence. G. Blackall

[38] "A History," pp. 224-230, WMGW. Characteristically he went even further in a letter to Pevsner: The Art Workers' Guild was "a movement of much larger range than that I started in the Century Guild, which gave them [Lethaby, Macartney, Horsley] the idea." A. H. Mackmurdo to Nikolaus Pevsner, January 1, 1941. *Architectural Review* 132 (July, 1962), 60.

Simonds became the first master, although that title—with its nice medieval connotations—did not actually emerge until 1887.

What was the aim of the Guild? Walter Crane, the third master, remarked in a vague way that "the Guild is a true fellowship of the Arts—men of all crafts meeting on a common ground." The Art Workers' Guild was certainly a more important enterprise than the Century Guild, which owed more to the Aesthetic movement of the 1870s, even though the greatest influence upon it was Morris. It was a much larger-scale fusion of decorators and architects, and it was not dominated by one figure. Although the architects from Shaw's office were the moving force in the founding of the Guild, the decorators tended to be its officers. It is the group of Shaw's students (even excluding May) of Lethaby, Newton, Prior, Macartney, and Horsley who are given credit for the founding and commemorated in golden letters in the Guild's Hall in Queen Square. They did provide continuity, as Macartney and Horsley were honorary secretaries from 1884 until 1897 and Horsley continued in the position until 1902.[39] Still, this seems a little unfair to the many others involved in the planning meetings and to the Fifteen. Is it yet another example of the allegedly major arts pushing out the minor ones? It was this particular group of architects who had called the meeting for January 15 "for the purpose of getting opinions from other artists as to whether it would be possible to form a Society or Association of Artists of every kind."[40]

The early masters were drawn from the ranks of the Fifteen. The first, Simonds, was called chairman, then president, then warden, and finally master; the members were to be brothers. The second master was the architect J. D. Sedding who was committed to the total craft ideal, as is evident in his most notable building, Holy Trinity Church, Sloane Square. C. R. Ashbee, who didn't like the building, remarked about it: "I

[39] I owe this point to Alan Crawford.
[40] Minutes of the Art-Workers' Guild, 1884-1885, p. 9.

never felt quite at home in what was considered his master-piece. . . . Though I appreciated the Guild spirit that inspired it."[41] From 1888 to 1890 Sedding used members of the Guild—realizing its purpose—to create this highly successful building: "the most important church of London for observing the liberating effect of the Arts and Crafts movement on ecclesiastical architecture."[42]

Membership to the Guild was by election. It is surprising how many of its members were painters, considering the origins of the Guild among architects and decorators, its animus against the Royal Academy, and its self-conscious differentiation from it. At this time, reaction against the Royal Academy was particularly intense. It was felt that the formal aspects of English society were stultifying. The Arts and Crafts organizations as well as the political and other artistic organizations being formed were attempts to break free, to change the direction of English society, to redesign it in all its aspects. For instance, the New English Art Club, founded in 1886, also arose out of a dissatisfaction with the procedures of the Royal Academy: most particularly that its juries were imposed from above rather than selected by the membership. It consisted of painters who had studied in France and hence were more cosmopolitan than the Art Workers' Guild (whose members, if anything, became influences abroad rather than being influenced by what was happening outside of England). The Club and the Guild, like the Academy, were elitist: their membership was not open to all. But within the organizations they were run more democratically and were more flexible and imaginative than the official organizations. The painters of the New English Art Club, most of whom had trained at Julian's studio in Paris, were interested in "values" in a paint-

[41] C. R. Ashbee, carbon of typescript from Ashbee Journals, "Masters of the Art Workers' Guild from the beginning til 1934, n.d. (?1935), p. 270, Art Workers' Guild Archives. Pevsner calls the church "the most enjoyable church of the 'nineties in the whole country." "The Late Victorians and William Morris," p. 218.

[42] Nikolaus Pevsner, *London II* (London, 1952), p. 42.

ing: the relation of tone and color. They were reacting against the emphasis on narrative painting and in fact marked its comparative decline in England. Eventually they were absorbed into the establishment, as their more prominent members became members of the Royal Academy: Sargent in 1897, Clausen in 1898, Orpen in 1910, Shannon in 1911. As early as 1877 the opening of the Grosvenor Gallery had marked a rebellion in an aesthetic direction against prevailing taste, as did the opening of the New Gallery in 1887. The New would serve as the exhibition space for the New English Art Club as well as for the Arts and Crafts Exhibition Society. The Club and the Guild members were against the oligarchic nature of the English art establishment: its accurate reflection of the nature of English society as a whole. Both organizations were conceived somewhat in terms of a studio, where equals would gather together and exchange ideas and views, not as hierarchical organizations.

By May 13, 1884, the Art Workers' Guild's original group had elected 50 members, all committed to the craft ideal. By the time of the first annual meeting on December 5, 1885, there were 26 painters, 15 architects, 4 sculptors, and 11 various craftsmen. In 1885 there were 66 members: 30 painters, 18 architects, 5 sculptors, 3 designers, 2 metalworkers, 1 weaver and dyer, 1 wood engraver, 1 engraver, 1 goldsmith, 1 potter, 1 woodcarver, 1 bronze founder, and 1 paperhanger. In 1886 there were 71 members, increasing in the next years to 92, then 115, then 136, then 150. In 1895 there were 182 members, of whom 52 were architects and 50 were painters.[43]

The stand against the Royal Academy and the Institute of Architects was quite specific, and although there were obviously many painters and architects who were members of the Guild, they were subsumed under the category of craftsmen. They were "neither oil-painters of the Academy nor Surveyors of the Institute but craftsmen in Architecture,

[43] Massé, *Art Workers' Guild*, p. 113.

Painting, Sculpture, and the kindred 'Arts.' "[44] The Guild did discriminate against women, amateurs, and musicians, although makers of musical instruments have been members of the Guild. Prominent painters joined over the years, among them Edward Poynter, Augustus John, Lawrence Alma-Tadema, William Richmond, and Roger Fry. Other leading artists who were members were George Clausen, Solomon J. Solomon, and Hamo Thornycroft, but they did not set the tone. The percentages of the members for the period 1885–1889 were: 38 percent painters, 31 percent architects, 17 percent craftsmen, and 6 percent designers. Almost all of the members were from London.[45]

In some respects the number of members, or even the divisions among various fields, is not crucial. The existence of the Guild was the important factor. In the world of politics, comparably, the numbers in the Social Democratic Federation and the Socialist League were small, but their effect was considerable in making the ideas of Marx better known in England and advancing the socialist cause. Although the Guild was deliberately nonpropagandist, it had a permeating effect on many aspects of the art and design world of the time both in England and abroad. Its influence helped move design away from Victorian complexity to simpler structures and initiated an attempt to understand objects. It would be hard to sum up the beliefs of such a large group, but presumably they adhered to the Ruskin-Morris ideas of the sacredness of work and the attempt to make objects true to their material and their purpose.

The architects in the Guild were looking for craftsmen who would assist them in their buildings. The craftsmen were seeking to affirm their own significance and independence. Despite the crucial role of the St. George's Art Society, its position as the official founder and the initial dominance of members from "grander" arts of painting, sculpture, and ar-

[44] Crawford-Walker Lecture.
[45] Ibid., p. 3(2).

chitecture, it was the craftsmen who stamped their image upon the Guild. Often the meetings focused on a demonstration of a craft rather than a discussion of an architectural style, although most of the meetings were talks on architecture, painting, and applied arts. As the Second Annual Report stated: "The Guild was formed for the purpose of bringing into closer union all classes of Art Workmen, and for the furtherance of practical knowledge of various crafts."[46]

The first regular meeting of the Guild was on June 10, 1884. The chairman, Simonds, gave a talk on modeling. The first annual general meeting was on December 5, 1884. Up until 1914 the Guild had temporary rooms at various places including Barnard's Inn and then at Cliffords Inn. Finally it settled at 6 Queen Square, where its meeting room is decorated with portraits of past masters and the names of members. As the official history of the first fifty years of the Guild notes, it was particularly appropriate that the building should be in Queen Square. Morris lived from 1865 to 1872 at number 26, and his workshops were there even longer.

Ironically it took some time before Morris himself was elected to the organization: he did not seek election, and as he was in his most intensely political period, he hardly had the time. But he was elected in 1888 when Walter Crane was master. Perhaps the members hesitated as it appeared to be an organization for younger men: Norman Shaw never joined, and Philip Webb declined honorary membership in 1892. The average age of the members was probably in the low 30s. On February 19, 1888, Morris had given an address to the Guild on the origins of ornamental art. There is a persistent story that when he was elected as a member on November 2, 1888, there were so many blackballs that the scrutineers suppressed that fact. The story may not be true, although its existence may reveal a certain ambivalent feeling in the Guild about Morris, mixed feelings about its obvious progenitor as well

[46] The 2nd Annual Report, p. 3, Art Workers' Guild Archives.

as dislike by some of his politics.[47] Morris did not hesitate, unlike others of his generation, to accept membership and, in fact, was interested, not surprisingly, in making the Guild more publicly active. On November 28, 1890, he spoke on gothic illustrations in printed books, maintaining his interest in aesthetic matters at a time while still giving innumerable political speeches. In fact his aesthetic concerns were now turning toward the adventure of the Kelmscott Press.

Guests might come to its meetings from the very beginning, but there weren't many "strangers." The Guild's proceedings were private, and there was little publicity about them. On December 4, 1885, it had been agreed not to publish its proceedings. The Guild was aware that it could be an important voice, and it had to decide how to play its role.

Although the Guild had several small exhibitions, it determined not to do so on a large scale, even though its exhibitions were quite important in its early years. The Arts and Crafts Exhibition Society was formed particularly for that purpose in 1888 as a separate organization. In 1885 the proposed program for the Guild consisted of two papers and six exhibitions. But the Guild rapidly moved toward an increase in the number of papers and demonstrations, and fewer exhibitions. It was also connected with The National Association for the Advancement of Art and its Application to Industry.

William Martin Conway, the Roscoe Professor of Art at Liverpool University, was the moving spirit in the formation of the National Association. He was in touch about it with various artists and designers who were members of the Guild. He also corresponded with the Guild as a group—an indication of how rapidly it had established itself. The committee of the Guild took note of the circular it had received from Conway on May 10, 1888, and invited him to attend their meeting on June 1, at which point Conway asked members of the Guild to attend the first meeting of the Association in Liverpool in December.[48]

[47] Massé, Art Workers' Guild, p. 71.

[48] See Joan Evans, The Conways (London, 1966); Peter Stansky, "Art,

Papers were given at the Liverpool meeting by seven members of the Guild—Crane, Sedding, Simonds, Brett, Robinson, Morris, and Gilbert—and they were to be redelivered to the Guild in London. That year, in his annual report as master, Walter Crane remarked that the Congress in Liverpool represented a triumph for the views represented by the Guild: "It struck me as a remarkable thing at that Congress, that the view of Art (and the assertion of its essential unity) which we may take our guild to represent—the claims of Architectural art covering the arts and handicrafts in their true relations may be said to have won all along the line. The importance of the Arts and Crafts, and the close relation of designer and workman was [sic] generally acknowledged, and the fact of their severance in our industrial century generally deplored and felt to be one of the chief reasons of the decline in all applied art. It is an interesting and important fact that no less than one third [?] of the papers were read by members of the Art Workers' Guild." Crane in his next annual report (he was the last of the two-year masters) remarked, "I should like, too, to include the actual workman among us."[49] Here was Crane's socialism appearing. Although many of the guildsmen did practical work, there were not many or any actual laborers in the Guild. Crane had in mind a wider unity than contemplated on the shield of the Guild—a combination of the Guild and the Socialist League! He remarked that in Liverpool the ship of the Association was launched, as "we have long ago launched and christened our Guild: long may our good ship float upon the waters of fellowship, and influence for good."[50] On March 15, 1889, Sedding and Simonds repeated the papers they gave in Liverpool, and on May 17 Crane read his paper. During 1889 there were 21 meetings of the Guild, which at this time numbered 136 members.

The Guild also became somewhat involved in one of the issues that lay behind the formation of the National Associ-

Industry, and the Aspirations of William Martin Conway," *Victorian Studies* 19 (June, 1976), 465-484.
[49] Annual Address, December 6, 1889, p. 13, Art Workers' Guild Archives.
[50] Annual Report, pp. 11, 15, Art Workers' Guild Archives.

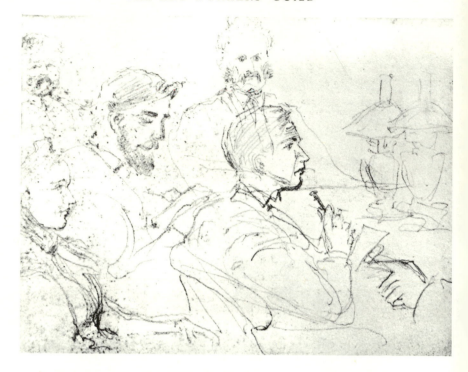

8. Christopher Whall, "Pages from a sketchbook, showing William Morris (second from right) and others at the Edinburgh Congress of the Natonal Association for the Advancement of Art and its Application to Industry, 1889."

ation. Conway had stated, in, I suspect, a frivolous moment, that one reason the Association had been founded was to fight the Liverpool city fathers over their opposition to the nudity of one of the bas reliefs by T. Stirling Lee planned for the decoration of St. George's Hall in Liverpool. (Lee was a member of the Guild and became its master in 1898.) He reported by letter to the meeting of the Guild on April 11, 1890, that Philip Rathbone, of the great Liverpool family, had offered to pay for the finishing of the sculpture "and that he had been

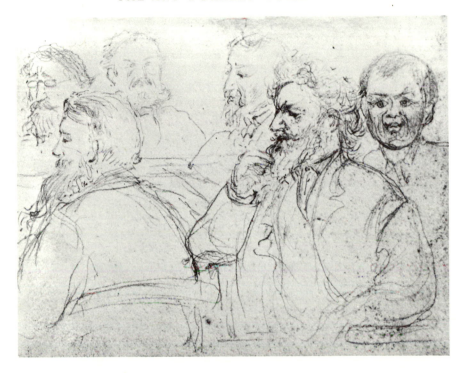

induced to make this offer mainly through the action taken
by the members of the Guild."[51]

The Guild was now at a very interesting juncture in its
fortunes and was tending to become more public in its activ-
ities: this situation shortly came to a crisis. Some argued that
since the Guild was a representative body of the advanced and
progressive in the art world, it should take stands on public

[51] Minutes, April 11, 1890 (1889-1890 minute book), Art Workers' Guild
Archives.

issues even though its original intention was to be somewhat private. It was expanding its physical activities. There was an annual country meeting—an expedition to some appropriate spot, and eventually it began to organize trips abroad for its members. But these were internal events, and the question was whether it would attempt to pronounce on issues and to influence events on a national scale.

Its meetings were not reported in the press. Members of the Guild could feel free to speak their minds. They took themselves seriously and felt that they were engaged in important work. But how public should they make their thoughts?

In 1890 the Guild began to flex its public muscles, but it was not a satisfactory experience. It considered whether it should take steps against public advertisements but withdrew from any further corporate action at this point. John Brett, the master that year, was distressed at what he considered the weakness of the Guild in contrast to a resolution against advertisements taken at the meeting of the National Association for the Advancement of Art at Birmingham at the end of 1890. Brett used his position to castigate the Guild: "Thus we see the spectacle of a Guild which, though comprising within its fold a large selection from the rising artistic talent of the day, yet has so little of definite purpose that it confirms the worst that has been said of the unbusinesslike character of the artistic temperament. When a great opportunity for practical efforts arises, it hastens precipitately to conceal itself."[52] The Guild returned to the issue at the end of 1892, at the end of Morris's mastership that year. On December 16 it had a special meeting. On a motion made by Brett and seconded by Lethaby, it was decided to form an Anti-Advertising League. But as far as we know, nothing further was heard about this matter. At the next meeting, on January 6, 1893, there was a return to more mundane concerns, the crisis of members losing and exchanging umbrellas. It was recommended to "members to bring old ones to the guild in future."[53]

[52] Massé, *Art Workers' Guild*, p. 50.
[53] Minutes, 1893-1894, Art Workers' Guild Archives.

Despite its belief in privacy, a sense of crisis about what was happening to the "built and decorated" world drove the Guild to feel that it should be more outgoing in its activities. Perhaps this was in part because 1890 had marked the last annual meeting of the National Association for the Advancement of Art. That national platform would be no longer available. On October 21, 1891, an education committee report by Heywood Sumner, Selwyn Image, and Reginald Blomfield, recommended that the Guild should seek out issues on which it might wish to express itself. The upsets to society such as the dock strike—the culmination of a restless decade—emphasized that England was facing problems of a new sort, an inescapable truth recognized in the Guild, even by Blomfield, one of its most conservative members (he resigned from the Guild in 1894, perhaps in part because he felt it was becoming too politicized, nonetheless he had joined in this recommendation of 1891). And even before then despite its commitment against publicity, the Guild had taken a few stands on issues of public interest. In February 1890, for instance, it had written a letter to the London County Council protesting the destruction of Emmanuel Hospital.

The internal dangers for the Guild of taking action had been made abundantly clear in 1891. On December 5, 1890, Mackmurdo had launched a campaign against the mosaic decorations in progress in the chancel at St. Paul's and called for a public meeting of the Guild. Mackmurdo tackled the matter with his customary vehemence, to such a degree that a past master, the highly regarded J. D. Sedding, objected to the "general personal tenour of his remarks" and added that in his opinion the work at St. Paul's was "in the hands of competent and responsible men."[54] The situation was acutely embarrassing. William Richmond was doing the work to which Mackmurdo was objecting. Not only was he a member of the Guild, but he was its master for 1891. The motion was withdrawn, but Mackmurdo returned to the fray on January

[54] Minutes, 1889-1890, Art Workers' Guild Archives.

9, 1891. Members of the Guild were not alone in having doubts about the mosaics—their design and installation were both the "magnum opus" and the most troubled aspect of Richmond's career. When the plan was announced, there was a great outcry against putting them in a Renaissance building. But Richmond claimed that Wren himself had intended to use mosaics, and that they were needed to cheer up the internal gloom of the building. Richmond perhaps carried Guild-like xenophobia a little too far in that he decreed that only British workmen could work on the project and declined to use the famous Venetian firm of Salviati's, which had done much work in England and would presently do the mosaics for the chapel at Stanford University in America. Also, he stipulated that no trade union members were to work on the project, although the well-known labor leader John Burns was a model for one of the figures. Richmond worked on the mosaics for eight years and received a knighthood at the end—which he regarded as a "barren honour."[55]

Such a controversy threatened to split the organization and hardly supported the friendly implications of the motto "Unity of Art." On the other hand the Guild was launched to encourage the frank expression of opinions within its walls. Blandness would result if controversial issues were avoided. The members compromised and decided to send a subcommittee to visit St. Paul's. Hence, this potentially extremely divisive discussion was postponed for three months, on a motion carried twenty to sixteen. The Guild was placed in an awkward position by such disputes. Either it was likely to have discussion in which members attacked one another's work, or if it took a position against work being done by non-Guild members, it would look as if it wanted the work for its own. But it might be appropriate for it to express views, should it so wish, on what it regarded as ill-considered steps taken by public bodies. In the case of St. Paul's, the issue seems to have evaporated or have been quietly dropped.

55 See A.M.W. Stirling, *The Richmond Papers* (London, 1926), pp. 378-400.

That same year the Guild protested successfully about the demolition of the gateway to Lincoln's Inn.

Despite the evident dangers of taking public stands, the Guild, at its meeting of April 17, 1891, expressed the view that it should be more active in shaping public opinion. At the meeting of July 17 it was decided that the editorial committee should sign its opinions so that they would not give the impression of being *ex cathedra* statements from the Guild. This was a close decision at a poorly attended meeting: nineteen to twelve.

Eighteen ninety-two was the year of Morris's mastership. It was a fairly active year for the Guild and reflected some of Morris's concerns. He came to speak at the meeting of November 20, 1891, on the influence of building material on Architecture, a talk published the following year in *The Century Guild Hobby Horse*. It was at this meeting that he was announced as master for the following year. There had been a ballot on November 6 at which Morris received 45 votes, G. T. Robinson 25, and J. M. Swan 19. (The membership now stood at 168.) A committee of past masters selected from among the top three, and on the basis of numbers and distinction, they selected Morris. Perhaps Morris should have refused the position; he was extremely busy with the Kelmscott Press, and his health was beginning to decline. The number of public speeches he was giving lessened notably in these years. The previous masters had been very conscientious in fulfilling their obligations; in contrast, Morris took the chair at only three of the twenty meetings held during 1892 and at only four of the many committee meetings. The official reason was that he was so often down at Kelmscott Manor in the country. Perhaps as an indirect comment on Morris's delinquency it was decided at a committee meeting on October 25, 1892, that if a member missed three meetings without making excuses, he would no longer be considered a member. During his mastership there were excursions to his factory at Merton Abbey on July 1 and 15 and talks on the history and revival of craft guilds. These excursions and talks were of

course particularly appropriate to Morris. He did not have the time, energy, or inclination to politicize the Guild, but he had not changed his beliefs, nor had he lessened his commitment to the relationship of art and politics.

During Morris's mastership, there was a discussion on February 1, 1892, about writing articles to the press. The following year, in January the Guild returned to the question of outdoor advertisements and created a committee to look into the question.

In 1893 there was almost a replay of the Mackmurdo situation; this time caused by Morris himself. He would not allow issues of tact to prevent him from doing what he thought was right, particularly when it concerned his beloved city of Oxford. A battle had been going on for some time before Morris felt constrained to attempt the tactic of bringing the question to the Guild itself. At the end of December, 1892, Thomas Jackson, the eminent architect and the creator of many major late nineteenth-century buildings at Oxford, had sent to the *Times* the exchange he had had with the Society for the Protection of Ancient Buildings about the restoration of the statues at St. Mary the Virgin, the parish church of Oxford (Figure 9). Anti-Scrape, of which Morris had been the principal founder, was against the restoration of the fourteenth-century statues, feeling that either they should be left as they were, with perhaps some patching, or else removed. Jackson denigrated this position, pointing out that parts of the statues were only forty years old and that the older parts "continue to shed their heads, hands, and other members."[56] The correspondence continued, with Thackeray Turner, the secretary of the Society, replying on January 3, and answers and counteranswers appearing on January 5, 9, and 10. On February 7 Turner reported that two members of the Society had examined the statues and reported that in the opinion of the investigators the statues could be protected without being restored or replaced by copies. Later on there was an inves-

[56] *Times*, December 28, 1892.

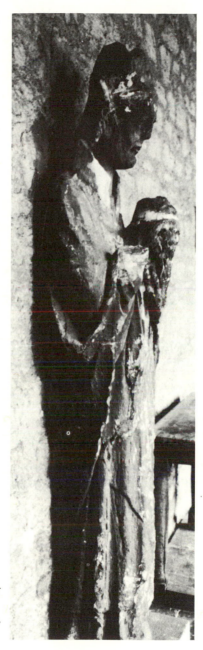

9. "Statue from the tower of St. Mary's, Oxford, now in the Cloister of New College, Oxford."

tigation carried out by Morris and William Richmond, the villain in the St. Paul's episode. They visited the church, as described in Jackson's memoirs; naturally he emphasizes that Anti-Scrape's solutions either to bind the old statues by iron or to string up nets to catch the falling pieces were unreasonable. Richmond did not dare to climb out to look at the statues, but Morris walked around the outside. In May he came to the Oxford Convocation to plead, unsuccessfully, for what he called his "ragged regiment." Jackson claimed that Morris was surprised at how much of the work of the statues was modern but if so the Society did not share this belief as recorded in the *Times*.[57] Convocation having proved unsuccessful, Morris turned to the Guild.

The fight about the church spire became quite intense, and Jackson was attacked on both flanks, as Thomas Case, a formidable Oxford figure who, although an ardent disciple of John Stuart Mill, was opposed to almost all local change (such as the admission of women and the abolition of Greek as a requirement of entry to the University), disapproved of Jackson's plans for the pinnacles of the spire, and published in 1893 a book on the church, *St. Mary's Clusters*. As part of his fight he took up the cause of the statues and reprinted in his study the report on them issued by the Society for the Protection of Ancient Buildings, which was quite passionately on the side of the figures: "The original faces are magnificently wrought for distant effect, and it is most remarkable that the whole design and gesture of these great and important figures still remain to us in spite for their having been exposed to the weather for five centuries. . . . There seems to be no possible danger of any of the whole figures falling. . . . All the original stone is in a remarkable state of preservation. . . . Ancient free standing statues in exterior niches, so frequent in France, are comparatively rare in England. It may be fearlessly stated

[57] T. G. Jackson, *Recollections* (London, 1950), pp. 234-235. Turner succeeded Morris as secretary in 1883. He was an architect, a partner of Eustace Balfour, A. J. Balfour's brother.

that this series of ten heroic-sized figures is second only to those on the west front of Wells Cathedral. . . . They are the chief glory of the ancient architecture in Oxford; they may be left alone for future delight, or they may now be destroyed."[58]

Whether because of all this fuss or not, Jackson in fact modified his position. In the history of the church that he wrote in 1897, he places the blame for the insistence on slavish imitation upon the university, and indicates, which he did not dwell upon in his reminiscences, that his wishes were in fact consistent, although he does not say so, with part of the attitude expressed by Morris and Anti-Scrape. Anti-Scrape believed that the statues could be saved; but if they couldn't, then new statues should be put in the niches that might share the spirit of the originals but were not to be slavish imitations. Seven statues were as closely reproduced as possible; Edward II, Hugh of Lincoln, St. Cuthbert, two bishops, and two archbishops. One statue was kept from the fourteenth century, an archbishop, and three statues were completely new: Walter de Merton, St. John the Evangelist, and St. John the Baptist. These were done by a highly regarded sculptor of the period (and in 1902 master of the Guild), George Frampton. Jackson's comments in the history of the church reflect the practical man's irritation at a do-good group. Nevertheless he inadvertently suggests that Morris's pressure and the role of the Guild may well have changed his attitude and the final result. The statues taken down from the spire were placed in Congregation House on the side of the church and then were removed to the cloisters of New College, where they are now.

Jackson vents his anger at Morris, although not by name, and his supporters in his history of the church. He points out that the statues were in any case badly repaired in 1850-1852. The ancient statues were made out of Burford oolite; Jackson implies that it is rather impressive that they should have survived as long as they did. He agreed with Anti-Scrape that

[58] Thomas Case, *St. Mary's Clusters* (Oxford, 1893), pp. 16-18.

the sculpture was of very high order, and he clearly speaks with deep personal feeling when he wrote, "Even if he disregards, as he had better do, the well-intentioned but hysterical outcries of societies and individuals who shrieked whenever an old building is touched, without staying to inquire what reason there is for touching it, and who never scruple to set their mere emotions and imperfect information in the balance against the matured opinion of those whose business it is to inform themselves of every circumstance, the architect has himself to satisfy before he proceeds to extreme measures." Jackson then put forward his belief of the danger of the statues falling apart and parts of them falling on passersby: "All these considerations, which go for nothing with the mere sentimentalist, have to be taken seriously by a responsible adviser." He disagreed with Morris and Anti-Scrape that the statues, other than one, could be saved. He claimed that he did adopt the next position held by Morris: that if the old were not preserved, then wholly new work should be done. Reproduction was to be avoided as the worst solution to the problem of preservation. Jackson wanted, he says, all of the statues done in this modern manner, but he was overruled by the Oxford authorities. They only allowed him to follow his plan in the case of three statues that they felt were so hopelessly decayed that they could not be reproduced. These were the figures done by Frampton. As Jackson commented: "The new figures [were] as good artistically as modern art can make them, not copying the mannerism of the old work, though preserving its general feeling and of course paying due consideration to the surrounding architecture. This however was overruled [for the others], and though greater freedom of design was allowed in the case of [the Frampton figures], which had no ancient authority, the University decided that the other figures should be copies of the old."[59]

This dispute appears to be rather emblematic of the nature of restoration and preservation debates during the period,

[59] T. G. Jackson, *The Church of St. Mary the Virgin* (Oxford, 1897), p. 161.

although apparently in this particular instance Morris was wrong and Jackson was right. Jackson was probably a much better judge of the state of stone than Morris, and the present condition of the statues in New College seems to suggest that they would not have lasted if they were left up on the spire.[60] But Morris was not content to let the battle go, and he brought it to the floor of the Guild. On June 2, 1893, he proposed a motion against the removal of statues. The awkwardness was that Jackson was a member of the Guild and was to be its master in 1896. Morris did accept a softening of his motion, and the removal of the phrase "deprecates their removal emphatically." If the motion were passed, Jackson would probably have resigned from the Guild. After many amendments and much discussion, the softened amendment was postponed and apparently never resurfaced. Philip Webb commented on the meeting in a letter to Morris: "I have gathered from Cockerell and Lethaby that the outcome on Friday evening at the A. W. Guild was a flat compromise to avoid breaking of heads.[61]

Despite this long and rather protracted fight Jackson did not allow it to sour his relations with Morris. He refers to this incident mildly in his autobiography while expressing admiration for Morris. In his *Recollections* he records a visit in 1893 when he called on Morris at Kelmscott Manor: "This I think was almost the last time I ever saw him. It would be difficult to over-estimate the influence he has had on English decorative art. That it is as easy now as it used to be hard to get beautiful wall-papers, chintzes, and hangings for our houses is due entirely to the impulse given by Morris. . . . Morris's Gothic work lives, while that of the mock-medievalist is as dull as ditch-water and as dead as a door-nail."[62] This is a wonderfully ironic passage, even in its use of clichés; Morris and his associates were accusing Jackson in his support for a

[60] Opinion of Michael Black, Spring, 1979; letters from Robert Potter, June 8, 1979, and Lawrence Stone, July 6, 1979.

[61] Philip Webb to Morris, June 5, 1893, f. 38, Victoria and Albert Museum.

[62] Jackson, *Recollections*, p. 247.

modern reproduction of the statues (which was in fact what ended up at St. Mary's) of betraying art—that reproductions are of neither time, but empty gestures to the past. In his lecture on the aims of art, Morris talked of the false piety, the easy assumption of restoring the past that would in fact betray the real aims of art. Jackson could see what Morris had done, but could not apply the message to himself.

Morris may well, through his motion, have been protesting against what he regarded as the vandalization of Oxford. Jackson, as an architect, represented the move in the late nineteenth century to return to a greater commitment to historical styles, in a milder form than had been true before the influence of Shaw, Webb, Street, and Morris. This went against the belief in the comparative styleless "vernacular" ideal (with Gothic roots) of the Arts and Crafts movement. Nikolaus Pevsner with his allegiance to the movement and to the International style, both of which Jackson was, in effect, opposed to (although he was a more competent architect than many) commented on Jackson's work: "By this time 1882–83 *Sir Thomas G. Jackson* had already set his elephantine feet on many places in Oxford. From the moment he won the competition for the Examination Schools in 1876, the Gothicists of all shades and all those who believe in William Morris's message must have known that Oxford would never be the same again. There they were preaching restraint and refinement and the virtues of the medieval past, and here a new architect was putting up a huge building right in the High Street, and bigger still towards Merton Street, who felt all that to be only a straightjacket and proclaimed levity and license—license to mix motifs from anywhere between the Italian Quattrocento and the Georgian, but with a special gusto for Elizabethan and even more the impure English mid C17, i.e. classical motifs treated unclassically. . . . Anglo-Jackson the impudent results have been called. Yet there was a tremendous panache in the way he handled big jobs."[63]

[63] Jennifer Sherwood and Nikolaus Pevsner, *Oxfordshire* (London, 1974), p. 59.

The protests that the Guild felt it could make were private, and it continued to take an interest in preservation matters. In 1896 it considered having one of its members stand in its interest for election to the newly constituted London County Council. Jackson, as master that year, ruled that such a step would be an unwarranted departure. The Guild developed the tradition that any stand it was to take would not be public. In April, 1899, despite the fact that the work had been done by a past master, the Guild finally did make a private protest to St. Paul's about the mosaics. A resolution was passed "that some action be taken by the Art Workers' Guild with reference to certain changes in the character and structure of the building made by the decorations now in course of execution in the Cathedral."[64] In May a resolution was passed that the mosaics were injurious. But it was firmly established that nothing was to be said in the press.

The Guild was significant in bringing various artists of different pursuits together. Membership in the institution it-self became useful as members would turn to brothers to assist them. There were divisions of opinions within its ranks, but there was much more exchange of information and views than would have been possible without the Guild. The Guild was not monolithic, and it certainly did not adhere to all or even most of the views of William Morris. It had no political stand; although it had some sense of public obligation, it was willing to operate only in a private and fairly limited way. The Guild reflected a belief that the world as it was seen was not satisfactory. The members wished to do something about it. Its founding was part of a profound unease about the state of art, building, and design in England at the end of the century. In its quiet way it was a powerful force in modifying the state of those activities, and in moving toward a "plainer" style. It played an important part in the birth of the Modern movement, even though most of its members would reject such an idea. In their thinking, rather than in their doing,

[64] Massé, *Art Workers' Guild*, p. 50.

they were firmly opposed to new trends—one indication being the hatred many of them had for Art Nouveau. The Guild members were in the grand tradition of English innovators—conservative in many ways, and firmly believing that they were returning to older essentials, to a form of "naturalness." In the process the Guild provided part of the platform from which others—notably foreigners—could leap forward into a Modern style. It had a belief in a "stylessness" in which the materials could express themselves and there would not be a slavish imitation of a past style. As W. R. Lethaby remarked in 1915, commenting on Hermann Muthesius' study of the English house and the "free architecture" of the period: "Then, just as our English building became real, or at least very, very nearly real, a pusillanimous reaction set it, and again the old styles emerged out of the catalogue of styles."[65]

The Guild gave birth to various other organizations of which the most notable was the Arts and Crafts Exhibition Society. But there was also an Art Workers' Guild formed in Liverpool that had a small joint exhibition with the Art Workers' Guild itself at the time of the Liverpool Conference. In 1910 there was the illegitimate use of the name by an organization in Christchurch, Hampshire: "It was not what it pretended to be, and had to be written to very firmly."[66] There was The Women's Guild of Art, the Junior Art Workers' Guild, and similar organizations in Birmingham and Edinburgh, significantly enough cities in which the National Association had met.

Ashbee, looking back in 1938, had a somewhat mixed re-action. He saw men at the end of the century caught between individualism and some attraction for socialism. From his point of view, the Guild represented a striving toward a conception of a workshop. Yet the intense individualism of the time (of which he himself might be said to be an example)

[65] Quoted, no source given, by Julian Poesner, in the preface to Muthesius, *The English House*, p. ix.
[66] Massé, *Art Workers' Guild*, p.29.

made it hard to operate in the slightly collectivist way implied by the very conception of a Guild. Even though those who in theory were most receptive to some sort of collectivist behavior, such as that suggested by the idea of the Guild, and the beliefs of the radical and Marxist organizations to which a few of them belonged, they were still, in the English tradition, individualists determined to go their own way. In this sense, Morris too was a profound exemplar of the tradition.

The Guild's members, leading men in a whole range of artistic fields, cooperated more than they would have otherwise, but the dreams that the leaders of the Arts and Crafts movement held were not realized. The guilds they helped to found frequently ended in comparative failure, which may account for the somewhat querulous tone that enters into the unpublished writing of Ashbee and Mackmurdo. As Ashbee wrote bitterly: "The essential discovery of those men,—their contribution to the social and economic endeavours of their time, was that the unit was not the individual designer but the workshop. Great figures individualists first, not guildsmen. . . . They looked at their craft from the point of view of the individual designer,—not as one of a group whose craft is a common touch. This was true of Morris." It is extraordinary that he should rather turn on Morris in this way, but Ashbee himself was ironically a great individualist who nevertheless was dedicated to a group idea. As Ashbee went on: "For the earlier Masters this individualism was inevitable. They and their generation were adventurers in the uncharted sea of Victorian commercialism."[67] The Art Workers' Guild became in its time, as in the way of most such organizations, less progressive. It was never particularly concerned with what was happening outside of England, although many of its members were interested in older European styles. Quite a few of the guildsmen had elements in their work that we would now call Art Nouveau; yet they were practically unanimous in attacking a style that they regarded as an "insidious

[67] Ashbee, "Masters of the Art Workers' Guild," p. 60.

disease." Walter Crane, more in the Art Nouveau style than many, led the fight against the gift to the Victoria and Albert of French Art Nouveau furniture at the end of the century. They were also highly unsympathetic to the art of the next generation, as when Mackmurdo wrote Selwyn Image violently attacking an exhibition of the art of Paul Nash.[68] A lecture was given by a doctor to the Art Workers' Guild attacking the paintings of the Post-Impressionists as insane.[69] The progressivism of the Arts and Crafts movement was always somewhat limited and tended to be small scale and insular. Yet exhibitions abroad of their work were a notable progressive influence on the Europeans.

The Guild served to give its members a sense of identity and solidarity. Obviously the numerous members of the Guild cannot all be seen as holding views consistent with those of William Morris, yet he was the dominant figure behind the Guild. Ruskin was vitally important, too, but Morris made Ruskin practical. The Guildsmen were the generation after Morris and were crucial in spreading his ideas. Those ideas reshaped English design and architecture, and through their effect upon the Continent, they were significant progenitors of modernism. Influenced by the aims and discontents that motivated Morris, the Art Worker's Guild helped institutionalize his ideas and accomplishments.

[68] Ms Eng. Letter d. 141 f. 156, June 4, 1927, Bodleian Library, Oxford.
[69] C. J. Holmes, *Self and Partners* (London, 1936), p. 280.

· CHAPTER IV ·

The Arts and Crafts
Exhibition Society

WILLIAM MORRIS was deeply concerned with the relation-
ship between the worker, the object, and the public, believing
there should be a vital connection between them. This basic
idea was an energizing force behind many of the organizations
that came into being in the 1880s, such as the Art Workers'
Guild and the Arts and Crafts Exhibition Society. It is to the
latter that we shall now turn. In some respects it was a child
of the Art Workers' Guild. Like it too, it still exists, although
under a different name since 1961, the Society of Designer-
Craftsmen.[1]

Exhibitions had always been an idea present in the minds
of the founders of the Art Workers' Guild, and several were
held. But the Guild, as we've seen, increasingly became a
group that turned inwards, in some instances applying pres-
sure behind the scenes, but primarily concerned with the val-
uable exchange of information and views among the members
themselves: cooperation on particular projects, an achieve-
ment of the unity of art. Arts and crafts were more public
than painting and sculpture, particularly in their concern with
the most present of arts—architecture—and with the design

[1] I am extremely grateful to two past chairmen of the Society, G. Hugh
Spendlove and Jeanne Werge-Hartley, and its archivist, Helen Brooks, for
their assistance in helping me to discover more about the early days of the
Society.

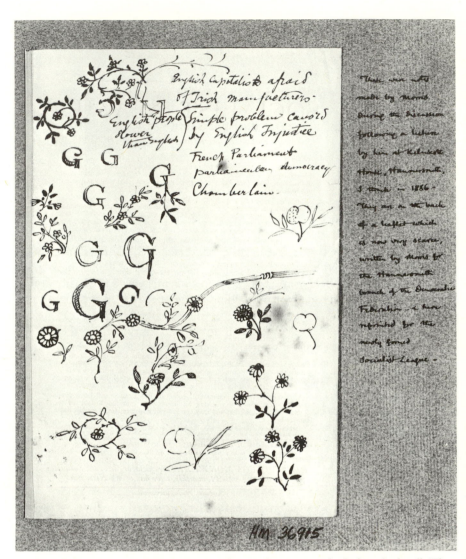

10. "Doodles and Notes by William Morris with an explanatory note by Sydney Cockerell: 'These were notes made by Morris during the discussion following a lecture by him at Kelmscott House, Hammersmith, I think in 1886—They are on the back of a leaflet which is now very scarce, written by Morris for the Hammersmith branch of the Democratic Federation—& here reprinted for the newly formed Socialist League—.' "

of ordinary objects. From the very beginning the Art Workers' Guild had not been enthusiastic about making its work known to the public in a way of exhibitions. At a planning meeting on January 15, 1884, George Simonds had stated that he felt that it would not be wise to start exhibitions; rather the Guild should be primarily dedicated to social intercourse among its members.[2] Even an organization dedicated as it was to a more "popular" art form developed a certain sense of exclusiveness. It did not turn a face to the public. The Guild did have small exhibitions for its members (those already within the pale) but made no attempt to demonstrate to outsiders the virtues of a simple style in the English tradition. Within the membership of the Guild there were in fact some who wished for an exhibition to be held for the members of the general public, but little came of the idea.

There were vague aspirations toward a more public face among the followers of the Arts and Crafts. But as frequently is the case it required a negative stimulus to create action. The conservative and exclusive attitude of the Royal Academy irritated the Arts and Crafts practitioners and led them first to band together as the "Chelsea conspirators" and finally to the formation of the Arts and Crafts Exhibition Society. The social pattern of an artist and the role of institutions in England—that interplay of individuality and organizations—made the situation particularly complex. The Royal Academy continually had an adversarial relationship to the world of design. Academy membership might confer social superiority as well as economic success, but the Academy seemed particularly reluctant to bestow its laurels upon designers. All through the century there had been a railing against its failure to do more for the training of those who were not painters or sculptors. Some architects were members of the Academy, but they were in a distinct minority. Some, such as Norman Shaw, preferred the Academy, with its suggestion of alliance with fine art, and a more genteel status, to the Institute of British Architects;

[2] Minutes, Art Workers' Guild Archives, Queen Square, London.

and partially for the status it conferred, some Arts and Crafts practitioners may have wished to be allowed to join the Academy. There was a practical reason, too: it had a well-established annual summer show that would provide an excellent showcase for the Arts and Crafts artists.

But the Royal Academy did not seize the opportunity to change—it has been successfully resisting such an opportunity almost since its formation in 1768. Perhaps its resistance to change helped bring about reform outside the Academy. One of the reasons for the interesting development of the Schools of Design earlier in the century was the reluctance of the Academy to become involved in design training. In 1863 a Royal Commission advised the Royal Academy to do far more for "workmen of great excellence in metal, stone, wood and other materials" and to appoint two vice-presidents from different artistic areas, presumably including the decorative arts, than the field represented by the president who had been a painter from 1768 to 1919, with only the one exception of James Wyatt. The commission also advised that there should be more members who were sculptors and architects. Little was done about any of these recommendations.[3] Perhaps the actual establishment in 1888 of the Arts and Crafts Exhibition Society somewhat bestirred the Academy, for in 1889 it established a committee to consider reforms on the procedures of the schools and summer exhibition, and a few changes were made. The Academy itself was aware of its limitations and adopted a motion that year that even if by natural rotation there were not a sculptor and an architect on the Council, they should be co-opted. But three years later, in 1892, this

[3] Sidney C. Hutchison, *The History of the Royal Academy 1768-1968* (London, 1968), p. 120. The Royal Academy made some gestures toward the Arts and Crafts world in future years with the Arts and Crafts Exhibition in 1916, the Exhibition of the Decorative Arts in 1923 when the Arts and Crafts section was done in cooperation with the Exhibition Society, and more dramatically holding at the Royal Academy the fiftieth anniversary exhibition of the Society itself in 1938. Or perhaps these events indicate that the stand against the Academy, as so frequently in the past, had fizzled.

step was undone with a return to strict rotation. There was a proviso that if there were not a sculptor and an architect on the Council, one should be appointed to it, *ex officio*, who would have a voice but not a vote.

Frederic, the future Lord Leighton, who had become president in 1878, was dedicated to attempting to make the Academy more progressive. Paradoxically, if understandably, it is just in such periods of possible change that progressive forces feel that not enough is being done, and in fact, little happened. Leighton felt the academicians should take their teaching duties more seriously; he also regretted that such eminent painters as Rossetti (who had died in 1881), Holman Hunt, and Madox Brown were not members of the Academy.[4] Indeed, at the time of this unrest Madox Brown suggested that a counterexhibition be held at the Hogarth Club, named after the great painter who himself had disapproved of the Academy. Burne-Jones, having consented to become an associate in 1885, resigned in 1893, perhaps because he still had not yet achieved full membership. And all this occurred while Leighton was coming to represent the respectability of painting: in 1886 he was made a baronet, and a baron just before his death in 1896.

As usual, Arthur Mackmurdo saw himself playing a major role in the development of the movement for exhibitions; he claimed he tried to persuade the Royal Academy to be more welcoming to decorative artists, but not to any particular effect: "While working with Craftsmen in the Century Guild workshops I became so conscious of the live, creative atmosphere that I felt that from these applied arts would come a renaissance of Architecture and not otherwise. Upon this I was so keen that I did all I could to persuade Sir Frederic Leighton, then P.R.A., to have an exhibition of Arts and Crafts at Burlington House. He promised to use his influence with the Academicians to this end."[5] And it is likely that many

[4] See Leonee Ormond and Richard Ormond, *Lord Leighton* (London, 1975).
[5] Mackmurdo, "History of the Arts and Crafts Movement," p. 2, WMGW.

of the decorative artists, Mackmurdo among them, would have been willing to cooperate with the Royal Academy in such an exhibition, had the occasion arose.

But Morris himself, as might be expected of him, was a less compromising spirit. In reviews of the Royal Academy Summer Exhibition in 1884, the year of the foundation of the Art Workers' Guild, he remarked on the weakness of the two thousand works displayed. Looking for "traditional workmanlike skill," he found instead works that he considered "dashing, clever—and useless." Of Millais's *An Idyll*, showing a boy soldier playing his fife to some admiring girls during a pause in the battle of Culloden, Morris remarked that it was "the record of a ruined reputation, of a wasted life, of a genius bought and sold and thrown away." He was particularly indignant at the paintings bought from the exhibit by the Trustees of the Chantrey Bequest, John Pettie's *The Vigil* and John Seymour Lucas's *After Culloden*. Morris commented, "This is the sort of thing which gets the Academy the bad name it has got, and makes it perhaps the most contemptible public body in England—which is saying much."[6]

Morris's reviews are so vivid and pungent that they deserve further quotation. They also make clear how deeply he felt that the bad state of art was a consequence of the failures of society. The efforts of the Arts and Crafts movement were in the right direction, but more thoroughgoing steps would have to be taken if there was to be a genuine betterment.

Morris described *Soir d'Été* by one Van Beer as, "A most detestable picture; careful and smooth in execution, but with little merit even on that ground save the capacity of laying on oil-paint minutely; a very token it seems of the last corruption of the bourgeoisie, a conscious pandering to the worst tastes of that part of it which consciously preys upon others."

[6] These quotations from Dennis Farr, *English Art 1870-1940* (Oxford, 1978), pp. 58-60.

And drawing a moral from the exhibition he so deplored, he wrote,

> I have tried to show . . . that the degradation of archi-
> tecture and the lesser arts is as much the consequence of
> the supply and demand system, the system of unbridled
> competition, as the recurring crises in trade or any other
> economical phenomenon; is it conceivable that while these
> arts are degraded, the intellectual arts of which they are
> the very food can flourish: What, I say, is to feed the
> imagination, the love of beauty of the artists of to-day
> while all life around them is ugly; sordid poverty on the
> one hand, insolent or fatuous riches on the other? . . .
> Those who wish to have art in these passing days must
> forget three hundred years and go to school with the
> craftsmen and painters of the fifteenth and sixteenth cen-
> turies. . . . I cannot conceive of anyone who loves beauty,
> that is to say, the crown of a full and noble life, being
> able to face it, unless he has full faith in the religion of
> Socialism. . . . I believe, as I have done for long, that
> the new art will come to birth amidst the handicrafts; the
> longings of simple people will take up the chain where
> it fell from the hands of the craft-guilds of the fifteenth
> century, and that the academical art which was developed
> from that misreading of history which we call the Ren-
> aissance, will prove a barren stem. However that may
> be I know surely that the new society, which we hope
> and work for, will develop a new art, fit for the life that
> will be lived under it, and furthered in a way which we
> slaves of Competition cannot conceive of by that new
> life of the COMMONWEALTH.[7]

This review was written for *To-day* in July; in May he had written a shorter piece on the exhibition for *Justice*, which

[7] "The Exhibition of the Royal Academy," *To-Day*, July, 1884; in May Morris, *William Morris*, I, 238-241.

was equally severe and makes clear to what a degree Morris was a driving force for artistic and political reform, and why he saw the Royal Academy as the bastion of established society: "It is with a certain exultation that one walks through the wild jumble of inanity that clothes the walls of the Royal Academy to-day, when one thinks that the dominant class, the commercialist, noble and non-noble, who have deprived the people of art in their daily lives, can get for themselves nothing better than this for the satisfaction of their intellectual craving for beauty. . . . It is common for artists to prostitute their talents such as they are, not to popularity, which would be respectable comparatively, but to fortune-hunting: the ignorant public I have been mentioning is not the simple, uneducated public, but the cultured and guinea-shedding public."[8]

Arts and Craftsmen objected not only to the restrictive practices of the Royal Academy that so heavily favored the "fine" arts, most notably painting, but also to its method of selection by a jury consisting only of academicians. Morris helped initiate the campaign against the Royal Academy that can be most easily traced in the columns of the *Pall Mall Gazette*, although other papers entered into the fray. In the columns of the *Gazette* "An Outsider," the art critic M. H. Spielmann, made a proposal for reform in June, 1885, at the time of the summer show that helped crystallize the discontent felt by many with the Royal Academy, particularly those in the world of design. Spielmann thought that the recently opened summer show of that year was particularly disappointing. He suggested a mild reform: restricting the number of paintings submitted so that the jury might have some chance of considering them in a more leisurely fashion, two as the limit for nonmembers of the Academy and four from members of the Academy rather than the eight submissions allowed them. He did not dwell upon the questionable procedure that the forty

[8] "Individualism at the Royal Academy," *Justice*, May 24, 1884, in May Morris, *William Morris*, II, 140-142.

members of the Academy had the absolute right to hang eight pictures each, although in fact few took advantage of the full number. Undoubtedly the academicians received the best placement, were not "skied," that is, hung near the ceiling on the crowded walls of the galleries.[9] On June 20 two communications were published in the *Pall Mall Gazette*: one Sydney Hodges who lived at 40 Fitzroy Street, close to Mackmurdo (but there was no suggestion that he was associated with him), proposed a guild of art be formed open to all members of recognized art societies and those who exhibited at the Royal Academy. It is of some interest that the term guild should have been used—it was certainly employed loosely at the time; Morris for one was fully aware that the old guild system could not be revived. But words, even if inappropriately used, are significant, as was the case here with "guild" with its echo, even if a weak one, of brotherhood.

The other communication, from "An Onlooker," suggested that a group be joined to the Academy, on a third level (corresponding to the basic class system?) below the academicians themselves and the associates of the Academy. This group would be unlimited in number, although the method of selection was not clear—presumably it would hinge on having one picture accepted—and that henceforward such members would be entitled to display a picture a year. One is struck at how rapidly artistic questions take on a political coloration. "An Onlooker's" suggestion for dealing with those who complained of the Academy's procedure was "Treat him as Government treat an obnoxious and dangerous opponent in politics. Change him from an outsider into an insider (however slight the connection) and the thing is done."[10]

The Royal Academy seemed quite content to ignore the artists' complaining at its gates and was fairly impervious to all this criticism, even though Leighton himself was sympathetic to the idea of reform. The *Gazette* endorsed moderate

[9] See *Pall Mall Gazette* 41 (June 18, 1885), 1-2.
[10] Ibid., June 20, 1885, p. 6.

reform; all along its attitude was that the existing situation could be improved. The debate, continuing for the next year or so, at its most concentrated in the *Pall Mall Gazette* but also in other papers and journals, considered the eternal conundrum: reform from within or revolution from without, at least to the extent of a creation of a rival institution. The *Gazette* maintained that reform was the only way, and it is intriguing to consider the sort of language it used: "Any good effect which the leader [in favor of reform] may have, however, is considerably discounted by the proposal that outsiders should join in Boycotting the Academy by forming themselves into a trade union and opening a yearly exhibition of their own. This is sheer nonsense. Such a proposition can only introduce an undesirable feeling of bitterness in the controversy which had far better be left out if any good is to come of the 'Reform Bill.' "[11]

Walter Crane fired a salvo at the Academy in the *Gazette* in 1885 in which he had pointed out what he considered its irresponsible power and corrupting influence. Crane asked the rhetorical question, in his opinion to be answered in the negative, "Can the Royal Academy be reformed?" and went on, "Is there one single vital impulse in modern art which has originated inside the Academy? Is it not notorious that every original and distinctive growth has obtained public recognition and fought its way to the front in spite of Academic opposition or neglect?"[12] This letter seemed to mark the end of the debate for 1885, but it would come to the fore again when the next summer exhibition opened the following year.

Eighteen eighty-six marked a continuance of the attack on the Royal Academy. An important blow was the formation of the New English Art Club in January. Some of its founders were involved in another new venture, the planning of a possible national exhibition, which became the progenitor of the Arts and Crafts Exhibition Society. The New English Art

[11] Ibid., June 22, 1885, p. 3.
[12] Ibid., July 1, 1885, p. 1.

Club had had one exhibition and was not yet as firmly established as it was to be in the 1890s, when it replaced the Grosvenor Gallery as a progressive force in English art. Its existence indicates restiveness about the Royal Academy, partially a sense of unease about semiprivate, semipublic institutions being placed in a powerful position of authority—there had been a surprising number of rejections for the Summer Exhibition of 1886. (The Academy's great annual event, the Summer Exhibition, still regarded with a mixture of derision and awe, moves slightly with the times yet serves as the symbol and actuality of what is respectable in English art.) George Clausen, involved both in the New English Art Club and the plan for a national exhibition, wrote to Walter Crane proposing that there be an exhibition in which all artists might exhibit who had shown in the country over the past three years and that these artists should elect the selection committee.

Artists had been attacking the Royal Academy virtually since its foundation. Rossetti had founded the Hogarth Club in 1858 as an association of artists and others opposed to the Academy, but it only lasted three years. Sir Coutts Lindsay's aesthetically inclined Grosvenor Gallery was, in part, a gesture against the Academy as well. Clausen had been largely persuaded to take an anti-elitist stand by his fellow member of the New English Art Club, Herbert La Thangue. In planning a national exhibition, he was trying, without much success, to make the procedures more democratic, to limit works to two, to make all those eligible who had exhibited somewhere in the past two years. In other words, he wished to expand those who could participate in the selection, those who had the "franchise." As La Thangue remarked, "The arguments for and against a wide suffrage in art are the same as those for and against its widening in other and more important affairs."[13] La Thangue was important in starting the painters

[13] Herbert La Thangue, "A National Art-Exhibition," *Magazine of Art* 10 (July, 1887), 31.

out on the road to reform, even though they eventually did not continue with the enterprise. A series of special meetings of the New English Art Club took place in the spring of 1886 in which Clausen tried to take a middle course. There was, in the end, no democratization of the selection procedures of the Club, and La Thangue resigned. Crane consulted with La Thangue during the summer, and La Thangue also met with Havard Thomas and George Clausen, who were to be active in the first stages of setting up a separate organization.[14]

In the *Gazette* for July 17, 1886, Spielmann returned to his rather mild attack on the Academy. He pointed out that the quality of the exhibitions was in decline, which was reflected in a falling off of receipts: something needed to be done. Independently of this agitation, others were launching plans to supersede the Royal Academy, to create some sort of guild of art. On August 7, 1886, a letter appeared in the *Gazette* signed by the Pre-Raphaelite, William Holman Hunt, Clausen, the drafter of the letter, and Walter Crane, a leading figure in the Arts and Crafts movement, one of the Fifteen who had helped found the Art Workers' Guild, and a disciple of William Morris. They were upset at what they regarded as the intolerable behavior of the Royal Academy, most particularly the great number of objects that its members were allowed to show, and that the hanging committee consisted entirely of members of the Academy itself. Many English institutions are based on a premise of self-policing and the psychologically difficult assumption that those in control are able also to represent the rights of outsiders. It was against this assumption that the letter argued. It pointed out that the depiction of the Royal Academy as a national institution was "a delusion for which doubtless the Royal Academy is not responsible, as it has always asserted and maintained its privacy." The argument about discrimination is familiar. If it is a private insti-

[14] See Fred Brown, "Recollections," *Art Work* 6 (Winter 1930) 269-278. Also Kenneth McConkey, *Sir George Clausen R.A., 1852-1944* (Bradford ?1980), particularly p. 31, and, on La Thangue, Kenneth McConkey, *A Painter's Harvest* (Oldham, 1978), p. 10.

tution, how can an outsider legitimately object to its setting out its own rules? The brave intention of the signatories was to take the Royal Academy at its word, which obviously it did not mean, and to establish a genuinely national exhibition. The three visualized a democracy of artists—who can claim that the democratic ferment of the 1880s had not also reached the world of art?—and advocated "the establishment of a really national exhibition, which should be conducted by artists on the broadest and firmest lines—[in] which no artist should have rights of place; and all works should be chosen by a jury elected by and from all artists in the kingdom."[15] This was a more sweeping adaptation by Clausen of the New English Art Club principle of the previous April that both members and exhibitors should elect the jury. Clausen, Crane, and Hunt were attempting to instill some logic in the working of an institution and also to achieve some reforms. As Holman Hunt commented to Crane, he intended "to appeal not less distinctly for a redress of injustice which the Royal Academy does to the whole profession by its opportunity to assume authority over without acknowledging responsibility towards outsiders."[16] Having helped launch the attack, the *Gazette* held firmly to all the delaying tactics of the English constitutional scene: first, reform from within. In its issue of August 12 it called for a royal commission to investigate whether the Academy was violating its original intention: "The Academy was founded to promote the 'arts of design.' As a matter of fact, it is a mere society of painters in oil colours." In the same article doubt was expressed about the likelihood that a national exhibition suggested by Hunt, Clausen, and Crane would prove to be a paying proposition. The *Gazette* felt that there should not be a boycott but a reform, as had taken place at Oxford and Cambridge colleges through government intervention, leading to the formation of a university of art.[17]

[15] *The Times*, August 7, 1886.
[16] Crane, *An Artist's Reminiscences* (London, 1907), p. 287.
[17] *Pall Mall Gazette* 44 (August 10, 1886), 1-2.

On August 14 there appeared a long letter in the *Times*, signed R.A., that is, Royal Academician, defending the Academy's procedures and the current summer show. Holman Hunt was particularly irate at this letter, and on August 18 he wrote a long reply commenting on what he regarded as the cruelty of the letter in its attitude to outsiders and its author's lack of compassion for those art objects that were excluded from being shown at the Academy, for whatever reason. Holman Hunt remarked of the anonymous writer, "With the august honors he enjoys, he has forgotten the feeling of outsiders and the power which they may exert if they will be but united." Holman Hunt regarded the attitude of the Academy as "a perpetual injury to art" and felt that the institution needed to be far more representative. It had obviously always been devoted to "correct" values, and that had been part of the ideas of the planner of the institution, Benjamin West, an American and hence in some sense an outsider, and its first president, Sir Joshua Reynolds, intent in his *Discourses* in establishing rules for art.[18] It is slightly ironic that the painters—well represented in the Academy—were those who were best able to get themselves quickly organized and had already established the New English Art Club.

Holman Hunt had long been opposed to the Royal Academy, having testified against it in 1863 at a royal commission. But he was anxious to refute the charge that he was reacting against it in a personal way because it had neglected him. Some years later in a letter to Spielmann, after the campaign had failed, he expressed his thought that the abuses of the Royal Academy were incurable because it was "inflated with vanity. . . . The poor I always maintain (*and I did so before the Whitechapel people declared for my work*) do look out for sterling purpose and sensible workmanship—and they cannot support the artist and the rich are only taken by clap trap."[19]

[18] *The Times*, August 18, 1886.
[19] Holman Hunt to Spielmann, July 25, 1889, based on Jean Agnew's report of papers, The Royal Academy Archives, London.

The dispute was the subject of a long fourth leader in the *Times* on August 19. There the paper commented editorially that it was generally agreed that the latest Summer Exhibition had been "below the mark" and that in effect Leighton had apologized for it at the annual banquet. The *Times* was appropriately judicial and opined that Holman Hunt was being rather idiosyncratic in his presentation of the view of the "extreme left"—the phrase in the editorial—and that he was being vengeful for his neglect by the Academy in past years. It also disagreed with Holman Hunt's attack on the basic English belief in the fair role of a semipublic, semiprivate institution legislating for an area, be it art or whatever. Holman Hunt expressed "the views of those who believe that a close corporation cannot under any circumstances be trusted to further the interests of art." But the *Times* nevertheless felt that the Royal Academy stood in need of drastic reform: "The Royal Academy, like the House of Lords, wants mending rather than ending" (an intriguing comparison). The *Times* rejected completely the contention that the Royal Academy was a purely private body that was accountable to no one— it was not exempt from interference as it was a public institution that had to be both accessible and accountable.[20] This responsible opinion should have moved the Royal Academy toward reform, abortive as it might have been.

All through August and September the debate kept percolating in the columns of the *Gazette*. An article on its first page by the art critic Harry Quilter, a favorite butt of Whistler's, entitled "The Royal Academy Club," pointed out the long agitation that had taken place to reform the Academy, its studious neglect of what Quilter considered the greatest English art—watercolor—and also of sculpture and of its responsibilities toward education.[21] This did not speak directly to the issue raised by Holman Hunt, Clausen, and Crane of the neglect of design. Crane was turning against reform, rep-

[20] *The Times*, August 19, 1886.
[21] *Pall Mall Gazette* 44 (August 10, 1886), 1-2.

resenting as he did the socialist wing, what the *Times* would have called the extreme left. In the past parliamentary investigators and others had urged, indeed almost ordered, reform of the Royal Academy, but nothing had happened; as Crane asked, what assurance was there that future proposed reforms would be carried out? Despite its tendency to compromise, the *Gazette* continued vigorously to attack the Academy. In its issue of August 19 Harry Quilter pointed out how outrageously the Academy had neglected its responsibilities toward education and toward "outsiders" and had devoted itself only to the interests of its members, ignoring the minor decorative arts: "Under their [the Academicians'] management the National Exhibition has become a monument of feebleness, frivolity, and melodrama."[22] Nevertheless the *Gazette* continued to believe the Academy could be reformed and reported on August 20 that Crane and Holman Hunt were willing to contemplate reform by some sort of royal executive commission. But the next day Crane wrote to say that he was misrepresented, that he did not believe that the Academy deserved one more chance. He urged that an alternative organization be formed. There appeared to be a division between Crane and Holman Hunt; the latter was more inclined to believe that there must be reform of the Academy through "parliamentary coercion of the fossilized Forty."[23]

Holman Hunt, Clausen, and Crane thought that architecture and sculpture as well as design and handicraft were neglected. They put forward a specific proposal to remedy this situation in the *Times* on September 15: "The action of the Royal Academy in the conduct of its exhibitions and in its relation to the arts generally has been practically admitted by all. The Royal Academy is evidently not disposed to move in the matter; therefore the remedy must be sought outside that body." The letter urged those interested to communicate with the sculptor John Havard Thomas, temporary honorary

[22] Ibid., August 19, 1886, p. 5.
[23] Ibid., August 23, 1886, p. 6.

secretary of this new body. The letter proposed that all artists who had exhibited in principal shows over the past two years would be eligible to submit two works each and would also be able to elect the jury.[24] This particular scheme was in fact too sweeping and cumbersome, but it served the purpose of getting together the interested parties and ultimately led to the formation of the Arts and Crafts Exhibition Society. It achieved some of the goals outlined in the original proposal for a national exhibition and moved away from being largely a negative reaction against the entrenched power of the Royal Academy.

Crane saw the failure to opt for a sweeping reform as a temperamental difference: The English in contrast to the Europeans were not capable of absolute reforms. Perhaps this recognition was one factor that drove Crane to seek political solutions as a way to cope with the situation. In his reminiscences years later he noted ruefully that several of the protestors eventually did join the Academy: "While in the principal cities in the Continent 'Secessionist' bodies were being formed, or have since been formed, entirely independent of the older Academic schools and institutions, and devoted to the exposition of the newer ideas and aims in art, with their own buildings and funds, it seemed impossible in England owing perhaps to the intensified individualism of the artists, or to the inveterate English habit of compromise, to unite the younger men in the same way and with a similar purpose."[25] In any case the proposal for the national exhibition group was to select a jury on the basis of some sort of universal suffrage of artists, in some sense parallel to the system used for the French salons. This reflected the overlap with the New English Art Club, most or all of whom had been trained in France.

The group began meeting in Chelsea, at first on Saturday evenings in Thomas's studio on Manresa Road, and referred

[24] *The Times*, September 15, 1886, p. 5.
[25] Crane, *Reminiscences*, p. 297.

to themselves as the Chelsea conspirators. This was geograph-
ically appropriate, as Chelsea has somewhat Bohemian con-
notations. (The artists of greater respectability had built them-
selves grand houses in the Holland Park area, of which the
most notable was Leighton's own, with its exotic touch of a
Moorish courtyard.) For these meetings the painter Fred Brown,
eventually himself a member of the Academy, acted as chair-
man, and Herbert La Thangue served as secretary. The great
archaesthetic rebel, Whistler, sent his blessings but did not
attend. Perhaps because they were satisfied with the formation
of the New English Art Club, the painters on the whole
tended not to be too active in the planning of the new or-
ganization.

The members' concern seemed dominated by their objec-
tion to the restricted method of selection by the Royal Acad-
emy jury. Among the very earliest steps by the planners of a
national exhibition of the arts was to draft a letter of invitation:

> The proposal for a national Exhibition of the Arts lately
> put forward in the public press has raised the whole ques-
> tion of the adequacy of the present representation of Arts
> in exhibitions. The principle set forth in these proposals
> is *'That the juries for selecting and placing Works of Art must
> be elected from, and by the Artists of the Kingdom.'* The un-
> dersigned hold that this principle is sound and just, and
> that it is the basis on which a representative exhibition
> of the Arts should be conducted. Believing that this prin-
> ciple will, on fair consideration, meet with the agreement
> and cordial support of Artists generally, they beg to ask
> you if you will form one of a Provisional Committee to
> consider the best means of carrying it into effect.[26]

This original "round robin" was signed by 399 artists, most
of whom are now more or less forgotten figures, but including
names who had or would fairly soon make their mark, such

[26] Society of Designer-Craftsmen Archives, Victoria and Albert Museum
Library, London. Hereafter SDCA.

as Frank Brangwyn, Lewis F. Day, George Frampton, Henry Holiday, Herbert P. Horne, Selwyn Image, T. Sterling Lee, W. R. Lethaby, A. H. Mackmurdo, Mortimer Menpes, Charles Shannon, and C.F.A. Voysey, among others. (The presence of the Century Guild names—Horne, Image, and Mackmurdo—indicates that Horne did not follow the advice given by a friend in October, 1886: "If you are going to take any action in the matter it will have to assume a much more practical form than in the curious scheme which was enunciated in the *Pall Mall Gazette.*"[27]) It was an impressively long list but was not heavy with authority. In the fall of 1886 it did look as if the movement for an anti-academy, a revolutionary step, so to speak, was gaining ground. On October 2 a committee of twenty-two proposed "that a [second, more specific] letter be written to invite certain Artists to join a Provisional Committee on the basis of the principle agreed upon (viz., that the juries for selecting and placing works of art must be elected from, and by the Artists of the Kingdom), and that this letter be signed by all Artists willing to support the principle."[28] A subcommittee was formed to write the letter of invitation that was approved at the meeting of October 9 when thirty-two artists were present. The process was a little unwieldy, but the artists of various sorts, meeting in increasingly large groups in the studios of Chelsea, continued with great enthusiasm. It was also made clear that this provisional organizational committee would include representatives of all branches of art. On November 6, with sixty artists present, the date was extended for receiving signatures of support until November 12. And finally at a meeting on November 13, with seventy-five artists present (the numbers attending were quite dramatically increasing, and Crane and others could legitimately claim that they were indeed extending the franchise of the artists participating), it was decided,

[27] D. Barron Brightwell to Horne, October 24, 1886, quoted Tickner, "Selwyn Image," p. 461.
[28] SDCA.

on a proposal by Crane, with a second by Heywood Sumner, that in the various categories to be represented on the provisional committee—"Painting, Sculpture, Architecture, Engraving, and the Arts of Design"—(note that the order maintains the traditional hierarchy) that the numbers of those being asked to serve be limited to twenty.[29] Among them were some of the same people who had been involved in the founding of the Art Workers' Guild, such as Mervyn Macartney and Heywood Sumner.

A comparative newcomer and central figure in the later formation of the Arts and Crafts Exhibition Society was W.A.S. Benson. He is generally credited with having the specific idea of the exhibition. Mackmurdo says that it was Benson's idea, and it is so comparatively rare for Mackmurdo to give someone else credit for an innovation that one tends to think that it must be so.[30]

The agitation continued in the press but more along lines of reforming the Academy than of establishing a new organization. The *Pall Mall Gazette* of September 29, 1886, reported that 293 of the newspapers in London and in the provinces had recorded themselves in favor of reform of the Royal Academy, and 6 against, and 74 journals were for reform and 3 against—those three being the *Court Journal, Pictorial World,* and the *St. James's Gazette.*[31] In view of this strength of public opinion, it is surprising that so little happened. Yet one does not know how strongly these many papers and journals took up the issue; it was hardly a burning one. The *Pall Mall Gazette* continued its support of reform rather than of a new organization; it felt that a national exhibition ultimately could not compete with the established standing of the Academy and its financial ability to help artists or their widows and orphans. The *Gazette* spoke in the rather soothing if unexciting voice of moderate reform: "The chief danger, indeed, that the re-

[29] SDCA.
[30] Mackmurdo, "History," p. 235, WMGW.
[31] *Pall Mall Gazette* 44, September 29, 1886, 4-5.

formers now have to fear is that of wasting their strength in excess of zeal. . . . Now, as no one really believes that a rival show could compete with the Royal Academy, and as further, even if successful, it would only meet a few of the evils complained of, why should not the lesser be merged in the greater, and all the malcontents join in a united demand for a Royal Executive Commission for the nationalization of the Royal Academy?"[32] The *Gazette* became more and more convinced that the "Chelsea conspirators"—not its term—were launched on an ill-advised and Quixotic scheme. There was now a clear division in attitude toward the Academy among the supporters of the national exhibition. Crane was the most antagonistic to the older institution. Solomon J. Solomon wrote to the *Pall Mall Gazette* that there was no intention of boycotting the Academy. In the same issue William Hunt (not to be confused with William Holman Hunt) stated in a heavily ironic way: "Far from desiring any harm to come to the R.A., I would simply wish to see that august corporation enjoy the repose and retirement its age and infirmities justly entitle it to."[33] George Clausen, of the original three, seemed to feel that reform was possible, and he would become the leader of compromise. For him, the role of the provisional committee selected by the national exhibition system was to consider the question of suffrage, to do something about "the utter irresponsibility of the selecting and hanging committees under the present system."[34] Crane still held out for a more thorough change: the *Gazette* reprinted a letter of his written to the *Manchester City News*, on the next to last and most obscure page in its issue of November 29: "Artists must combine, and learn like other workers the old lesson that unity is strength."[35]

It is not clear how the balloting for the provisional committee took place. There were groups of potential members of the committee—painting, sculpture, architecture, engrav-

[32] Ibid., September 14, 1886, p. 3.
[33] Ibid., November 1, 1886, p. 2.
[34] Ibid., November 4, 1886, p. 6.
[35] Ibid., November 29, 1886, p. 13.

ing, the arts of design—consisting of twenty names each. These were to be asked to serve. On the list of painters there were four members of the Academy, Alma-Tadema, Orchardson, Watts, and the president, Leighton, and two associates, as well as nine who were either associates or fellows of the Royal Institute of British Architects, perhaps indicating a greater acceptance of their professional attitude than heretofore. Among the sculptors there were two academicians, Armstead and Ledward, and one associate, Hamo Thornycroft. In the list of engravers there was one member of the Academy, Hubert von Herkomer, but it is unclear why he counted as an engraver rather than as a painter. The last category—the arts of design—included Benson, Mackmurdo, Morris, Sumner, and Voysey. There were no initials after names indicating acceptance by one academy or another, although quite a few had been elected to membership in the Art Workers' Guild.

There was also a proposed program of creating a national exhibition. But it was one thing to have a program and another to have it implemented. One suspects that comparatively few of the hundred approached actually agreed to serve. Early in 1887, with Thomas still as secretary, meetings were called to consider the future of the concept of a national exhibition. Crane was anxious to assert the independence of this new organization and proposed such in an amendment: "That in consideration of the aims of the movement which the present Provisional Committee represent are larger than any reform of the Royal Academy will cover. It is desirable to work on independent lines to attain our object." One would also gather that there was some shortage of funds as this document, dated February 17, 1887, notes that "the Sub-Committee will report on the advisability of sending a letter to the Charity Commissioners and Trustees of the British Institution *re* British Institution Funds."[36]

[36] SDCA. All documents cited, unless otherwise indicated, are from this source.

The next agenda preserved—for what may have been the last meeting to be held, on February 26—consisted largely of various motions of conciliation toward the Royal Academy, such as that by George Clausen: "That it is desirable that an effort should be first made to secure to all the arts the right of representation on the basis of suffrage in the exhibitions of the Royal Academy," and Thomas's amendment to it: "That the efforts of this committee be first directed to producing the acceptance of the principle of suffrage *by the Royal Academy*" (my emphasis). J. E. Christie moved "that the committee consider ways and means for *approaching* the Royal Academy" (my emphasis). The "revolt" appeared to be in a state of great disarray. Clausen also moved that members might vote by mail, a sign of lack of interest. The idea of a national exhibition was running downhill.

The split over the issue is recorded in letters that Crane, the ultimate president, wrote to Benson, the ultimate secretary and treasurer, and prefigures their building the Arts and Crafts Exhibition Society out of the ruins of the agitation for a national exhibition. The divisions and disappointments are perhaps characteristic of all such organizations; they also bear some parallels to the troubles that had bothered Morris when he left the Social Democratic Federation and that he was now having with the Socialist League. The fights in all instances were generally over the issue of whether to cooperate with existing institutions—in the political sense, cooperation with parliamentary institutions—or whether to attempt to achieve independence and reform the world by that means. The solution that tended to emerge was pluralism—the existence of several organizations. The activity and strength of the Royal Academy continued. In the left-wing political sphere the establishment in 1893, in part because of the various disputes of the 1880s, of the Independent Labour party out of an amalgamation of various dissident groups marked a major result of the agitation of those years. The national exhibition was headed in that direction and aimed to be, so to speak, an

organization of consolidation—but in fact only the designers were active in it.

Even before the February 26 meeting of the provisional committee, the "hard liners" were aware of the difficulties and that the provisional committee was, in their view, caving in to the Royal Academy. A group, under Crane's leadership, was beginning to try to rescue something out of the experience and to concentrate on an exhibition that would emphasize the decorative arts. Crane planned to meet with Benson, Pollen, Sumner, and Longden. They should "have a palaver on the situation & the advisability of taking steps about a decorative exhibition. . . . I quite think that it would be no bad thing to see what we could do with an exhibition of the kind, even regarded solely as a demonstration to the public that there were designers & artists in the crafts." In his postscript to this letter he wrote, "I should say that I sent in my resignation yesterday as the chairman of the Prov. Comm."

The next day Crane wrote Benson again. In the previous letter he had said that they would meet the coming Saturday, the same time as the meeting of the provisional committee. Benson apparently felt that it was worthwhile to make one more try to keep the campaign going against the Royal Academy, and Crane was willing to postpone the meeting of the rebel group: "You will see Thomas will whittle down to the very vague demand for the suffrage which may be made to mean next to nothing. The movement which I thought was to be a wide one will narrow itself to the action of a clique." Crane still held very firmly to the question of the suffrage in the selection of juries "as in any large movement it must be considered as most important if exhibitions are to be really open & conducted on a fair basis." Crane concluded this letter, "Well, I wish you & Sumner & Longden joy of the Prov. Comm: on Saturday. You having only joined at the eleventh hour, as it were, do not know them as well as I do."[37] One sees here the eternal nature of small-group politics, which are

[37] Crane to Benson, February 22, 23, 28, 1887, SDCA.

not that much different whatever the issues, artistic or political. Crane was right: Clausen's motion urging reconciliation with the Royal Academy passed at the meeting fourteen to four. Those voting against it—Benson, Longden, Macartney, and Sumner—were about to send in a joint resignation. Crane was now happy to move along with the alternate plan of a decorative art exhibition, with the five of them meeting together on March 5. An exhibition limited to the decorative arts would reflect one of the original impulses behind this movement: a protest against the decision of the Art Workers' Guild not to have exhibitions in any serious sense.

The idea of a national exhibition of art did not have a very long life. It did have one further spurt that summer, which seemed to reinforce the belief that to attempt to reform the Royal Academy was more or less hopeless. On July 28, 1887, Thomas, the secretary of the provisional committee, perhaps as a final gesture, sent to the Royal Academy the names of 783 artists who supported the principle that juries that selected works for exhibition should be elected from and by the artists of the kingdom. The following November the Royal Academy responded: it was unwilling to entertain any proposal for a change in its procedures in the selection of juries.[38]

But the movement for reform of the Royal Academy at least served the crucial purpose of getting together those from the Arts and Crafts world interested in making sure that the "applied" arts would receive some public attention, particularly as the Art Workers' Guild had evolved in such a way that it did not have a public face. For these men the applied arts were every bit as aesthetically important as the fine arts, and in fact more vital because of their evident relation to how people lived. Walter Crane emerged as the senior figure in the forming of the Society; in 1870, at the age of twenty-five, he had met Morris and had become his follower both artis-

[38] Calendar of the Spielmann papers SP/1/89, July 28, 1887, November 17, 1887, Royal Academy Archives, London. The Academy appears to have mislaid the papers themselves.

tically and politically. It was appropriate that he should be a central figure in the organization of the most public of the Arts and Crafts bodies. His earlier training with the radical engraver, W. J. Linton, made this hardly surprising. Crane's role as a political follower of Morris served to strengthen his commitment to the importance of the crafts. Crane's own artistic works comprised his now rather disappointing paintings (more highly regarded in their time, particularly in Germany), his splendid illustrated children's books, his fine illustrations and political pictures. He also designed wallpapers, textiles, and metalwares, among other objects. To a considerable degree, in his feeling and approach, he was a decorator, a patternmaker, and these were major factors in his influential career. He became a leading teacher of the generation through his positions in the 1890s, first as director of design at the Manchester Municipal School of Art in 1893, then as art director at Reading in 1896, and as principal of the Royal College of Art in 1898. He disliked being at the Royal College, which had changed its name from the National Art Training School in 1896, but during his one year there he was able to move against the more formalistic methods of the South Kensington schools "teaching design in concrete forms, and in direct relation to tools, methods and materials, with the object of calling out the individual feeling and setting it free to express itself under the natural limitations of art in its own way."[39] He was also highly influential through his books: *The Claims of Decorative Art* (1892), *The Bases of Design* (1898), and *Line and Form* (1900), "made him the most influential art teacher in Britain, especially in the Schools of Art in manufacturing areas."[40] Crane advocated Arts and Crafts principles of moving away from a more fanciful ornament to a freer design. Art was to be adapted to need. As he remarked in an address in 1892, "The study of the art of the middle ages is the most

[39] Naylor, *Arts and Crafts Movement*, p. 145, quoting Walter Crane, "On the Study and Practice of Art," *William Morris to Whistler* (London, 1911), p. 114.
[40] MacDonald, *Art Education*, p. 296.

profitable to a designer, since in that period we see the evolution of free and beautiful art perfectly expressive and organic, because perfectly adapted to the wants of the time, whether ecclesiastical, civil, military or domestic: an art, too, entirely unencumbered with pedantry."[41]

Crane was also associated with the Royal Society of Arts, which played a peripheral role in these activities. That Society was itself committed to the practical relation of design to industry. It continued its traditional role of encouraging good design through awards and was involved with Arts and Crafts figures; for instance, it gave medals to Morris and Crane. Crane and others participated in its meetings. On June 3, 1887, marking the formation of the applied arts section of the Society under the chairmanship of Sir George Birdwood,[42] Crane gave a talk on "The Importance of the Applied Arts, and their Relation to Common Life," in which he remarked: "It is, therefore, hardly possible to attach too much importance to art in its applied forms, seeing its intimate association with, and bearing on, life itself, through all sources of refined pleasure."[43] Once the Arts and Crafts Exhibition Society had been established, the Society of Arts wished to give prizes to it, and they were given once, in 1889. But the committee of the Exhibition Society was not very enthusiastic about the awarding of prizes; it probably felt that such comparisons were invidious and that within the brotherhood of the Society the exhibits should have a certain equality.

W.A.S. Benson was the other principal organizer of the Society. Benson's metalwork, particularly his lamps in copper and brass, very successful in his own time, are receiving in-

[41] Walter Crane, *The Relations of Art to Education and Social Life* (Leek, 1892), pp. 19-20.
[42] Birdwood in *The Industrial Arts of India* (1880) bemoaned the way the English were destroying native Indian crafts. He and John Lockwood Kipling attempted to reverse this trend. See Mahurkh Tarapor, "John Lockwood Kipling and British Art Education in India," *Victorian Studies* 24 (Autumn, 1980), 53-81.
[43] *Journal of the Royal Society of Arts* 35 (June 3, 1887), 723.

creasing attention in our own (Figure 11). He provides a good
example of the gentleman craftsman who was an increasingly
recognizable figure in the 1880s. Such men, coming out of
the middle class, were also becoming more professional. They
felt a need for exhibitions of their work, at the level of those
in an art gallery: places of sale but not shops. In effect, Benson
sought a way to mix the worlds of business and of art prop-
erly. These arts and crafts organizations in some sense, albeit
somewhat indirectly, were concerned with status and became
more important in the 1880s—a period of some social con-
fusion. Many of those who now turned to the world of de-
sign—some of whom were also radical politically—came from
a middle-class background. This had not been completely
untrue before, but there now appears to be less social differ-
entiation between those who went into "high" and those who
went into "low" arts.

Morris himself was a prime example of this, and so was
Benson. His family was solid middle class, and he received
the best education available at Winchester and New College,
Oxford, where he attended Ruskin's lectures. There he came
to know Heywood Sumner, who married his sister. His
younger brothers also had distinguished careers: Sir Frank
Benson, a prominent actor, sportsman, and the organizer of
the revival of the Shakespeare festival at Stratford-on-Avon,
and Godfrey Benson, Lord Charnwood, a Liberal politician
and writer of an important biography of Abraham Lincoln.
Benson was specifically motivated by Ruskin and Morris. In
a memoir, W. N. Bruce remarked that Benson agreed with
them that "Art must be a maimed and stunted thing until the
whole community feels the need for beauty in the ordinary
surroundings of daily life and until those who work with their
hands feel pride and joy in their handiwork." Benson's aim,
as he stated in a prospectus for his customers in 1883, was
"to produce work consistent and original in style, of shapely
form, and carefully designed for the convenience of use." This
is a concise statement of the congruence between the Arts and
Crafts and the Modern movements.

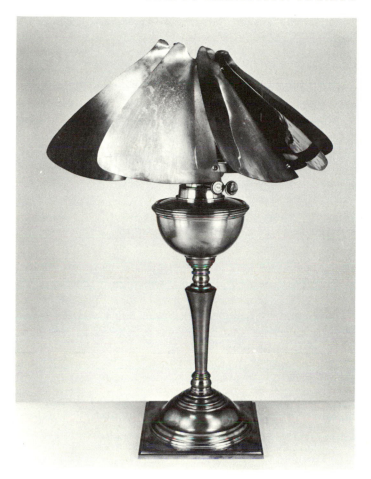

11. "Oil lamp in cast and turned brass and copper, ca. 1890 made by Morris & Co. for Standen, East Grinsted, a house designed by Philip Webb."

It was largely Ruskin's lectures at Oxford that led Benson to decide to become an architect. He became a pupil of Basil Champneys; he came to know Burne-Jones, whom he served as the model for the head of Pygmalion and also for the figure of Cophetua in perhaps Burne-Jones's most famous painting, *Cophetua and the Beggar Girl*. He also made a suit of armor and a ship to serve as models in paintings by Burne-Jones. In 1879, when he was twenty-five, he met Morris. Partially under his influence he went into both business and design, opening a workshop the next year, even though, as his memoirist points out, some regarded such a decision to be a "social misdemeanour." He became increasingly close to Morris, being influenced in his ideas, apparently not politically, but certainly in his approach toward craft. Benson imbibed the Arts and Crafts position; as he wrote in 1883, his aim was "to avoid the capricious eclecticism and overmuch training after effect which are the besetting sins of a draftsman. Therefore, to begin with, I have endeavoured to make tables and chairs and such things which form the bulk of our household requisites studiously simple in line."[44] He was associated with Morris in the designing of metalwork and schemes of lighting. He had an intriguing exchange of letters with Oscar Wilde in 1885 in which he defended Morris as a designer and thinker. Wilde had written to him about Morris's wallpapers: "I hope they will be used much less frequently than they are, and that Morris will devote his time, as I think he is doing, to textile fabrics, their dyes and their designs, and not so much to a form of wall decoration which has its value of course, but whose value has been overestimated, and whose use is often misunderstood. . . . How can you see socialism in *The Earthly Paradise*? If it is there it is an accident not a quality—there is a great difference." Benson replied to this letter: "I simply said that Morris wallpapers were the best that could be done in the material. . . . As to the Earthly Paradise I didn't mean

[44] Hon. W. N. Bruce, "Memoir" in W.A.S. Benson, *Drawing, Its History and Uses* (Oxford, 1925), pp. vii-xxiv.

to say that you will find Marx's theory of surplus value in it accidentally or of design but there is the delight in an old world society as strongly marked in it as in his socialist lectures in which this is always the main thought."[45] In 1887 he designed a room at the Manchester Art Gallery with Morris's guidance. Benson was the sole designer for his own firm as well and by 1887 had a factory and retail shop. While remaining close to Morris, he made an interesting contrast: he designed exclusively for manufacture by machine.[46] Eventually, after Morris's death, he became in 1896, while maintaining his own firm, managing director of Morris & Co. Some years later in a further reorganization he became chairman of William Morris & Co., Decorators, Ltd., as the firm was then renamed. He wrote to May Morris at the time, "I need not tell you how proud I should be to have any hand in carrying on the tradition of those whom I have always looked up to as my masters though I was never formally the pupil of any one of them."[47] In 1915 he was a founder member of the Design and Industries Association. His career makes clear, I believe, both the decisive influence of Morris in the design events of the period and beyond but also the ways in which his disciples moved on from him.

It is hardly surprising that the Arts and Crafts Exhibition Society, soon to come into being, should carry so clearly the stamp of Morris's aims and personality, even if he himself had doubts about the shape his influence was taking. Absorbed as he was in politics in the 1880s, it was hard for him to recognize the extent to which the activities of men such as Benson, fond though he was of them personally, were also leading to a change in the values of society.

[45] Oscar Wilde to W.A.S. Benson, May 16, 1885; W.A.S. Benson to Oscar Wilde, May 16, 1885, William Andrews Clark Memorial Library, University of California, Los Angeles. Wilde's letter in Rupert Hart-Davis, ed., *The Letters of Oscar Wilde* (London, 1962), pp. 175-176.

[46] See Shirley Bury, "A Craftsman Who Used the Machine," 172 *Country Life*, March 18, 1965, 624-626.

[47] W.A.S. Benson to May Morris, March 25, 1905, BL, 45, 346, f. 197.

As early as 1878 Ruskin had given his blessing for an exhibition of the applied arts in a letter to Morris: "How much good might be done by the establishment of an exhibition anywhere, in which Right doing, instead of Clever doing, of all that men know how to do, should be the test of acceptance!"[48] By the late winter of 1887 progress was being made. Longden, Macartney, Sumner, and Benson were looking for quarters. On March 22 a meeting of Crane, Day, Longden, Pollen, Sumner, Macartney, and Benson decided to send out a letter to artists and craftsmen asking their support for an exhibition of combined arts. The term "The Combined Arts," coined by Benson, headed the circular. The response was rather slow, but then on May 11 a provisional committee of a more formal sort was established—larger than the committee of seven that had been previously operating. The committee of twenty-five had Crane as its chairman and Benson as the secretary. The minutes provide a list of the committee, including such figures as Morris himself, Cobden-Sanderson, Burne-Jones, Lethaby, William De Morgan, J. D. Sedding, Thomas Wardle, and Emery Walker. It was decided at this meeting to write to Sir Coutts Lindsay to see if the new group might have the use of Grosvenor Gallery. This would have been putting the group under the wing of the Aesthetic movement, and in quite a few ways it would have been appropriate; the Grosvenor Gallery was well known for its support of Whistler and Burne-Jones. At the meeting Cobden-Sanderson suggested the term "arts and handicrafts" for their activities. There was not a suggestion that artists be excluded, but the term "arts" rather than art does convey some idea of the "lesser" arts. The group did not wish to cut itself off from the more traditional arts, and a motion in favor of limiting

[48] John Ruskin to Morris, December 3, 1878, BL, 45, 345, f. 19. Also in Mackail, *Life of William Morris*, II, 202. In the same letter Ruskin thanked Morris for his support in the Whistler case: "I am very proud of getting a letter from you—and entirely grateful for the sympathy you and Ned Burne-Jones have given me and the quiet firmness with which you acted and were ready to act."

itself to decoration was defeated. It was then proposed that the exhibition be devoted to the decorative arts "without excluding painting or sculptures less directly of a decorative kind when space is available." This was being rather vindictive toward the Royal Academy and the motion was defeated, although in effect it was carried out in the exhibitions. At this meeting of May 11 the aim of the Society was put forth: "The object in view is to show as far as possible the artistic and inventive powers of the designers and makers of the various works that may be exhibited and to illustrate the relation of the Arts in application to different materials and uses, which is not attempted in any existing Exhibition." This led on to a point in which Morris had little interest and felt was "trivial": "All work will be exhibited under the name of the designer and the responsible executant." Morris preferred the comparative anonymity of the medieval craftsmen, whereas these planners were showing a more democratic instinct to credit both the designer and the maker. Or perhaps it was a remnant of bourgeois individualistic liberalism.

It was decided the exhibition was not to serve as a salesroom, but those interested in buying the objects would make contact there with the exhibtors themselves. (Morris, who tended to be rather pessimistic and nay-saying in some areas, felt that the exhibition would be little more than a collection of shop windows. Even so, those admitted to exhibit at the show would gain a certain imprimatur, and the grouping together of work of quality would make for an exhibition of high interest.)

The meeting of May 25 has great significance. Cobden-Sanderson, seconded by Lewis Day, moved that the organization be called the Arts and Crafts Exhibition Society, giving birth to the term "Arts and Crafts." It is an important combination, the two words coming together served psychologically to bring the two worlds closer: one to infuse the other, and both to demonstrate the unity of art.

The concerns of the next meeting, on July 12, 1887, suggest that the Society may have been running a little ahead of itself.

Although it would be more than a year—October, 1888—before it held its first exhibition, it was already considering the selection of objects and the preparing of a catalogue. The committee spent much of its time in the immediate future looking for a place to exhibit, and also worrying about finances—the members of the committee, at the meeting of January 7, 1888, expressed a willingness to give a guarantee of ten pounds each. At the March 5 meeting they had decided that the exhibition would be held at the New Gallery, and set up committees: finance, literary, and, perhaps the most important, selection, which consisted of Day, Morris, Webb, Sumner, and Macartney. The president, Crane, and the secretary, Benson, were ex officio members of all three committees. At the meeting on March 13, 1888, it was agreed that the organization needed a paid secretary, and the part-time nonpaid labor by such as Benson would not be sufficient. The committee asked Aubrey Stewart, Ernest Radford, and Gerald Horsley, who had been so active in the very first days of the Art Workers' Guild, whether they were interested. Radford emerged as the most promising figure. Artisan, poet, and barrister, and active in both the Fabian movement and the Socialist League, he was an artistic and political radical. He was a friend of Marx and Engels, and of Eleanor Marx, and eventually he would be Graham Wallas's brother-in-law. On April 11 the committee offered Radford £150 per year and stipulated that his hours would be contingent on the success of the exhibition. Radford countered by saying that he would accept the post for £175. He became the secretary at that meeting.

The minutes of the literary committee have been preserved, covering meetings from April 18, 1888, until that of September 10, 1888, shortly before the opening of the first exhibition. The committee consisted of Crane, ex officio, and Benson, Somers Clarke, G. T. Robinson, J. D. Sedding, and Emery Walker. "Literary" was interpreted rather loosely; the committee would worry about the looks of the catalogue, but the main concern was "the best means of bringing the Society

into Public notice." The committee blocked out the catalogue sections; the first section was to be devoted to textiles, and it was hoped that Morris would provide a preface. Most of the meetings were concerned with the mechanics of sending in material. At the meeting of August 20 the question of having a course of lectures was raised in response to a letter from Cobden-Sanderson. The committee also concerned itself with the issue of advertisements in the catalogue—presumably a classic conundrum: gain versus appropriateness and appearance. As late as the meeting of September 10 both the question of advertisements and the course of lectures were unsettled. Advertisements were not placed in the catalogue; but as we know, lectures were arranged, largely paralleling the subjects of the short sections in the catalogue itself.

The Society met June 14 and definite plans were made for the exhibition itself to be in October at the New Gallery. Cobden-Sanderson felt that the group was being rather vulgar and perhaps going a little too far in its decision to have a sandwich man march around the town advertising the show, but as an order had been already given, it was too late to countermand it, even though the opening was not for some months. Some of the exhibitors failed to follow the proviso for the catalogue and had not provided the name of the executors of their work. The exhibition would be open on Sunday and in the evenings at a reduced admission charge. The question of Sunday openings of museums was a vexed one at this time; even to discuss the issue became a contested point at the inaugural meeting in Liverpool in December, 1888, of the National Association for the Advancement of Art and Its Application to Industry. (Benson, in a note he wrote in 1918, viewed the founding of this association as one of the outcomes of the move for a national exhibition.[49]) Sunday opening was an anti-sabbatarian gesture. The Society was not reluctant to be associated with such ideas.

At this meeting the selection committee reported that mem-

[49] W.A.S. Benson, "Memorandum," January 20, 1918, SDCA.

bers of the Art Workers' Guild, as well as certain firms, had been invited to submit works and that at least so far there had been very little response from the firms. The call for submissions made it clear that the purpose of the exhibition was to raise standards, to provide useful comparisons and assistance to those engaged in Arts and Crafts, as well as educating the public: "Something very like a revival of the arts and handicrafts has been taking place among us of late years. It has not been possible for a craftsman to test his work by the side of others, or, by careful selection of examples, to prove that there are artists in other ways than oil or watercolour, and other art than that enclosed in gilt frames or supported on pedestals. In short, there is no exhibition which gives an opportunity to the designer and craftsman as such to show their work under their own names, and give them at least a chance of the attention and applause which is now generally monopolized by the pictorial artist."[50] The animus against the Royal Academy is very clear.

The next important meeting was on September 17. It was reported that works were being received, and the members of the committee had inspected them. Indeed, the committee would be working every day until the day of the opening on October 1, in, as is generally the case, something of a rush, as a number of the exhibitors were late in sending in material.

As usual Morris himself was being pessimistic about whether groups of this sort could survive. He felt concerned that the fledgling society would not be able to find the money to rent space.

> I don't think . . . that you will find commercial exhibitors willing to pay rent for space, and the shillings at the door will not, I fear, come to much after the first week or two: the general public don't care one damn about the arts and crafts; and our customers can come to our shops to look at our kind of goods; and the other kind of ex-

[50] Quoted in Ray Watkinson, *William Morris as Designer* (London, 1967), p. 73.

hibits would be some of Walter Crane's works and one or two of Burne-Jones: those would be the things worth looking at: the rest would tend to be of an amateurish nature, I fear. In short, at the risk of being considered a wet blanket, a Job, or Job's comforter, and all that sort of thing, I must say I rather dread the said exhibition: this is of course my private view of the matter, and also of course I wish it success if it comes off.[51]

Morris was much too pessimistic and indeed was quite wrong about the public's interest, as he admitted in October: "I believe they are getting on pretty well."[52] And he cooperated fully with the organizers. He made sure that the Morris family was well represented; he wrote to his daughter May, "By the way are you asking for space for yourself at the A & C Exhibition and is your mother? Because if not you should either do so or write to F. Smith [the sub-manager] about what you want in our allotment: he hasn't got quite as much room as he wants."[53] Peter Floud maintains that Morris may not have been eligible to show at the exhibition as about 30 percent of his goods were not made at his own firm, but in fact he did display. It would have been quite an irony if he had been exluded.[54]

It was ironic enough in any case that just when his design interest was bearing rich fruits, he had become convinced that such group efforts were in vain while society was still capitalistic. As Mackail remarked about Morris's attitude toward the decision to give the names of both the designer and the maker, "it was not by printing lists of names in a catalogue that the status of the workman could be raised, or the system of capitalistic commerce altered in the slightest degree."[55]

[51] Morris to unknown recipient, December 31, 1887, in Mackail, *Life of William Morris*, II, 202.

[52] Morris to Jane Morris, October 17, 1888; in Henderson, *Letters*, pp. 301-302.

[53] Morris to May Morris, September, 1888, BL, 45, 341, f. 80.

[54] Peter Floud, "Lecture," March 18, 1955, BL, 52, 772, ff. 62-79.

[55] Mackail, *Life of William Morris*, II, 201.

But despite his pessimism the first exhibition actually took place and was a great success. Morris himself was full of enthusiasm for the event, though he did continue to worry about the future of the organization and its significance. (He even gave a weaving demonstration.) The first catalogue was a grand affair, listing the many exhibitors and in many cases the makers of the works—there were 517 items. Sales did not take place at the exhibition, but prices were available. Radford, who was in attendance, put prospective buyers in touch with the artists. The exhibition at the New Gallery was open from 10 A.M. to 7 P.M. at one shilling and sixpence admission charge on weekdays. Sunday it was open free by ticket from 3 to 9 P.M., but not in the morning when it might interfere with church services. By October 24, £900 had been cleared, more than sufficient to cover expenses.

There was a considerable number of items from Morris & Co., most notably three arras tapestries of the *Morte d'Arthur* as well as silks, chintzes, and carpets. Morris also showed several of his calligraphic manuscripts, an important indication that his artistic interests were turning toward questions of calligraphy and lettering. Radford and H.J.L.J. Massé (elected a member of the Society in November, 1888) of the Art Workers' Guild, did most of the work on the catalogue. There were works from Voysey, Sedding, De Morgan, Crane, and thirty-four items from the Century Guild. Mackmurdo was very cooperative with the Society. As Crane had written to him the previous June: "I am very glad that you so heartily sympathise with our objects and are willing to help us and I trust we may be favoured with some of the Century Guild work. . . . We should be delighted if you succeed in gaining us support from the companies you mention."[56] (But there is no evidence that the "support" was forthcoming.)

The exhibition included a piece of furniture by Ernest Gimson, arguably the best English furniture maker of the period. Gimson's career illustrates the importance of such exhibitions

[56] Crane to Mackmurdo, June 1, 1888, J859, WMGW.

and the special significance of this moment in the history of design. The coming together in London of various craftsmen at just the time when Morris's influence was at its peak had important ramifications. The story of Gimson's meeting with Morris when Morris came to give a talk—"Art and Socialism"—at the Leicester Secular Society in 1884 is well known. After his talk he went to Gimson's father's house. The Gimsons were an old Leicester family, and the father himself a very well-off iron-founder. Morris suggested to the twenty-year-old son that he come to London. There he was articled to the architect, J. D. Sedding, at whose office he met Ernest Barnsley. In due course Barnsley introduced Gimson to his brother, Sidney, and Gimson's career would be intimately connected with the two brothers. At the Art Workers' Guild, when Sedding was master, there was a small exhibition in November, 1887, of plasterwork as applied to ceiling decoration. The following December, in 1888, when Crane was master, there was an exhibition of chairs. These were to be Gimson's two greatest interests. Sedding's office was next to Morris's showroom on Oxford Street, so the opportunity for exposure to Morris's work was considerable. Morris, and the organizations discussed here, formed a crucial part of Gimson's career—a coming together of forces. There was a continuation of the Morris tradition in the founding of the furniture firm of Kenton & Co., in 1890, with the Barnsleys, Lethaby, Mervyn Macartney, and Reginald Blomfield as principals. (The company soon failed because of undercapitalization.) In 1893 the Barnsleys and Gimson moved to the Cotswolds, and Gimson became devoted to the countryside and a hater of London. Urban events such as the Arts and Crafts Exhibition were crucial in the development of these movements in design that did so much to shape the looks of the modern world. "Gimson's position was therefore somewhat contradictory. While wishing to live the life of a country gentleman, with an active interest in local traditions and rural crafts, the main factor affecting the style of his designers was the vast range of work he saw in the late 1880s [in London],

which would not have been seen by most rural craftsmen. Even his initial motivation to move to the countryside came from the theories of a comparatively limited circle of people in London, rather than from any independent awareness he had of the benefits of rural life."[57] On the other hand, his move to the Cotswolds was partially motivated by work he did with a rural chairmaker, Philip Clissett, in Bosbury in Herefordshire—but it was seeing Clissett's chairs at the Art Workers' Guild that led him to take this step.[58] The intersection of older rural traditions at the metropolitan center was an important part of what was happening in the 1880s. And the Arts and Crafts Exhibition Society played a significant role in these developments.

With Massé's assistance, ads for the exhibition were placed in leading newspapers. The *Pall Mall Gazette* continued to be helpful. Even though it had disapproved initially of Crane's position, it had not objected to an exhibition that actually catered mostly to the decorative arts. In its issue of September 2, two days before the opening, it published an interview with Walter Crane, "The Arts and Crafts Exhibition: What it is and what it is for." Crane was very conscious of the relationship between trade and art: "No man in whom the spirit of art is can do his best work with the weight of the trader's yoke about his neck." He was particularly concerned to point out that a number of commercial firms had cooperated. It was ironic that an organization that had begun as a breakaway group was rapidly becoming assimilated into the role of adjudication in its area. The interviewer stated, "The Society will become accepted as an authority on all matters of ornament," to which Crane replied, "I hope so."[59]

"I am convinced [Morris had written] that the only time of the year available for the exhibition is from the middle of

[57] Stephen Baker, "Grimson's Cotswold Furniture," *Apollo* 109 (January, 1979), 49.

[58] Lionel Lambourne, *Ernest Gimson* (Leicester, 1969), p. 3.

[59] *Pall Mall Gazette* 48 (September 29, 1888), 6.

March to the middle of August. Any other time it would only be visited by the few who are interested in the subject. Isn't it now too late to get the thing afoot during this period this year?"[60] (It must have been a real joy to have Morris around pouring cold water on the plans that owed so much to him.) The *Illustrated London News* also had doubts about timing, but of a different sort. It felt that the exhibition showed signs of haste and had opened too early—in fact, that it should have waited another two weeks: "It would have been more prudent to have awaited the return to town of those who set the fashion even in exhibition going—and more especially in the case of an exhibition which appeals almost exclusively to the fashionable and would-be taste dictators of the country." In a somewhat condescending way the paper recognized that the display was dealing with a relationship between art and industry, what its reviewer chose to call "the personal element of our industrial system." He went on to remark, "There is too patent an effort on the part of the majority of the artists to produce what they regard as useful and an equal effort on the part of the craftsmen to disguise, under a decorative exterior, the direct purpose of their work."[61] Clearly, so far as he was concerned, the practical and the well designed had not yet reached their proper relationship; but he was perceptive enough about the purpose of Arts and Crafts work.

Other reviews were generous. One F. Elliot in the *Scottish Art Review* stated that both the exhibit and the catalogue "have essayed the task of educating those of the public who visit the New Gallery into a right understanding of what they are called upon to see. . . . The education of the people will speedily mean the education of the manufacturer." The exhibition, Elliot felt, demonstrated "the existence of the highest class of art work in our midst other than painting; and secondly, [it brought] before the public . . . efforts of craftsmen

[60] Mackail, *Life of William Morris*, II, 202-203.
[61] *The Illustrated London News*, October 13, 1888, p. 438.

who are as truly sharers in the generic term 'artist' as any follower of the purely pictorial side of art."[62]

There was also a characteristically quirky and amusing review of the show by George Bernard Shaw, published in the *World* on October 3, 1888: "It has been for a long time past evident that the first step toward making our picture-galleries endurable is to get rid of the pictures . . . signboards all of them of men who might have been passably useful as architects, engineers, potters, cabinet-makers, smiths or bookbinders." Shaw was a friend and admirer of Morris and maintained his friendship with him even though they disagreed about political tactics. (In the early 1890s Shaw, Morris, and Hyndman issued a joint socialist manifesto, but as Shaw was to comment, the common denominator was so bland that anyone could agree with it.) In his review Shaw is full of praise for the varied activities of Morris and comments specifically on the calligraphic manuscripts that he displayed: "The smaller unbound pages . . . show . . . what Mr. Morris can do with his valuable time in his serious moments, when he is not diverting himself with wall-decoration, epic story-telling, revolutionary journalism and oratory, fishing and other frivolities of genius." Shaw picked out a cassone by Burne-Jones as the most beautiful object in the exhibition, and he also mentioned, which must have gladdened Mackmurdo's heart, the work of the Century Guild: "The Century Guild are naturally prominent at an exhibition which they have done much to render possible. The *Hobby Horse* is enshrined in one of the glass cases, showing the other magazines how attractive a printed page can be made."[63]

[62] *The Scottish Art Review*, I, No. 6 (November, 1888), 160-162.

[63] This review was reprinted in the *Studio* of 1938, marking the fiftieth anniversary of the exhibition itself; "Fifty Years of Arts & Crafts," *Studio* 116 (November, 1938), 225-230. Included with it was a commentary by Nikolaus Pevsner. He underlined what he sees as the significance of the Arts and Crafts, and particularly of Morris. Although he may make a little too much of the Arts and Crafts as an essential step in bringing about the international style of the twentieth century, Pevsner's attitude nevertheless justly

Walter Crane summed up the genesis and effect of the first exhibition:

> The members of the society, who were also most of them members of the Art Workers' Guild aforementioned, were well aware of the difficulties they would have to face in the endeavour to realise their aims and carry out their principles. Their main object, however, was to demonstrate, by means of a representative public exhibition, the actual state of decorative art in all its kinds as far as possible. They desired to assert the claims of the decorative designer and craftsman to the position of artist, and give every one responsible in any way for the artistic character of a work full individual credit, by giving his name in the catalogue, whether the work was exhibited by a firm or not. They also desired to bring the worker and the public together. In spite of all drawbacks the richness and artistic interest of the exhibition was generally acknowledged, and the novelty of the idea attracted the public.[64]

And as important as the exhibition was the group of talks and the essays published in conjunction with it, bringing into popular view the ideas that marked the movement as the decade was coming to a conclusion.

At just the moment when the worlds of art and decoration were intersecting in an exciting way—and 1888 can be seen as the *annus mirabilis* of the Arts and Crafts movement—the opportunity to show their work appeared to be denied to the

emphasizes that these activities were not only important in and of themselves but had significant implications for the future: "If we, in this century of ours, are once more convinced of a contemporary style in architecture and the arts and of the fact that the designer of furniture or lamps or textiles is just as important an artist as a painter, we should realize that it is William Morris to whom we owe this revelation. The new conception of art, though theoretically established by Pugin and Ruskin, was first put to the test of practical applicability [when Morris founded his firm.]"

[64] Walter Crane, "The English Revival of Decorative Art," *Fortnightly Review* 58 (1892), 819.

members of the Society: certainly the Royal Academy gave little sign of being cooperative. The point is stated clearly in Walter Crane's introductory essay:

> The decorative artist and the handicraftsman have hitherto had but little opportunity of displaying their work in the public eye, or rather of appealing to it upon strictly artistic grounds in the same sense as the pictorial artist; and it is a somewhat singular state of things that at a time when the Arts are perhaps more looked after, and certainly more talked about, than they had ever been before, and the beautifying of houses, to those to whom it is possible, has become in some cases almost a religion, so little is known of the actual designer and maker. . . . It is undeniable that under the modern industrial system that personal element, which is so important in all forms of Art, has been thrust further and further into the background, until the production of what are called ornamental objects, and the supply of ornamental additions generally, instead of growing out of organic necessities, have become, under a misapplication of machinery, driven by the keen competition of trade, purely commercial affairs. . . . The true root and basis of all Art lies in the handicrafts. If there is no room or chance of recognition for really artistic power and feeling in design and craftsmanship—if Art is not recognized in the humblest object and material, and felt to be as valuable in its own way as the more highly rewarded pictorial skill—the arts cannot be in a sound condition; and if artists cease to be found among the crafts there is great danger that they will vanish from the arts also, and become manufacturers and salesmen instead.[65]

Here is a conception of the unity of art and of the need to turn to the handicrafts to revivify the arts. Gradually, under

[65] Walter Crane, "Of the Revival of Design and Handicraft," *Catalogue* (London, 1888), pp. 5-8.

the influence of the figures of the Art Workers' Guild, and now the Society, values in design were changing. At times those in the crafts could be strident and aggressive against the more established "fine" artists, but it was largely because the latter would not admit the craftsmen to their ranks. The craftsmen wished to influence all the arts, as was clear in the iconography of the catalogue. As the tailpiece there was a nautical image done by Heywood Sumner, a sailboat with a boy holding a sail labelled "The Arts & Crafts," and the words, over heads of putti from left to right, "Pottery Glass Painting Architecture Sculpture Metal Work Design." Architecture was in the center with painting and sculpture on its left and right.

The catalogue put forward a manifesto against what it saw as the crass commercialism of the more popular and successful artists. As artists became more professional, it was harder to tell them apart from the doctors and lawyers who filled the late Victorian landscape. But now on the threshold of the twentieth century a new sort of simpler and more direct world was being envisioned. It is for this reason, among others, that Morris was such an important bridge.

Morris's wide interests largely determined what aspects of the crafts world were emphasized. Morris transformed worlds of design and politics—as a poet, he was more conventional, although his interest in epic and folktales was part of the historical revivals and anthropological interests of the period. He was the major shaper of the directions in which design would go, and his reactions to what ideas and artifacts were put forward were highly important. Tapestry weaving and lettering were his greatest design interests at the time of the exhibition, and he wrote a short paper on tapestry and carpet weaving for the catalogue, a version of which he also gave as a talk at the first public meeting in connection with the exhibition (Figure 12). As the motto of the Socialist League was "agitate, organize, educate," so too that might be seen as the role of the Arts and Crafts Exhibition Society. His essay on tapestry was quite doctrinaire and took a stand against the Aesthetic movement's affection for things Japanese, and against

Arts and Crafts Exhibition Society.

YLLABUS OF LECTURES, IN CONNEC-
TION WITH THE ARTS AND CRAFTS
EXHIBITION NOW OPEN, TO BE GIVEN
IN THE NEW GALLERY, ON THURSDAY
EVENINGS IN NOVEMBER, AT 8.30 P.M.

Thursday, Nov. 1.—" Tapestry and Carpet Weaving."
William Morris.

Thursday, Nov. 8.—"Modelling and Sculpture." George Simonds.

Thursday, Nov. 15.—" Letterpress Printing." Emery Walker.

Thursday, Nov. 22.—" Bookbinding." T. J. Cobden-Sanderson.

Thursday, Nov. 29.—" Design " and Presidential Address.
Walter Crane.

The Object of the Lectures is two-fold : (1) to set out the aims of the Society, and (2),
by demonstration and otherwise, to direct attention to the processes employed in the Arts
and Crafts, and so to lay a foundation for a just appreciation both of the processes
themselves and of their importance as methods of expression in design.

The Lectures will be given in the North Gallery, and after each Lecture all the
Galleries will be thrown open, and will remain open till 11 p.m.

Admission by ticket. Price for a single lecture, 2s. 6d. ; for the course, 10s. For the
admission of workers in any Art or Craft, tickets, to be filled in with the name, address, and
Art or Craft of the worker, will be issued at 1s. each, or 25 for 20s., each entitling
to admission to a single lecture.

Exhibitors, Artists, and Craftsmen mentioned in the Index to the Catalogue may have
tickets free on application.

Doors open at 8 p.m. ; chair to be taken at 8.30 p.m. All tickets to be had at the
Gallery. Further information, if desired, to be had of the Hon. Lecture Secretary,

T. J. COBDEN-SANDERSON
Hendon N.W.

Chiswick Press :—C. Whittingham and Co., Tooks Court, Chancery Lane.

12. "Flyer for Lectures given in conjunction with the Arts and Crafts Exhibition,
1888, with decoration by Walter Crane."

imitation: "It may be well here to warn those occupied in embroidery against the feeble imitations of Japanese art which are so disastrously common amongst . . . us. A Japanese design is absolutely worthless unless it is executed with Japanese skill. . . . The Japanese have no architectural, and therefore no decorative, instinct. Their works of art are . . . quite outside the pale of the evolution of art, which, I repeat, cannot be carried on without the architectural sense that connects it with the history of mankind." There is a contrast between the more delicate Aesthetic movement and the more gruff, "down-to-earth" quality of the Arts and Crafts, although quite a few, such as the members of the Century Guild, shared characteristics of both movements. In designing for textiles, and presumably Morris felt this was important for all designing as well, the aim should be "to combine clearness of form and firmness of structure with the mystery which comes of abundance and richness of detail. . . . It is the pleasure in understanding the capabilities of a special material, and using them for suggesting (not imitating) natural beauty and incident, that gives the *raison d'être* of decorative art."[66]

In the lecture given on November 1, reported in the *Pall Mall Gazette*, Morris emphasized the special quality of tapestry work that can be taken to stand for the special attributes of the exhibition itself: the relationship between the artist and the executor: "Here [in tapestry], he said, we found perfect unity between the imaginative artist and the handcraftsman. The one was not too free, the other was not a slave."[67]

Crane gave a rather sweeping talk, "Of the Arts and Crafts Movement: Its General Tendency and Possible Outcome." It was the concluding talk in the series, as was appropriate for the president of the organization. The *Pall Mall Gazette* remarked of his lecture, "Then came a little bit of Socialism, very sensible and very quietly put. 'How can we have fine art when the worker is condemned to monotonous and me-

[66] Ibid., pp. 26-29.
[67] *Pall Mall Gazette* 47 (November 2, 1888), 6.

chanical labour in the midst of dull or hideous surroundings, when cities and nature are sacrificed to commercial greed, when Cheapness is the God of Life?' " The fact of expense, frequently thrown in the face of the movement, was faced— good design was not cheap—the point was to provide a model and to make it affordable by all. As a footnote it is interesting that the reporter gently chided Crane, "Like Mr. Morris, he quite underrates the art of Japan."[68]

The version of Crane's talk in the catalogue was more modest and entitled "Of Decorative Painting and Design." Even in the shorter version a reader can see Crane's purpose: he sought to bring the arts back together and restore, as he saw it, the painters' and sculptors' organic connection with the world of design. Here there was an important modernist strain moving toward design and pattern and away from the anecdotal burden of Victorian painting. Perhaps Crane, like Morris, was on shaky historical grounds, but his point was nevertheless significant: "We know that painting was strictly an applied art in its earlier history. . . . Painters will find again the lost thread, the golden link of connection and intimate association with the sister arts and handicrafts, whereof none is before or after another, none is greater or less than the other."[69]

Cobden-Sanderson gave a talk on bookbinding. Some years before, in 1883, Jane Morris, whether facetiously or not, had noticed that there was not a bookbinder in the group of people around her husband. She suggested to Cobden-Sanderson that he take up the art. Practically next door to Kelmscott House, Cobden-Sanderson started the Doves Bindery, named after the nearby public house, which became, probably, the most important bookbindery of the period. He bound Morris's copy of the French edition of *Das Kapital* (Figure 13). The binding, done in 1884, was the second independent one that Cobden-Sanderson had made, and parallel to the title on the

[68] Ibid., 48, November 30, 1888, 3.
[69] *Catalogue*, 1888, pp. 35-38.

13. "Binding by T. J. Cobden-Sanderson, 1884."

back he had engraved, "William Morris and Friends 1884."
The paradoxes and tensions of the relationships of politics and
design were noted in the 1968 Morgan Library exhibition of
this binding and others by Cobden-Sanderson: "The text was
of some importance to Morris and his circle, and according

· 219 ·

to a long autograph note on the final fly-leaf, before Morris brought the book to C–S to bind it, it 'had been worn to loose sections by his own constant study of it.' The binding pleased Morris, and F. S. Ellis thought it 'the best bit of modern finishing he had seen,' though he was shocked by 'the want of fitness in giving such a binding to such a vulgar, double-columned piece of printing.' "[70] Cobden-Sanderson noted in his own time book "blue, straight grain, tooled all over, own design, value by Ellis Bookseller at 10 guineas."[71] In 1900 he and Emery Walker established the Doves Press, one of the great private presses, notable for perhaps the most beautiful typography of the period. Cobden-Sanderson, in his short practical piece in the catalogue, pointed out the necessity for the unity of labor: "The work, as the craft of Beauty, suffers, as do the workmen, from the allocation of different operations to different workmen. The work should be conceived of as one, and be wholly executed by one person, or at most by two."[72]

Perhaps I should say a word about Cobden-Sanderson here, as he certainly became one of the most important figures in the Arts and Crafts movement, particularly in the history of the book. He was very active in the Arts and Crafts Exhibition Society and was responsible for the lectures and papers. Born in 1840, the son of a tax commissioner, he went to Cambridge but did not take his degree because he disapproved of competition. In 1882, he married Anne Cobden, the daughter of the great politician and free trader, Richard Cobden. She proved to be a much more vehement socialist than her husband whose socialism seems rather watered down in the English style, as an ethical rather than a political commitment. In 1890 they followed Morris into the Hammersmith Socialist Society. In

[70] *Bookbinding by T. J. Cobden-Sanderson* (New York, 1969), p. 11. Perhaps it is a further irony that the book is now in the Doheny Memorial Library at St. John's Seminary, Camarillo, California.
[71] October 9, 1884, BL, 49, 061, f. 2.
[72] *Catalogue*, 1888, pp. 88–89.

part in order to preserve an eminent family name and in part as a feminist gesture, he added her name to his. His aim, in his taking up of bookbinding, was to dignify what might be considered a somewhat lower craft. Two years before, Cobden-Sanderson had written in his journals about the importance of his work: "I bethought me with a smile of Morris's dictum made to me some twelve months ago at Rule's, that 'he did not want to multiply the lesser arts.' . . . So far as I, even I—*pace* Morris—may have any influence, to do the very thing he objected to, namely, just to multiply the lesser arts and to show people how beautiful life may be, life spent upon them."[73] These words too suggest that there was an element of making a task grander because it was a gentleman who was doing it.

Cobden-Sanderson expanded on the unity of art in the longer definitive version of the talk, writing in his rather fancy prose (he generally lacked Morris's sense of particularity):

> In bookbinding then as in other crafts I would commend for the work's sake and for the man's sake, the union of the lower and higher work, and the concentration in one craftsman of as many as possible of the labours which go to the binding, and to the decoration of a book. . . . The aim of the craftsman, worthy of the name, is to do good work, for good ends, and his desire is to be allowed unimpeded to pursue it. To be paid that he may work, not to work that he may be paid. . . . [The object is] the union of the highest life of the imagination and of the spirit, with the labour of the hands. . . . The so-called *educated* class are becoming more and more removed in knowledge and in sympathy, as well as in fact, from the practice of the Arts and industries. . . . [The working-class are more and more debased into finding] in the black coat and in the tall hat the consolation and the satisfaction

[73] *The Journals of Thomas James Cobden-Sanderson 1879-1922* (London, 1926) I, 243-244.

of their aspiration. . . . I commend to you the art and craft of the bookbinder and the life of the craftsman artist.[74]

The version of the talk reported anonymously by Oscar Wilde in the *Pall Mall Gazette* was more political—even though most of the talk was technical—an exaltation of the position of the worker. Cobden-Sanderson is quoted as having remarked: "The apron is the banner of the future." Wilde felt that the practical demonstration was more impressive than the talk itself. But he recorded Cobden-Sanderson's political position: "Before we have really good bookbinding we must have a social revolution. As things are now, the worker diminished to a machine is the slave of the employer, and the employer bloated into a millionaire is the slave of the public, and the public is the slave of its pet god, cheapness."[75] It is not clear, except in a romanticized medieval past, that the worker and the gentleman had ever been close, but whatever had been the case, Cobden-Sanderson believed that it was necessary now for the gentleman and the worker to unite via the crafts.

From the point of view of the greatest influence upon the history of design, there can be no question that the most important lecture given in connection with the exhibition was Emery Walker's on letterpress printing on November 15, listed in the printed essays as by both Walker and Morris. This lecture was the immediate progenitor of the Kelmscott Press, Morris's last great activity in the world of design, his solace along with his collection of books and manuscripts, of the last years of his life. It is wrong to state, as it is sometimes, that Morris was disillusioned with politics. But at the end of the decade his political energy, and health, not surprisingly, did wane, although he still did more politically—while pursuing other activities—than most other human beings.

[74] See John Dreyfus, ed., *Four Lectures by Cobden-Sanderson* (San Fransicso, 1974), pp. 62-65. Dreyfus based his version mostly on that given at the National Association for the Advancement of Art meeting at Edinburgh the following year.

[75] *Pall Mall Gazette* (November 23, 1888), 3.

Through his submissions to the exhibitions, Morris demonstrated his growing interest in calligraphy; he had also felt a growing concern, now greatly increasing in intensity, as to how his books looked. Eighteen eighty-eight was the year of his *The House of the Wolfings*, printed in a type selected by Emery Walker and Morris. He followed its production closely at the Chiswick Press, where Walker was an adviser and which, as Stephen Calloway has noted, was "an ordinary commercial printing firm, albeit one with a good typographical tradition." Morris's attempt there, however, was "to produce acceptably artistic books. Only partly successful, Morris's *The House of the Wolfings* and *The Roots of the Mountains* are really the first books of the modern movement."[76]

Walker was extremely close to Morris both artistically and politically, serving as secretary of the Socialist League and assiduously attending its meetings. At the same time he pursued a career that made him one of the greatest English typographers and a crucial figure in the history of the design of the book. Although Victorian book design was not quite as bad as some have made it out and was improving under the impetus of such events as the Caxton quadricentennial of 1877, it was only toward the end of the century with the work of Walker, Morris, Whistler, and of others, such as Charles Ricketts and his Vale Press established in 1896, that the page came to be thought of in an artistic way.

The private presses, as well as the furniture and other goods produced by Morris & Co., are frequently thrown in the face of Morris, and Walker too, presumably, as contrary to their claim to be socialists. It seems simple-minded to assume that if there had been no private presses, the revolution could have been hastened. And if the revolution were to have beautiful objects, a beautiful book should be among them. For Morris a beautiful house and a beautiful book were the two grandest things in the world and would be essential aspects of the post revolutionary world. Walker was both his leader and fol-

[76] Stephen Calloway, *Charles Ricketts* (London, 1979), p. 17.

lower, and he was so dedicated a socialist that it was somewhat of a surprise that in 1930, three years before his death, he accepted a knighthood. Selwyn Image, who did not share Morris's political views, commented to Mackmurdo, "What say you to dear old Emery's acceptance of a knighthood? Gad, it strikes me, I confess, as funny enough. What would W. M. say to it?"[77]

Walker had a long-time career in printing. Born in 1851, the son of a coachbuilder, he was self-taught and in the 1870s became coproprietor of a firm doing high quality engraving. He and Morris met at a socialist gathering in Bethnal Green in 1884. From then on they were companions in design (although their close association did not start for several years) and politics, living close to one another on the Mall in Hammersmith and working together endlessly on political matters for the rest of the decade. In 1885 they jointly established the Hammersmith branch of the Socialist League—the League's membership card, which Walker signed, was designed by Walter Crane and depicted Morris on its face.

In the 1890s Morris's greatest design interest, the Kelmscott Press, and his greatest political concentration, the Hammersmith Socialist Society, founded in conjunction with Walker, were established on the Upper Mall in Hammersmith. There is a traditional closeness between printing and radicalism, printer's "chapels" on newspapers frequently being the most radical and demanding of unions. The foreman printer for *Commonweal*, the paper of the Socialist League, was Thomas Binning, who later became father of the chapel, that is, head of the printers, at the Kelmscott Press. And it was through Binning's efforts that Mrs. Pine of the Kelmscott Press became the first woman member of the London Society of Compositors. Walker would go with Morris to Hammersmith Bridge on Sundays, where he preached the gospel of socialism. By

[77] Image to Mackmurdo, January 2, 1930, Ms Eng Lett, d. 140, f. 301, Bodleian Library. Morris was disconcerted in 1894 when Burne-Jones gave into the entreaties of his son and accepted a baronetcy.

1888 the two men were working together on the designing of books. This activity had been stimulated by Morris's irritation that, to his mind, none of his books were worthy of being included in the Arts and Crafts Exhibition.

It was in conjunction with the Exhibition that Walker gave his famous lecture on printing that Morris attended and that would have such significant consequences. In brief form, the lecture was printed in the 1888 catalogue; and in an expanded version in the 1893 edition, edited by Morris, of the *Arts and Crafts Essays*. Oscar Wilde, reporting the lecture in the *Pall Mall Gazette* with a good deal of enthusiasm, mentioned the importance of (what would soon become a considerable contribution of the Kelmscott Press; in some respects its chief legacy to modern printing) thinking about the total page. "With regard to illustration, the essential thing, Mr. Walker said, is to have harmony between the type and the decoration."[78] Like many truths, once stated it was self-evident, but little regard had been paid to such considerations earlier in the century. Walker had been reluctant to give the lecture, but Cobden-Sanderson, who was in charge of that part of the program, had persuaded him to do so. In his talk, Walker pointed out the need for illustrations to be integrated into the text and not serve a merely decorative purpose. For Morris the most important aspect of the lecture was the projection of enlarged photographs of Jenson letters from the edition of Pliny on a screen, inspiring him with the possibility of designing type.

Morris has left a vivid account of the lecture in a letter to his daughter, Jenny. (Incidentally, these letters make the most touching reading and contradict those who remark of Morris that he could be insensitive to others. Jenny was an epileptic; she tended to live out of the world, and her father felt a particular obligation to keep her informed of his doings, which he did in letters suffused with warmth and concern.) This particular letter suggests the extraordinary pace of Morris's

[78] *Pall Mall Gazette* 48 (November 16, 1888), 5.

activities and why he could give only limited attention to the Exhibition Society:

> I spoke on four consecutive days: last Saturday in St. Paul's Coffee, Sunday Hyde Park, Monday Store St. Hall, Tuesday Clerkenwell Green. At the latter place there was a bit of a shindy but not till the end when I had gone away: as a result I had to bail a comrade on Wednesday and spend a couple of hours in that sink of iniquity a Police Court. Thursday I was at the Arts & Crafts at Walker's Lecture on printing; he was very nervous and ought to have written down his words; but of course he knew his subject thoroughly well: there were magic-lantern slides of pages of books, and some telling contrasts between the good and the bad. There was a ridiculous Yankee there who was very much "risen" by Walker's attacks on the ugly American printing; who after the lecture came blustering up to Walker to tell him he was all wrong; so I went for him and gave him some candid speech of the said American periodicals.[79]

Morris had been greatly excited by Walker's lecture; on his way home he kept expostulating on the need, the compulsion, the pleasure, of making a new font of type: "Walker found in fifteenth-and sixteenth-century printing an answer to the question (which had been vexing Morris also for decades) of what was wrong with modern books; the failure lay, he decided, in the wrong proportions of margins, in excessive space between lines and words, in faulty type-design, and in the use of cheap ink and paper."[80]

In December, 1889, Morris asked Walker to go into partnership with him as a printer. He declined, "out of modesty"

[79] Morris to Jane Alice Morris, November 17, 1888, BL, 45, 340, f. 37; also in Henderson, pp. 302-303. The American may have been S. S. McClure. Susan Thompson, *American Book Design and William Morris* (New York, 1977), p. 37.

[80] William Peterson, "Introduction," in *The Ideal Book: Essays and Lectures on the Arts of the Book By William Morris* (Berkeley, 1982), p. xvii.

but also because he could not make a financial contribution—not that Morris would have required this. In any event, Walker was persuaded to perform crucial services for the Kelmscott Press. From its start in 1891, he put his knowledge of printing at Morris's disposal. He discovered Joseph Batchelor as the papermaker, Edward Prince as punchcutter, Janecke of Hanover as the best producer of ink. The printers resisted the German ink, but Morris told them if they would not use it, he would close the press. (The printers did have their revenge or at least were given their heads in their printing of the program of the annual wayzgoose feasts in which they used various designs from around the shop and created out of them a splendid Victorian jumble rather than the "designed" page that Morris did so much to further.) Walker was also useful in producing enlarged photographs of letters that assisted Morris in the designing of type—a fine reminder of Morris's willingness to use mechanical assistance to help him achieve what he wanted.

Morris's aim was to demonstrate that Gothic characters could be readable, but the two types—Troy and Golden—that he designed for the Kelmscott Press may not completely vindicate his claim. As the contemporary typographer and historian of typography, John Dreyfus has remarked, "Morris largely ignored the fact the Gothic letterforms were so infrequently read as continuous texts by his contemporaries that such letterforms, however beautifully and skillfully he interpreted them, were bound on account of their unfamiliarity to be considered less readable than roman type."[81]

[81] John Dreyfus, "William Morris Typographer," in *William Morris and the Art of the Book* (New York, 1976), p. 79. See also R.C.H. Briggs, "Sir Emery Walker: A Memoir composed on the occasion of the unveiling by Miss Dorothy Walker of a commemorative medallion put up at the London Country Council at 7 Hammersmith Terrace, London W. 6, 17 October 1959," and William Peterson, "Introduction." in *The Ideal Book*. Joseph Dunlap has remarked to me: "Golden was inspired by the Jenson type which is roman, while Troy was [Morris's] version of a rotunda gothic typeface. Of the former he wrote 'my Roman type, especially in the lower case tends rather more to Gothic than does Jenson's.' Thus Golden is roman with gothic features (and

This is not the place to tell the story of the Kelmscott Press. Its relevance here is that it arose out of the Arts and Crafts Exhibition Society. Such concerns had been in Morris's mind earlier, but it was Walker's lecture that immediately led to one of the most important events in Morris's life, the founding of the press, and thus to one of the most significant developments in the history of printing. And as Dreyfus has pointed out, the press had, in some sense, political significance: it was an attempt to control the means of production and obliterate, as so much of Morris's career was dedicated to, at least in theory, the divisions of labor, a blight of modern society. "Surely no previous printer, or none since Gutenberg, so effectively concerned himself with every step of the printing process as Morris did at the Kelmscott Press."[82]

Morris participated fully in the events of the exhibition, at the same time that he continued his intense political activity. He clearly felt some sense of enthusiasm as well as unease. What was happening was to considerable extent under his influence. He expressed some of these feelings in a short article, "The Revival of Handicraft," which he wrote for the November, 1888, issue of the *Fortnightly Review*. There he made extremely clear that he saw these developments in the context of a world that Marxism explained. To an extent one might almost say that Morris was won over to the view that the workman deserved somewhat more official credit than he had previously thought—that it was appropriate for the workman's name to be given as well as the designer's as demonstrating his full participation: "There has been a growing feeling that this art workmanship to be of any value must have

is really not difficult to read) while Tory is a gothic face with roman features—certainly not the angular textura gothic of northern Europe. This was his way of calling attention to the fact that a book should be coherent in all its aspects. Decorating weak typography he found to be useless in the 1860s, but now, by designing type, he controlled everything. By doing it his way he was 'pounding the table' in front of careless bookmakers" (personal communication, August 8, 1982).

[82] *William Morris and the Art of the Book*, p. 115.

some of the workman's individuality imparted to it beside what of art it may have got from the design of the artist who has planned but not executed the work."

Morris also made clear his full understanding of the sentimentalism that might influence antagonism against the machine: "People interested (or who suppose that they are interested) in the details of the arts of life feel a desire to revert to methods of handicraft for production in general; and it may therefore be worth considering how far this is a mere reactionary sentiment incapable of realization, and how far it may foreshadow a real coming change in our bits of life as inevitable as the former change which has produced the system of machine production, the system against which revolt is not attempted." As a communist, Morris might take, in a sense, a tolerant attitude toward the machine. It formed part of the inevitable process in the changing of the world: he saw the developments in the Arts and Crafts as playing a small, but nevertheless significant element in changing man's relationship to the machine. Therefore the Arts and Crafts, though not necessarily a route of liberation, were an indication that change could, would, and should take place. Morris maintained in this article that machinery did undermine aesthetics. But he did not take the pure aesthetic position that the main purpose of art was beauty. He was both a Ruskinian and a Marxist—purpose and utility in some sense were his primary concerns—art came from pleasure in labor and not necessarily in the beauty of the object achieved; art came from a proper human use of the material and not the subjection of the material to industrial use. Machinery should be a servant or less— never the master because of its commercial implications. This idea indeed went back to Ruskin's attack on the divorce between design and execution.

Morris is concerned in his article with the effects of machinery upon handicrafts—a central problem for the whole movement. Even those who were favorably inclined toward the machine wished to control it. Morris interpreted handicrafts rather broadly, yet in keeping with his famous dictum

of 1880, "have nothing in your houses that you do not know to be useful, or believe to be beautiful." If possible, useful things are to be beautiful, but Morris writes in his essay of 1888 that he includes under the term handicraft "all products of labour which have any claims to be considered beautiful" and not items which do not make such claims. He is dramatically unsentimental in his approach, "I must at the outset disclaim the *mere* aesthetic point of view which looks upon the ploughman and his bullocks and his plough, the reaper, his work, his wife, and his dinner as so many elements which compose a pretty tapestry hanging, fit to adorn the study of a contemplative person of cultivation. . . . What I wish for is that the reaper and his wife should have themselves a full share in all the fullness of life."

Morris felt that it was necessary for everyone to know something of Marx and his analysis of the division of labor, how man became first part of the machine and then a servant of the machine. The importance of the handicrafts in Morris's scheme of the world is that not only are they significant in themselves but they make clear the problem presented by the machine and by modern society, and demonstrate why worker control over the machine represented the proper solution of the problem.

The first exhibition was sufficiently a success for the Society to continue to operate, which it did for some years, but the constitutional structure of the organization was never strictly spelled out. There was a president and a secretary, and a governing committee of twenty-five, as well as a group of guarantors. An appointed, not elected, subcommittee, did the selecting. However, the committee—presumably the governing committee of twenty-five—was to be elected by the membership, so perhaps the democracy originally envisioned was achieved to some extent. There were elements of the traditional club in that potential members could be blackballed— one in six would exclude. In another draft of the rules, it was stated that potential members needed to be proposed by two members and that one blackball in twelve would exclude.

Membership in any case did not seem very important; there is no indication that it was required in order to display in the exhibition. It seems to have mattered only for those who were interested in the running of the organization and was not particularly striven for, unlike membership in the Art Worker's Guild.

In the records of the Society there exists a draft of Rules and Regulations, dated November 14, 1888. There it was stipulated that there should be lectures so that "the Worker may have an opportunity of demonstrating to the Public the Aptitudes and the Limitations of his Craft." Also surviving in the fragmentary papers of the organization is some record of its financial proceedings. For the five lectures given in November, 1888, by William Morris, George Simonds, Emery Walker, Cobden-Sanderson, and Walter Crane, there was a charge of either two shillings and sixpence each or ten shillings for the series. Admission to the exhibition was a shilling, or five shillings for the season. There was a certain casualness in the financial arrangements; the previous April Crane had received a letter from a solicitor advising him that the group should be formalized with a constitution; in order to limit liability there should be an official organization rather than a gathering of interested people.[83] As it turned out, the exhibition was a financial success, taking in £1232/8/3, with a profit of £149/16/2. The minute books continued for a while longer; from them we learn that at a meeting on November 14 concern was expressed about the future of the Society. Morris attended several meetings and urged that the Society not push its luck and typically suggested that it postpone having another exhibition for some time. The exhibition provided a public face for the movement, which the Art Workers' Guild had deliberately avoided. The National Association for the Advancement of Art, founded in 1888, was to be a body devoted to putting forward a public face and not directly concerned with objects. It might be most immediately in-

[83] George Gregory to Walter Crane, April 6, 1888, SDCA.

volved in educating the public. The Exhibition Society fell between the two.

The organization remained rather loose. In 1890 there were sixty-two members. Of these twenty served on the committee. There was also a list of forty-three guarantors that included two organizations: the Skinners' Company, and the Society itself. In 1894 there were about one hundred members. The financing seemed also to be somewhat ad hoc. At the end of the exhibition, as recorded in the minutes of December 15—the day the exhibition closed—there was £75 on hand. At the next meeting the guarantor fund was discussed, and Morris proposed that guarantors be asked to assure fifteen pounds, which by a narrow vote of six to five was considered too high, and Lethaby's proposal that the sum be five pounds won by the same margin. At the meeting of January 23 a committee of thirteen was established to plan for the new show. Once involved in something, Morris could not help taking a significant part, as indicated in a letter written the next day to Charles E. Hallé. Hallé, along with J. Comyns Carr, the art critic who had worked with Sir Coutts Lindsay at the Grosvenor Gallery, had founded the New Gallery. Apparently they did not feel that the Society was running itself in a proper financial way, and Morris tried to assure them: "I never called in question your right to claim some sort of representation in the arrangement of the expenses of the Arts & Crafts if it could be managed; but believing that we should be very glad of the advice of yourself and Mr. Carr in matters of which you have so much experience . . . perhaps some sort of assessorship could be managed. . . . The A & C Society is now somewhat more formally constituted than last year, with a definite executive and outside constituency. I have consented to be on the said committee in the hopes that I shall be able to give necessary time in taking an active part in the business."[84] Indeed, it was amazing how much time he was able to give to the Society's business, particularly as he re-

[84] Morris to Charles E. Hallé and J. Comyns Carr, January 24, 1889, Collection Stuart B. Schimmel, New York.

garded it not as a major reform but rather as a palliative. But Morris had a vivid sense of the disparate divisions within his personality held together by, if anything, his politics: "I have found out that my valuable skin covers say about a dozen persons, who in spite of their long alliance do occasionally astonish each other very much by their strange and unaccountable vagaries, by their profound wisdom, their extreme folly, their height of elevation, and their depth of baseness."

In a lecture, "How Shall We Live Then" given on March 1, 1889, to the Fabian Society, he took up some of the same themes as in his earlier article on handicrafts in the *Fortnightly Review*: That "the greater part of people were ill-fed, ill-clad, ill-housed, overworked, and as a consequence nasty and disagreeable." In this lecture he couples as his two purposes the regeneration of popular art—and this is where the Exhibition Society could play a role—and the regeneration of life through socialism. He uses the language of "religious experience," describing his conversion to socialism: "in short I was born again." He also makes clear again his conception of human nature and the place in it for work and craft as something natural:

> We shall not be happy unless we live like good animals, unless we enjoy the exercise of the ordinary functions of life: eating sleeping loving walking running swimming riding sailing we must be free to enjoy all those exercises of the body without any sense of shame; without any suspicion that our mental powers are so remarkable and godlike that we are rather above such common things. . . . We must be strong and healthy enough to enjoy bodily labor. . . . Most people would want to learn two or three of the elementary crafts whether they intend to practice them as a main occupation or not, smithying, carpentering (not cabinet making) and masons's or bricklayer's work.[85]

[85] Paul Meier, ed., "An Unpublished Lecture of William Morris," *International Review of Social History* 16 (1971), 7-15.

Meanwhile the Exhibition Society made plans for a second show. This time more employers were cooperative and were willing to give the names of the actual makers of the furniture. In an interview Crane had cited Gillow's as one of the firms that had not cooperated, and in the *Pall Mall Gazette* on October 6 a correction was published: the firm had not received the circular and in fact was eager to cooperate. At a meeting of the committee on February 5 it was decided to increase Ernest Radford's salary to £225, but out of that sum he would have to pay for a clerk. Mackmurdo also wrote to the Society as he was anxious to coordinate its exhibition with the next, the second, meeting of the Art Congress. The end of this important decade marked an extraordinary efflorescence of related activities in the Arts and Crafts, and the National Association for the Advancement of Art—the Art Congress— might serve to tie them all together. Mackmurdo's thought was that the Congress should meet two weeks before the exhibition, while the committee felt it might be more effective to have the Congress take place two weeks after it. That the timing made a significant difference is hard to imagine; one group would be informed about the other, and presumably quite a few individuals would attend both the Exhibition and the Congress.

For the 1889 catalogue, the president, Crane, simply repeated his preface from the first exhibition but did add the statement that "our little ship (as in Mr. Sumner's device) which after much anxious consideration, by united efforts was provisioned and set afloat with its first voyage prosperously." In the catalogue there are twenty-two pages of exhibitors. Morris was very much involved and much more enthusiastic, perhaps reflecting some of his euphoria and excitement about the plans for the Kelmscott Press; he was even combining some of his various endeavors, as when he wrote to Jenny on October 17 that "we are thinking of binding the large paper in our chintzes—that would be amusing wouldn't it?"[86]

[86] Morris to Jane Alice Morris, October 16, 1889, BL, 45, 340, f. 69. There

It is daunting to recall how much Morris was doing at this period. He embarked upon a new sort of writing—the long prose romances—with *The House of the Wolfings* in 1888 and *The Roots of the Mountain* in 1890. He devoted much more time and concern for the typographical nature of these books than he had done previously, giving particular consideration to how two pages looked, when opened, as a total picture, and the relationship between type and decoration. He also published in 1888 *A Dream of John Ball*. And one should remember that, as Philip Henderson has calculated, he delivered 260 formal lectures in the period between 1884 and 1890.[87]

Morris wrote to Jenny, "As for the exhibition I think it will be a success: the rooms look very pretty; and there are a good many interesting works there. The visitors come pretty well: these first 3 days they have taken more than double than they did in the same time last year; so this looks good."[88] Morris was ubiquitous in this exhibition. The firm contributed both woven and cotton goods, Morris wrote an essay on dyeing for the catalogue, and opened the lecture series with a talk on Gothic architecture. (This talk had a double connection with the exhibition; having been delivered first at the Exhibition of 1889, it was then printed, by the Kelmscott Press, during the 1893 Exhibition.)

In his opening lecture Morris enunciated his view, common among the senior figures associated with the Arts and Crafts, of the vital importance of architecture as the queen of the arts. He saw decoration as in a basic sense a part of architecture. This was one reason he was able to place painting and sculpture in what he regarded as a subsidiary position to his greatest interests. Architecture by definition was an art that requires cooperation and is not an individual endeavor: it is "inclusive

wasn't a large paper edition of *The Roots of the Mountains* but a special edition of 250 copies on Whatman paper was bound in chintz. (Personal communication Joseph Dunlap, August 8, 1982.)

[87] Cited by A. R. Dufty, "William Morris and the Kelmscott Estate," *The Antiquaries Journal* 43 (1963), 100.

[88] Morris to Jane Alice Morris, October 15, 1889, BL 45, 340, f. 66.

of all the serious arts, all those which are not engaged in the production of mere toys, or of ephemeral prettinesses. Now all these works of art are man's expression of the value of life, and also the production of them makes his life of value." Morris feared that modern civilization, the introduction of mechanical means, would destroy the architectural values the exhibition was meant to celebrate. He made clear how his world of design and politics intersected and his fear that the . continued triumph of capitalism would endanger both society and art: "If this tendency is to go along the logical road of development, it must be said that it will destroy the arts of design and all that is analogous to them in literature." He argued for a need for a "revolt against utilitarianism, toward the attempt at catching up the slender thread of tradition before it be too late." He adored Gothic architecture in part because it represented the fusion of purpose and method he had in mind. He regarded it as a "free" architecture, parallel to what he was pointing to in his own thought. For instance, he felt that the arch "taking into consideration its combined utility and beauty, must be pronounced to be the greatest invention of the human race. Architecture without slaves honored the arch." Morris's ideal was the cooperative nature of Gothic architecture; it was that sort of spirit that he hoped would be recaptured. Architecture appealed to his anti-individualistic strain, his prejudice against genius, his belief that talents were present in each individual, his fundamentalist sense of democracy, which does, for better or worse, seem to go against the grain of the hierarchies of talent and intelligence.

This important lecture also demonstrates that it is clearly unwise to associate Morris too much with the starkness of some aspects of the Modern movement. He does in some ways prefigure the movement; yet he was also far more alive and alert to complexity and richness of design than some modern theorists of functionalism: "The cant of the beauty of simplicity (i.e., bareness and barrenness) did not afflict [the Gothic style]: it was not ashamed of redundancy of material,

or super-abundance of ornament, any more than nature is. Slim elegance it could produce, or sturdy solidity, as its moods went." Despite his somewhat reluctant support of Mackmurdo's campaign on behalf of Wren, he really did not like his work and in this talk describes a taste for St. Paul's as comparable to "the taste of a man who should prefer his lady-love bald." Such buildings he felt were worthy of dons—not his favorite people. "Beauty and romance were outside the aspiration of their builders. . . . There is only one style of Architecture on which it is possible to found a true living art, which is free to adopt itself to the varying conditions of social life, climate, and so forth and that style is Gothic architecture. The greater part of what we now call architecture is but an imitation of an imitation, the result of a tradition of dull respectability, or of foolish whims without root or growth in them. . . . The modern world finds the eclecticism of the present is barren and fruitless, and that it needs and will have a style of architecture which, I must tell you once more, can only be as part of a change as wide and deep as that which destroyed feudalism." Gothic architecture for Morris was a symbol of a unified and organized approach to art and life that he felt to be necessary for the future. This unity could be achieved only by a transformation of the world of art and politics. The Arts and Crafts Exhibition Society was making that sort of effort and in its limited but important way was moving in that direction.[89]

The catalogue for the second show was similar to that for the first: there were 868 items in the exhibition. The literary committee of the Society had met during the year and considered, according to its minute book, what essays should be written for the catalogue and what lectures given as a series parallel to the previous year. It was considered briefly whether or not to give up the lectures. Cobden-Sanderson was again designated as the literary editor and the lecture secretary. Walker and Cobden-Sanderson supervised the printing of the cata-

[89] William Morris, *Gothic Architecture* (London, 1893).

logue at the Chiswick Press. The earlier overlapping of lectures and papers printed was avoided, and there were two different series. The papers in the catalogue tended to be shortish notes on various aspects of the exhibition: Ford Madox Brown, "Of Mural Painting"; Heywood Sumner, "Of Sgraffito"; G. T. Robinson, "Of Stucco and Gesso"; W. R. Lethaby, "Of Cast Iron"; William Morris, "Of Dyeing as an Art"; May Morris, "Of Embroidery"; Alan S. Cole "Of Lace"; R. T. Blomfield, "Of Book Illustration and Book Decoration"; and Lewis F. Day, "Of Designs and Working Drawings." The lectures, given weekly, began with Morris on Gothic architecture on November 7. Then every week thereafter until December 5, lectures were given at the New Gallery itself: Henry Holiday on stained glass, Cobden-Sanderson on the decoration of bound books, Lewis F. Day on ornament, Walter Crane on design and expression, and Selwyn Image on designing for the art of embroidery. The activity and organization were considerable, and this show too was quite a success. There were now fifty-nine official members of the Society, but as noted, membership did not seem very important as the right to exhibit was not limited. Members rather seemed to be those who were willing to do the work. It is of interest that unlike the Art Workers' Guild, membership was not limited to men and that May Morris, Evelyn De Morgan, and Kate Faulkner belonged.

The catalogue served as a rallying cry for those opposed to what they regarded as the dominating tendencies in design and manufacture. As Walter Crane wrote in the preface:

> With the organization of industry on the grand scale, and the enormous application of machinery in the interests of competitive production for profit, when both art and industry are forced to make their appeal to the unreal and impersonal *average*, rather than to the real and personal *you* and *me*; it is not wonderful that beauty should have become divorced from use. . . . Partly as a protest against the state of things, and partly to concentrate the awakened

feeling for beauty in the accessories of life, the Arts and
Crafts Exhibition Society commenced their work. . . .
[The movement] reflects in art the intellectual movement
of inquiry into fundamental principles and necessities.

Crane saw a radical approach and the need for change as
providing both a moral and a commercial benefit. Design had
been debased in the belief that doing so would make it more
popular and sell more.

The preface continued: "With some the question is closely
connected with the commercial prosperity of England, and
her prowess in the competitive race for wealth: with others
it is enough if the social well-being and happiness of her people
is advanced, and that the touch of art should lighten the toil
of joyless lives. The movement indeed represents in some
sense a revolt against the hard mechanical conventional life
and its insensitivity to beauty (quite another thing to orna-
ment). It is a protest against that so-called industrial progress
which produces shoddy ware, the cheapness of which is paid
for by the lives of its producers, and the degradation of its
users. It is a protest against the turning of men into machines;
against artificial distinction in art, and against making the
immediate market value, or possibility of profit, the chief test
of artistic merit. It also advances the claim of all and each to
the common possession of beauty in things common and
familiar, and would awaken the sense of this beauty, deadened
and depressed as it now so often is, either on the one hand
by luxurious superfluities, or on the other by the absence of
the commonest necessities, and the gnawing anxiety for the
means of livelihood; not to speak of the everyday ugliness to
which we have accustomed our eyes, confused by the flood
of false taste, or darkened by the hurried life of modern towns
in which huge aggregations of humanity exist, equally re-
moved from both art and nature and their kindly and refining
influences." Crane, perhaps more than Morris, visualized the
handicrafts themselves playing a central role in the transfor-
mation of the world, making "through art, the great social-

izer, for a common and kindred life, for sympathetic and helpful fellowship, and [creating] conditions under which your artist and craftsman shall be free. . . . It must mean either the sunset or the dawn."[90]

Part of Morris's message was that problems of design (and Morris would say problems of life) had to be approached in a total way and incorporate all the Arts and Crafts. As Blomfield remarked about the illustrator: "The artist must abandon the selfish isolation in which he has hitherto worked. He must regard the printed type not as a necessary evil, but as a valuable material for the decoration of the page, and the type and the illustration should be considered in strict relation to each other. . . . Thus, to the skill of the draughtsman must be added the far-seeing imagination of the designer, which, instead of being content with a hole and corner success, involving disgrace to the rest of the page, embraces in its consciousness all the materials available for the beautification of the page as a whole. It is only by this severe intellectual effort, by this self-abnegation, by this ready acceptance of the union of the arts, that the art of the book illustration can attain to a permanent value."[91]

The show was again a success, but *The Scottish Art Review*, finding it less impressive than its predecessor in 1888, pointed out the risks in an exhibition of the decorative arts—that shop windows might have wares as good as those that were being exhibited. Admittedly, progress was being made in the level of design, but the *Review* felt impelled to add that "The amateur is somewhat rampant."[92]

Whatever the risks, this time the show was financially successful. The guarantors had paid in £90, £13 of which was returned. A bank loan of £100 was repaid. Receipts from the exhibition were slightly more than £1400. After expenses were paid off, the Society was left with a balance of £72/7/4—hardly a huge sum but enough to keep the Society out of the red

[90] Preface, *Catalogue*, 1889, pp. 7-11.
[91] Ibid., pp. 92-93.
[92] *The Scottish Art Review* 2 (November, 1889), 174-175.

and make it feel that it could go on. The 1890 exhibition would not be so successful, however (Figure 14).

The original impetus seemed to be somewhat lessened. To have a large annual exhibition, without the established panache of the Royal Academy, was rather difficult. Yet the catalogue of the third exhibition in the fall of 1890 was still considerable: there were 642 listings. The Society continued its campaign against cheapness: "In fact, cheapness as a rule, in the sense of low-priced productions, can only be obtained at the cost of cheapness—that is, the cheapening of human life and labour; surely, in reality, a most wasteful and extravagant cheapness?" This was from Walter Crane's presidential preface. He ceased being the president this year, to be replaced by Morris, but became president of the Society again in 1895, continuing until 1915, the year of his death.

Crane indicated that the exhibition concentrated on furniture and embroidery, as did the essays in the catalogue. He also was particularly pleased that more firms had participated and that they no longer seemed reluctant to reveal the names of those who had made the pieces. (Perhaps the firms had been fearful that another business might try to steal their best workmen.) Crane appeared to suggest that the quality of the work was perhaps not as high as he would like: "Judgment is not always infallible, and the best is not always forthcoming, and in a mixed exhibition it is difficult to maintain an unvarying standard. At present, indeed, an exhibition may be said to be but a necessary evil; but it is the only means of obtaining a standard, and giving publicity to the works of Designer and Craftsman; but it must be more or less of a compromise." An effort was made to acquaint workers with the standard set, in that Monday evenings were designated as a time for free tickets for "craftsmen and others who may be unable to attend during the day." There was an awareness of the danger of the movement being dominated by the leisured amateur and the need to involve the more ordinary workman. As Crane remarked, the tickets were for "that part of the public who have no leisure in the daytime, namely, craftsmen,

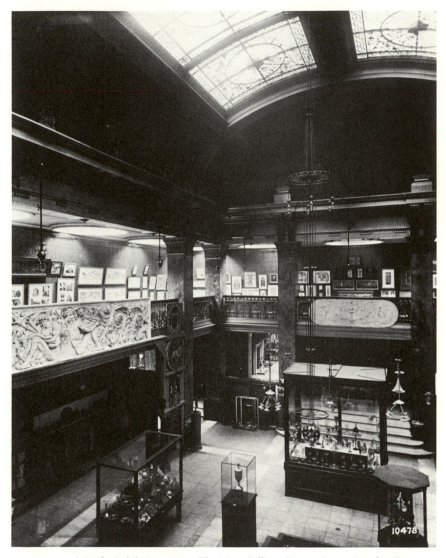

14. "Arts and Crafts Exhibition, 1890, The New Gallery, Regent Street, London."

students, and workers in the arts." He was also clearly aware
of the dangers of the goods being too expensive, although
ironically some apparently thought that the Society was trying
to show "cheap and saleable articles. . . . It should be re-
membered that cheapness in art and handicraft is wellnigh
impossible, save in some forms of more or less mechanical
reproduction."

The catalogue gives the sixty-two names of the members
of the Society, including the nineteen who were on the com-
mittee, mostly those who had been with the Society since the
beginning, such as Benson, Cobden-Sanderson, Day, Leth-
aby, Sumner, Walker, and Morris himself. The catalogue in-
cluded also a list of forty-three guarantors, among others,
Augustine Birrell, C. A. Ionides, and Sir George Sitwell. This
year, indeed, they were to be called upon, as the Society was
in the red to the extent of £138/19/1, having lost £250/11/6
on the exhibit. Expenses had exceeded receipts from attend-
ance. But there had been some enthusiastic appreciations, per-
haps most notably from William Butler Yeats (Yeats's text is
given in the Appendix).

There was an interesting set of essays in the catalogue on
furniture and embroidery. Edward Prior, the architect, inti-
mately involved with the founding of the Art Workers' Guild,
wrote on "Of Furniture and the Room," pointing out the
dangers of overcrowding—the modern emphasis on "less is
more": "These accumulations of fussinesses beget a weari-
ness, and one is betrayed into uncivilized longings for the
workhouse or prison-cell, the simplicity of bare boards and
tables." He objected to art being limited: "Art being the mo-
nopoly of painting, and having nothing to do with such vulgar
matters as furniture, commercialism has been able to advance
a standard of beauty of its own, with one canon, that of speedy
profits." Prior argued for a new/old unity of the arts: "When
we care for art sufficiently to summon her from her state-
prison-house of exhibitions and galleries, to live again a free
life among us in our homes, she will appear as a controlling
power, using painting, and sculpture, and all the decorative

arts to shape room and furniture under one purpose of design."

The next essay, "Of the Room and Furniture," was by Halsey Ricardo. He argued against the imitation of old furniture: "To take advantage of their survival and to increase their number by facsimile reproduction, is to paralyze all healthy growth of manufacture." We can see the "functionalist" approach in Ricardo's appreciation of a costermonger's barrow as "living art": "The value of furniture depends on the directness of its response to the requirements that called it into being *and to the nature* of the conditions that evoked it." Reginald Blomfield wrote "Of the English Tradition" in furniture; W. R. Lethaby, "Of Carpenter's Furniture"; J. H. Pollen, "Of Decorated Furniture"; Stephen Webb, "Of Carving" and "Of Woods and Other Materials"; and Thomas Jackson, "Of Intarsia and Wood Inlay." The latter group of these short essays were mostly passing on information, although both Blomfield and Lethaby spoke of decline: In Blomfield's case, of knowledge about furniture, and in Lethaby's, of the quality of plain furniture. They were taking the familiar but powerful line: what a falling off there had been from the past! Particularly in England, looking back to a golden age is a standard way of calling for possibly radical changes in the present.

The next essays in the catalogue were on embroidery. One, "Of Modern Embroidery" by Mary Turner, Thackeray Turner's wife, made a point on the decline of quality similar to that in the pieces on furniture: "The more, indeed, people will study the fine designs of the past, and compare with them the designs of the art-needlework of the present, the more they will realize that, where the former is rich, dignified and restrained, obedient to law in every curve and line, the latter is florid, careless, weak, and ignores law." The further essays were by May Morris on materials and on color and by Alan Cole on stitches. The final two essays were on design, the first by J. D. Sedding, who asked why the fluorescence of embroidery had not been more successful, clearly seeing it as part of the general resurgence of crafts, dating back to the

Gothic revival: "For the last sixty years, ever since the Gothic Revival set in, we have done our best to resuscitate the art of embroidery. First the Church and then the world took up the task, and much admirable work has been done by the 'Schools,' the shops, and at home. And yet the verdict still must be 'the old is better.' "

Sedding felt that the failure was in the area of design. There needed to be a turn to nature, rather than imitating and reproducing old work. It is in this essay, in this rather domestic context, that Sedding makes an important remark for the whole movement, asserting the humaneness, the humanity, of the Arts and Crafts: "Doubtless there is danger to the untrained designer in direct resort to Nature. For the tendency in his or her case is to copy outright, to give us pure crude fact and not to *design* at all. *Still there is hope in honest error: none in the icy perfections of the mere stylist.*"[93] (My emphasis. This sentence, slightly altered, was incorporated in a memorable design by Charles Rennie Mackintosh; Figure 15.) The final essay of the group, also on design, was by Selwyn Image. He too emphasized the importance of turning to nature for inspiration, as well as having a full knowledge of older traditions of embroidery.

The idea of exhibitions was not new: the first and most famous example being the Great Exhibition of 1851, which had so repelled Morris. The Royal Society of Arts had held exhibitions tied in with its interest in design and manufacture. But the exhibitions of the Arts and Crafts Society were special. They were not concerned with manufacture, although their ideas might be borrowed by the "art manufacturers." The aim was rather to try to reform design and to move it toward a simpler and less pretentious, nonhistorical style. Some had hoped that the Art Workers' Guild might have exhibitions as part of its program, but they were very few and tended to be just for one day, in support of a particular talk and not open

[93] *Catalogue*, 1890 (London, 1890), pp. i–127 (pages quoted i, 6–7, 8, 18, 24, 25, 27, 29–30, 86, 122, 127).

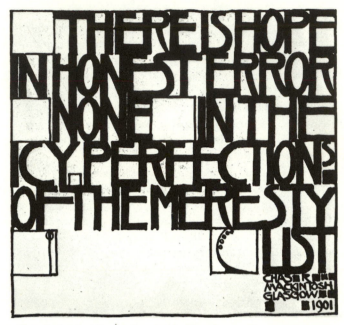

15. "Inscription by Charles Rennie Mackintosh, 1901."

to the public. In some slight sense the Society was a way of expressing dissatisfaction with the Guild, or rather it was doing something that some had hoped the Guild would do itself. But it was probably to the good that there was a separate organization, more open, and not afraid of publicity. The Art Workers' Guild worked behind the scenes, and fairly rapidly its members became quite successful in securing commissions and were likely to employ their "brothers." Its members also became very influential in shaping contemporary art education in its vast expansion at this time. The Guild provided a fine example of outsiders becoming insiders and probably in the process somewhat losing touch with Morris's original impetus.

The early history of the Society was fairly smooth, and

apparently there was little internal dissension. The commitee and membership took shape through election and co-option. There is no indication that it actually followed the policy of selecting a jury by canvassing the artists of the kingdom. Although there were paintings and sculptures in the exhibition, it was dominated by examples of the decorative arts, and quite a few of those were from firms, with the designer and executor indicated when possible.

In 1891 it was decided for financial reasons, but also because insufficient work of high quality was available, to omit an exhibition that year. Morris was elected president in place of Crane; and the next year he was also master of the Art Workers' Guild. Both posts were primarily honors given to the grand figure of the movement, and as such they reinforced the impression of his unquestioned authority. Those who might disagree with him politically did not allow that to stand in their way in honoring his role in the world of design. These posts were a recognition that "the whole modern arts and crafts movement had its origins and implications as the ideals and experiments of the Morris Firm."[94] Morris was listened to very seriously, and his advice taken, most immediately on the decision not to have an exhibition in 1891. But friends and colleagues would restrain him when they felt it necessary, as they did the next year, in rejecting his motion criticizing the decision of Thomas Jackson not to preserve the figures on the spire of St. Mary's.

There were financial difficulties. At the general meeting of May 7, 1891, the guarantors were called upon to give aid. There was also discussion as to whether there should even be an exhibition in 1892. Morris's growing interest in printing may have diverted his energies, although even as president he was unlikely to have devoted that much time to the Society. (The Kelmscott Press's first volume was his *The Story of the Glittering Plain*. Work on it had started in January, 1891, with

[94] A.R.N. Roberts, *William Richard Lethaby 1857-1931* (London, 1957), p. 12.

printing in February, completion in April, and publication in May.) At the general meeting on December 4, 1891, the question arose as to whether to dissolve the Society, and a vehement discussion took place. It was proposed that there be a small annual exhibition, but this motion failed, as did Ashbee's motion (already revealing his desire to move out of London) that the exhibition need not be in the metropolis.

These years were a rather difficult patch for the Society; it had made its point, with some effectiveness but not with the overwhelming success it may have hoped for. An exhibition every year involved too much work, and the quality was going down. Paradoxically, it might be said that the Society was too successful. The shop windows of Tottenham Court Road were reflecting its taste. Eventually the work of Ambrose Heal, Gordon Russell, and others would combine the style of the Arts and Crafts movement with greater productivity through machines. Heal in particular made plain yet stylish furniture available to the middle class. Handcrafted furniture was expensive, as undoubtedly was that made by the man Morris considered the greatest furniture craftsman of his time, Ernest Gimson, his associates, the Barnsleys, and his successor, Peter de Waal. Earlier in the nineteenth century ornate furniture style had filtered down into popular taste; now perhaps dominant taste would favor far simpler styles. This would have an effect both in England and internationally.

There was a three-year hiatus in exhibitions: the fourth exhibition was not until the fall of 1893. Morris was more directly involved than he had been before through his assistant, Sydney Cockerell. Cockerell was born in 1867 and grew up in the aesthetic suburb of Bedford Park. He entered the family coal business but was moderately unhappy with it and left it shortly. Ultimately he would become the director of the Fitzwilliam Museum at Cambridge, a great influence in the world of art and, as one of his biographies has called him, "The Friend of Friends." His diaries record the searchings of the young man and his increasing involvement with Morris, culminating in his being named one of his executors.

Cockerell first visited Kelmscott House in November, 1885, when he was only 18; he heard a paper by Morris on socialism, although it was actually read by Morris's daughter, May, as Morris himself was not there. Morris and Ruskin converted him in his earliest days to an aesthetic version of socialism. Cockerell heard Morris lecture several times about the dawn of a new epoch; he discussed socialism, and presumably also printing, with Emery Walker. As he became increasingly involved with Morris's world, his diaries take note of the weekly meetings of the committee of the Society for the Protection of Ancient Building, his growing involvement in the Kelmscott Press, and with the Arts and Crafts Exhibitions. Cockerell also recorded in his diaries, which were mostly very brief notations of his doings, his impressions of the exhibitions. Of the first exhibition in 1888 he wrote, "Went to Private View of Arts & Crafts Exhibn. Saw Wm Morris, Burne Jones, W. Crane, G. F. Watts, etc. there. Beautiful collection of the work of men of education and refinement—but very little contributed by ordinary craftsmen. . . . Spoke to Walker, Miss Morris, Sparling, W. Crane etc."[95] He remarked the next year: ". . . to Arts & Crafts Exhibition, which is on the whole very encouraging—the influence of Crane, Morris and Burne Jones is as obvious as last year though there are many more exhibitors, and fewer exhibits of the masters themselves. Of course therefore not so many masterpieces as before—but a good many things showing evidences of taste and designing power."[96] The next year Cockerell felt there was a decline, as was commonly conceded: "A fairly good exhibition, but inferior to the two previous ones, so far as one could judge from occasional glimpses of the exhibits through the crowds of people."[97] It was almost as if the Society was paying a certain price for its popularity.

In the following years he became even more involved with

[95] September 29, 1888, BL, 52, 625, f. 57.
[96] October 24, 1889, BL, 52, 627, f. 60.
[97] October 4, 1890, BL, 56, 627, f. 55.

the world of Morris: in 1892 he catalogued Morris's books. Increasingly he acted as agent in Morris's activities as a collector of medieval manuscripts and early printed books. Cockerell had great organizational skills, and that February Gimson and Barnsley asked him if he would become honorary secretary of the Society, but Cockerell declined. In December Cobden-Sanderson asked him to be the secretary for the exhibition itself in the following autumn in succession to Ernest Radford. He consented, and his diaries present a vivid picture of the 1893 exhibition. He was formally elected secretary of the Arts and Crafts Exhibition Society on February 9. He combined this post with being secretary for the New Gallery itself. His annual salary was at first £75, but it was quickly raised to £100. The society was run by people close to Morris, such as Cockerell, Cobden-Sanderson, Walker, and Benson, although there are no indications that Morris took any part in determining this result. It was not surprising that those associated with him should have some extra authority.

Perhaps because of the comparative weakness of the 1890 exhibition and with more time for preparation, the 1893 exhibit was carefully planned. Morris, now the president of the Society, was more active than he was in the Art Workers' Guild. Perhaps Cockerell's connecting the two worlds kept him in touch. Morris was still likely to be somewhat pessimistic about the success of the exhibition, at the same time he had hopes of some sort of permanent organization being established. He also appeared to be retreating into a sort of elitism. He wrote to Crane in July: "As to the society: of course I agree as to keeping our independence: but I think we might do so even if we were to rent the N[ew] G[allery]. . . . I should prefer much to try such a place as De Morgans, which would mean a new departure, which might grow into a kind of institute. And this all the more because I think it is far from certain that we should make a pecuniary success of the next N. G. exhibition. I don't think we should, I believe the public (the big public) are somewhat tired of our exhi-

bitions there and that we ought now to address ourselves to the small and really interested public."[98]

A Kelmscott book, Morris's lecture on Gothic architecture, was printed as a practical demonstration while the 1893 exhibit was going on. Thus were the ideals of the Arts and Crafts movement made vivid and actual, with the combination of intellectual content—the lecture itself—and actual workmanship and design being demonstrated to the public.

As early as the previous February it was decided that there would again be public lectures, and those delivered began appropriately enough with Morris himself on the printing of books. (This also provided a nice balance to the fact that it was Walker's lecture at the first Exhibition in 1888 which was so important in providing the impetus for Morris's Kelmscott Press activities.) That lecture was on November 2; on November 9 Lewis F. Day spoke "On some ornamental offshoots of the Italian Renaissance"; on November 16 Selwyn Image, "On the value of Italian Renaissance"; on November 23 Crane, "On the Use of Ornament"; and then as the last lecture on November 30, William Richmond, "On Mosaic." This last was ironic considering the internecine warfare that had been going on within the Arts and Crafts movement about the mosaics that Richmond was installing at St. Paul's. In December, 1890, Cockerell had recorded in his diary a discussion between Morris and Philip Webb at the Anti-Scrape meeting "as to the merits and demerits of St. Paul's Cathedral and the injury threatened by its proposed desecration."[99] Perhaps having Richmond lecture to the Society was a gesture of reconciliation. On May 18, 1893, the organization committee dealt with a request from several firms, including the eminent firm of Liberty's, to have adequate space at the exhibit. Although the Society was anxious to have firms participate, it would not, as at a trades fair, simply allocate space. The

[98] Morris to Walter Crane, July 30, 1893, Beinecke Library, Yale University.

[99] December 18, 1890, BL, 56, 627, f. 66.

particular works themselves that the firms wished to submit would have to be individually judged. It was at this meeting that it was reported that "Mr. Morris undertook to print a book in the exhibition, and to confer with Mr. de Morgan as to the possibility of having a potter at work." (Unfortunately as far as we know the latter demonstration did not take place.) There were great hopes about the possibility of practical demonstrations: "Mr. Cobden-Sanderson thought that he could arrange to have some bookbinding done. Blockcutting was mentioned as a craft likely to prove interesting to visitors."[100] Morris reported the next week that Cobden-Sanderson would not be able to send binders to the Exhibition, and finally on August 3 it was decided not to have any bookbinding.

There is also a further ironic touch in relations with Sir Frederic Leighton, the president of the Royal Academy. The 1893 Exhibition seemed to be the year of reconciliation, perhaps in some part representing the mellowing that appeared to take place in the last years of Morris's life. Leighton himself had always been interested in some reform of the Royal Academy but had been unable to make much progress, given the opposition of the academicians. As we've seen, a good part of the impetus for the founding of the Society had come from opposition to the Academy. Yet the Society had never taken an adamant stand against the Academy, and it sought more paintings for this exhibition. At the meeting of August 24 Cobden-Sanderson reported "that he had called upon Sir Frederic Leighton, & . . . had selected some model studies for the Perseus & Andromeda etc which Sir F. L. was willing to exhibit." (In the catalogue, items 253, 254, and 255 in the Central Hall are Leighton's *Perseus and Andromeda, Daphnephoria*, and the *Garden of Hesperides*.) The organization committee appointed a selection committee of Sumner, Macartney, Frampton, Pomeroy, Morris, Walker, Lethaby, Image, Cobden-Sanderson, Crane, Blomfield, and Benson. The

[100] Minute book for three quotations, SDCA.

committee, it seems worth emphasizing, was appointed not elected.

As usual, the actual work started late, and in his diary for September 11 Cockerell recorded working with a slightly different selection committee than the one appointed a few weeks before.[101] Perhaps some had not accepted. Morris appeared to have bowed out, probably because of other obligations. The committee now consisted of Frampton, Day, Walker, Sumner, Image, Blomfield, and Macartney—familiar and competent figures. Cockerell had worried somewhat about the quality of the show, but the selection committee acted ruthlessly—what Cockerell called the "massacre of the innocents"—and quality was maintained.

One of the other indications of the special nature of this exhibition was the edition of a handsome book, *Arts and Crafts Essays*, incorporating 35 pieces from the past catalogues in more permanent form. Morris wrote a preface for this publication in which he stressed the significance of the Arts and Crafts, and edited the volume, having failed in his attempt to have Cobden-Sanderson or Crane do so.

On September 26, 1893, he wrote to his daughter, Jenny, "I looked in at the Arts & Crafts for a few minutes yesterday . . . and thought it looked well." He was proud of his own contribution. "The tapestry came while I was there; so it was not in place of course. It will make the whole show a fine one." Philip Webb had written to him about this tapestry in anticipation: "Lethaby tells me that there is to be a large piece of tapestry at the Arts & Crafts show—after your figuring: that is good. Having anticipated a rather dismal show, I can now put in an appearance with some fair prospect."[102] Morris wrote on October 6, "I found the Arts & Crafts looking quite lively yesterday: Cockerell thinks well of its commercial prospects; we have been having about 500 shillings per diem be-

[101] Collingwood, Frampton, Day, Walker, Sumner, Image, Blomfield, Macartney. September 11, 1893, BL, 52, 63, f. 45.

[102] Philip Webb to William Morris, September 18, 1893, f. 39, Victoria and Albert Museum.

sides catalogues, which is better so far than in 1890, our best year."[103]

In an interview in the *Daily Chronicle* by Henry Norman on October 9, Morris made clear his sense of how difficult it was to create beautiful objects for the inhabitants of the contemporary world. "How on earth can you make anything beautiful out of people like them . . . with their stovepipe hats, their tight coats and cut-throat collars, their wasp waists, puffed sleeves, and microscopic bonnets falling off their heads behind, their artificially draped skirts and pointed toes?" Morris also elucidated his comparative indifference to the innovation of the Society that the name both of the designer and of the executor be given: "A work of art is always a matter of cooperation. After all, the name is not the important matter. If I had my way there should be no names given at all." Morris was particularly aware of printing and revealed his belief in buildings and books as the most important art forms. "The best work of art of all to create is a house which will prove, to my thinking, a Gothic house. A book comes next." He also emphasized the importance of removing arts and architects from what he considered their ivory towers and of having them design items for use.[104]

Cockerell was quite pleased by the Exhibition, recording in his diary on December 2, "It has been extremely successful."[105] The catalogue contained 516 items, somewhat of a decline from the Exhibition of 1890. Cockerell kept a rather meticulous sales book, and unlike the past, sales were actually made at the exhibition rather than by a complicated system of deposit and referral. The book records such items as a jug and pitcher of Aller Vale Ware sold to the Earl of Portsmouth, as well as Gimson chairs bought by Anne Cobden-Sanderson and Hubert Crackanthorpe. Some of the Guild of Handicraft work was very popular, particularly pieces of hammered hol-

[103] Morris to Jane Morris, September 26, 1893, BL, 45, 340, f. 127 and October 6, 1893, f. 129.
[104] *Daily Chronicle*, October 9, 1893.
[105] December 2, 1893, BL, 52, 630, f. 57.

low ware bought by Lord de Vesci, Anne Cobden-Sanderson, and Frederick Leighton himself. Presumably no commission was charged on sales, and the only profits for the Society were from admissions and catalogues. Cockerell recorded that in 1893 the total attendance, in the period when the exhibit was open from October 5 to December 5, was 18,786; this was in contrast to an attendance in 1890 of 14,140. The profit in the accounts of January 1, 1894, was £144/1/1, and this sum allowed them to repay those who had guaranteed the 1890 show, which had lost money.[106]

The 1893 format of a show every three years was deemed successful, and so the next exhibition was not to be until 1896. Cockerell continued as secretary to the Society as he also became closer and closer to Morris. In his last days, through Cockerell's agency, there almost seemed to be a coming together of two of the many strains of Morris's life—the Arts and Crafts and the Kelmscott Press. In 1894 Cockerell became Morris's librarian and also, replacing May Morris's estranged husband, Halliday Sparling, secretary to the press itself. It was in August of that year that the printing started on the masterpiece of the press, the Chaucer, which was to be completed just before Morris's death.

The Society seemed to be in better financial shape; it had approximately one hundred members, and it was decided that they should pay ten shillings subscription in the years in which there was not an exhibition, and one pound in the years that there was, in order to provide the Society with some working capital. Plans went forward on the 1896 exhibition, and on September 25, Cockerell brought in Kelmscott Press books for it and recorded in his diary, "It promises to be a very good exhibition—& a very encouraging one."[107]

The show was scheduled to have its private view on October 3, but it was on that day, at 11:15, that William Morris died. The story of the simple burial at Kelmscott in Oxford-

[106] SDCA.
[107] September 25, 1896, BL, 52, 633, f. 60.

shire has been told many times: the wet day, the rising waters of the Thames, the howling wind, the coffin carried in an open hay-cart, the wreath of bay, the simple service, the mourners, the villagers, friends, workers from Merton Abbey, quite a few members of the Art Workers' Guild. His beloved invalid daughter, Jenny, was at Kelmscott Manor at the time of his death, and Evelyn De Morgan and Walker went there to tell her the not unexpected news—Morris had been failing for some time.

THE EXHIBITION—consisting of 800 items from a wide range of designers and firms—did open two days later, as undoubtedly Morris would have wished. *Art & Life* was published the following year, lectures given in conjunction with the exhibition, more extensive than the short notes previously included in the catalogues. The title summed up the whole purpose of the entire movement. Cobden-Sanderson talked "On Art and Life"; Lethaby, "Of Beautiful Cities," arguing in favor of a "green belt"; Crane, "Of the Decoration of Public Buildings"; Reginald Blomfield, "Of Public Spaces, Parks and Gardens"; and Halsey Ricardo "Of Colour in the Architecture of Cities." Cobden-Sanderson felt that the essays marked a special memorial to Morris; he also pointed out that "Art, as a manifestation of the artistic spirit, has its origin, or, so to speak, more correctly perhaps, its opportunity in Craft, and Craft in the needs of life."[108] Not only were there these five lectures, one each week, but on October 29 there was a concert and discourse given by Arnold Dolmetsch and a playing by him and his wife, Elodie, of Rameau and Couperin on the harpsichord in the exhibit. The harpsichord was built by him and decorated by Helen Coombe, later to be Mrs. Roger Fry, Selwyn Image, and Herbert Horne. It had been Morris's interest that had spurred Dolmetsch to construct the harpsichord; he had seen quite a bit of Morris toward

[108] T. J. Cobden-Sanderson, "Of Art and Life," *Art and Life* (London, 1897), p. 7.

the end of his life and repaired Jane Morris's harpsichord. Just before Morris's death Dolmetsch had gone to play for him a pavane and galliard by William Byrd on the virginals.[109]

This exhibition also contained a special section in memory of Ford Madox Brown, who had died in 1893. One of the original members of the Morris firm, he had been estranged from Morris at the time of its reorganization in 1875 as Morris & Co., but they had been reconciled in later years. In the catalogue there was an essay on Madox Brown's work by his nephew Ford Madox Hueffer, better known later as Ford Madox Ford. Cockerell, as before, kept the sale book, and recorded that there was a profit from admissions and sales of the catalogue of £82/6/3.

The *Studio*, founded in 1893, was a product of the aesthetic and Arts and Crafts movements. Not surprisingly it contained an extensive review of the 1896 show, in four parts, by its editor, Gleeson White. He even noted that the Royal Academy, whose intransigence had done so much to bring the Society into existence, "might at any moment extend its rules a little to include half the objects hitherto relegated to the New Gallery." The *Studio* commented on Morris's role: "Looking at the beautiful objects which his enterprise had made possible, one felt that although the master had been taken, the principles he had established were so firmly rooted, that the legend of William Morris would be the creed of the new movement, and loyal adherence to his teaching would rank more than ever as its watchword." The *Studio* singled out favorably the work of Dawson, Ashbee, and Voysey but expressed some hesitation about the Glasgow four—Charles Rennie Mackintosh, Margaret and Frances MacDonald, and Herbert McNair. The latter group was nicknamed the "spook school." They were a little too fancy or too imaginative for English taste. As Thomas Howarth has noted, "Everyone was

[109] Campbell, *Dolmetsch*, pp. 100-104.

shocked by their grotesque conventionalization of the human figure and strange linear patterns."[110] But the *Studio* kept calm about them: "Probably nothing in the gallery has provided more decided censure than these various exhibits, and that fact alone should cause a thoughtful observer of art to pause before he joins the opponents." As the fourth article concluded, "If [the Society] initiates the ideas, and leaves others to carry them out, if it educates the public, and creates a demand which can be supplied by ordinary channels, then indeed it fulfills its purpose. . . . The bugbear of machinery should not prevent its use in due subordination; a predilection for any past style should be set aside if it conflicts with modern requirements."[111]

The *Times* noted that the opening of the exhibition had been delayed two days in honor of "the President of the Society and the leader of the movement in which these exhibitions originated. . . . The whole exhibition in one way or another testifies to his influence on his contemporaries." But the *Times* was out of sympathy with the show, felt that it was too much a gathering of artistic work for the wealthy, that it would not influence the salesman and the manufacturer, and inadvertently stated that the exhibition betrayed the hopes of the dead founder of the movement, "If we recognize that the exhibition appeals to the wealthy and leaves popular art without improvement or encouragement, we have nothing but praise for these many things of beauty."[112]

The *Times'* editorial on Morris's death is, I believe, a splendid document and sums up a great deal of the established English attitude toward him. It both recognizes his importance—facts are faced in the English way—but at the same

[110] Thomas Howarth, *Charles Rennie Mackintosh and the Modern Movement*, 2nd ed. (London, 1977), p. 38.
[111] *Studio* 9 (1896-97), 50-62, 117-134, 189-205, 262-285. Specific quotations, pp. 50, 55, 204, 285.
[112] *The Times*, October 5, 1896, p. 14.

time undercuts him with its sophisticated patronizing cynicism:

> The world can afford to judge him indulgently, as not apprehending much danger from his rhetoric. We do not desire to enlarge on the unpractical extremes to which his industrial and political opinions tended; they are only the results of a warm heart and a mistaken enthusiasm; they indicate, not the strength of the man, but his weakness, and are as nothing compared with the lasting work of his better genius. . . . No human power . . . would give the mass of our workers a love or a knowledge of art. Our national nature and the inevitable laws of economy, will not yield to persuasion, or promises, or dreams. . . . It must be allowed, however, that Morris's actual work was far more practical than his doctrine. . . . [He] ultimately worked something like a domestic revolution.[113]

A long review of the exhibition by Mabel Cox is quite discriminating and is far from being completely enthusiastic. Cox remarked there was not enough work by workmen, and not enough designs by the men who actually wielded the tools. She found the wallpapers disappointing except those designed by Voysey and Crane, but "from the School of Handicraft comes much that is delightful There is no better piece of work on exhibition . . . than the plain undecorated and untouched cabinet in the Guild Show. . . . The spirit of artistic craft which [Ashbee] has instilled into its members is very noticeable, and it is to be hoped that the influence of the Guild may in time come to be a far reaching one among men who earn their living by the practice of a craft."[114]

[113] Ibid.
[114] Mabel Cox, *The Artist Photographer and Decorateur* (Oct. 12, 1896), pp. 9-15. Cox pointed out that the aim of the show was "to promote a better understanding on the part both of workmen and the public, of the meaning

At the 1899 exhibition there was a room of Morris's work as a memorial, and a lecture about him by Lethaby, as well as Walter Crane repeating a talk from 1888, the title of which might be taken to stand for what the present book has attempted to discuss: "The Arts and Crafts Movement: Its Several Tendencies and Possible Outcome." Benson remarked about the exhibition: "English designers are doing their part; they are recognized in Europe as the exponents of the only vital modern style, a style still immature, and in the nature of things not reaching immediate perfection all round; but in the main logical, consistent, and progressive. Though we cannot calculate on the uprise of any commanding genius to vie with the memory of those whose loss we are lamenting, that the number of capable artists is steadily increasing is evident from the list of contributors to this autumn's exhibition at the New Gallery."[115]

The Society had been born at the time when Morris was at his most political with political events for him reaching a

of design as applied to different kinds of material; to ameliorate the condition of the craftsman, and finally to protest against the existing separation of art and industry, and the application of the former term only to pictorial expression. . . . The question is social, even before artistic. The result of one class living on another is apparent in a redundance of ornament." She was quite explicit about the power of the machine to satisfy a demand for cheap goods, and unlike some of the Arts and Crafts practitioners she was not optimistic that the machine could help; indeed she felt that it would hinder: "This advance of machine power, and the consequent extension of the sub-division of labour, gradually destroyed all handicraft, and with it all sense of propriety in the use of material, as well as in suitability of design. . . . We live in a hopeless chaos of ugliness, vulgarity, affectation. . . . When the public decides that it wants good things, the shop-keepers and manufacturers will see that it gets them." And yet she remarked: "The goods made by factories—and a great deal of our necessities will always, of course, have to be so made—may just as well be of proper design. The huge power of machinery must be an influence for good and not for bad on manufacture. . . . There is a great deal of art: sound, wholesome, everyday art; but there is not much craft."

[115] W.A.S. Benson, "William Morris and the Arts and Crafts," *The National and English Review* 34 (1899), 271.

sense of crisis and climax in Bloody Sunday of 1887. The year 1896 had been a comparatively quiet phase of his life, dominated by the Kelmscott Press and the great collection of incunabula and medieval manuscripts he was amassing just before his death. Undoubtedly the exhibitions elevated taste and emphasized to many the virtues of good design—for instance, bringing the Morton firm in contact with C.F.A.Voysey—as recorded by their historian: "The exhibitions . . . soon became a focus for all those seriously concerned in reviving and raising the standards of the various crafts connected with the decorative arts, and also gradually, as suitable products were made, for those interested in attempting to raise the standards of design in industrial products and to arouse the interest in these better standards. Although the initiators of the arts and crafts movement may have failed to resolve the paradox of Morris's work as expressed by Professor Pevsner—that whilst his 'art has in the end beneficially affected commercial production in many trades, that is precisely what he would have hated'—it soon became actively interested in incuding in its exhibits machine-made commercial productions designed by craftsmen and others."[116] One wonders how strenuously Morris actually would have objected. He was less opposed to machines than to the meretricious ugliness of a machine civilization.

[116] Morton, *Three Generations*, p. 112.

· CONCLUSION ·

Morris had shaped the movement and tried to stretch it beyond itself, to realize its political, social and artistic implications. In the 1899 catalogue, Crane also contributed a "Note on the Late President of the Society, William Morris." "In his social work, it was his passion for beauty, and love of a simple and wholesome life, however refined, which drove him to revolt against the gloomy conventions, the pretences, the meanness and shabbiness of so much in the aspects of modern existence."[1] Crane, as an artist and a socialist, was perhaps most vividly able to celebrate the combination of those two facets in Morris's life. He remarked in an article in 1896: "There seems to have been insuperable difficulty to some minds in realising that the man who wrote 'The Earthly Paradise' should have lent a hand to try and bring it about."[2] Crane best caught Morris's complexity and multiplicity in a speech he gave in the month of Morris's death, perhaps at the Art Workers' Guild.

> William Morris is dead. How hard it is for those who knew that great and forceful personality to realize the meaning of those words! Those especially, who only saw him the picture of health and energy, who associate him with all kinds of activities, artistic and social, how difficult it is to think that never more will that bluff and restless but kindly presence, that emphatic voice and lusty and hearty manner be felt and heard among us.
>
> Perhaps no man of our time stands out so distinctly as a strong individual type, a clear and marked personality as did William Morris, and yet even he once wondered (and I thought it at the time one of the most remarkable things I had heard from him), 'which of six distinct personalities he himself really was.' . . . Those who only

[1] *Catalogue*, 1899 (London, 1899), pp. 13-14.
[2] Walter Crane, "William Morris," *The Progressive Review* I (1896), 149.

16. "William Morris photographed by Emery Walker, 1889."

knew him from his poetry and his prose romances thought him a dreamer of dreams born out of his due time—as in fact he had described himself in his own Earthly Paradise. Those who only knew him as an artist and craftsman thought of him as a very refined designer of very decided aims, and exclusively medieval proclivities. The

producer of a wealth of wall paper, simple oaken furniture and rich carpets, embroideries, and tapestries. There are even some who thought of him as a keen man of business and manufacturing.

Those who only know the products of the Kelmscott Press thought of him as a master printer who worked his press in the spirit of an artist. Those who only knew him as a Socialist knew him as an enthusiastic and ardent champion of the cause, as an eloquent lecturer, and as a vehement debater and untiring propagandist.

Everyone of them might probably have a distinct and different conception of the man and his character, but for all that, in William Morris the man, all these different sides, these different activities were united and harmonized, and to close observers, the same golden threads of character—like the colours of his own tapestries—might be traced throughout all his work. . . .

We who now mourn his loss may not be able yet to see him and his work in true perspective, in true relation to his time, and his contemporaries—but what of that? It is of far more importance that the impression a man leaves upon his time, upon his friends and fellows is that of greatness, of thoroughness, of character. And while we praise the beauty of his invention and craftsmanship whether as a poet, a craftsman or a designer, we feel that his noblest work was after all done for socialism, where he threw all the weight of a strong personality and an enthusiastic spirit (not to speak of his ripe fame as poet and artist) on the side of the labourers, seeing the true and honourable basis of life, seeing how it was bound up with the welfare of the world, and the hope of the future—that future of which he has left so distinct and beautiful a vision in News from Nowhere of a perfect communist state.[3]

[3] Walter Crane, "William Morris," copy of manuscript, dated October, 1896, location of original unknown, copy courtesy of James Joll, London.

William Morris was a socialist, and his politics became the driving force in his life that tied together the multiplicity of his activities and that provided him with a unified vision. His vision is what E. P. Thompson has called his "moral criticism of society."[4] That he did not lose this quality is made perfectly evident in the famous lines from his "How I Became a Socialist," written for *Justice*, the publication of the Social Democratic Federation, in 1894, years after he had broken with Hyndman: "Was it all to end in a counting-house on the top of a cinder-heap, with Podsnap's drawing-room in the offing, and a Whig committee dealing out champagne to the rich and margarine to the poor in such convenient proportions as would make all men contented together, though the pleasure of the eyes was gone from the world, and the place of Homer was to be taken by Huxley?"[5]

Morris considered that revolution was needed in order to save art. Political drive gave Morris his impetus. It was a force shared by quite a few in the Arts and Crafts movement and was a necessary component in it. But for many, their artistic activities were sufficient. Their activities and work were moral statements about the nature of life and the need to present it clearly, cleanly, and simply, to reach essentials. Whether consciously or not, Morris and the others were responding to the drive toward a greater democracy in England in the 1880s. They wished to provide art for the ordinary person, even though their commitment to beauty, individualism, and their frequent animosity to the machine meant that their artistic achievements were not widely available. The political and social context of the 1880s was also important in providing greater attention to the attitude of the worker toward the work. Morris remarked about the medieval workman, "his relation to art was personal and not mechanical. So that he was free to develop . . . his love for ornament. He was not

[4] E. P. Thompson, *The Communism of William Morris* (London, 1965), p. 6.

[5] May Morris, ed., *Collected Works*, XXIII, 280.

hampered by having to produce a cheap makeshift for a market of which he knew nothing: the price of wares was kept down not by using a machine instead of thoughtful handiwork, but by simplicity, or roughness or work suitable to the use of the thing made."[6] The Ruskinian idea of the virtue of roughness might serve as a limitation for producing enough for large, modern societies. But the value of simplicity in form and Morris's formulation of this idea was an essential aspect of the Arts and Crafts movement. The organizations that forwarded these values—three of the most important have been discussed here—took their inspiration directly from him.

As Pevsner has argued in his *Pioneers of Modern Design*, the Arts and Crafts movement provided a bridge to the Modern movement. It is not necessary to think of that movement as an unmitigated blessing in order to be grateful for its achievements and to recognize that it has a certain loyalty to art for the multitude, for a democratic world.

England, the first industrial nation, was also the first to question the values of industrialism. Yet it seemed to be able to go only so far; perhaps the intense individualism in that country and the complicated issues of class prevented their working out the full implications of these ideas. In a way, Morris in his own thinking, as Peter Floud has suggested, did not see the implications of his own design work. There was "a fundamental contradiction between his theories and the basic unalterable nature of his personal genius as a designer. . . . He never designed anything that was not flat [and hence the] machine [was] ideal for his patterns."[7] Perhaps if he had consciously designed for the machine, the future of English design might have been very different. There is a curious parallel with a similar paradoxical position in Morris's political stance. So much of what he wished might be attained only with the help of state socialism, which he hated. Could popular accessibilty to art, to a better political structure, be achieved

[6] William Morris, "Some Thoughts on the Ornamented MSS of the Middle Ages," HM6440, p. 3, Huntington Library, San Marino.
[7] Peter Floud, "Talk to the Art Workers' Guild," March 18, 1955, BL 52, 772, f. 76.

without the rise of forces that he abhorred? So when the Social Democratic Federation veered toward parliamentary action, Morris's anarchist sympathies emerged. When the Socialist League was taken over by the anarchists, the more moderate cooperative aspect of Morris's thought was in the ascendancy. His theories of art and politics appeared to be caught between two worlds, and this was also true of the Arts and Crafts practitioners. They generalized and made accessible many of Morris's ideas about architecture and design—both its commitment to a simpler look and its social purpose—but they could not—and in probably most cases—did not wish to transform society. Yet in their work they helped bring forward Morris's ideas so that they helped shape how we see the world today.

The Arts and Crafts practitioners, on the whole, were less diffident about the machine than Morris. Yet perhaps for class reasons their manufacture was still limited, and even when they designed for factories, it was likely to be for more expensive goods. The Continent surpassed England, under the influence of English (and Scottish) architects and designers. The English were aware of this irony, as in the proposal some years later in 1915 for the foundation of the Design and Industries Association, issued from the Art Workers' Guild building. The Arts and Crafts "has been much studied and imitated abroad, while it has been allowed to struggle helplessly at home. With occasional extravagance and affectation it is certain that it produces ideas in plenty, ideas which, in many cases, have been taken up and worked by foreign rivals. The difficulty has been that the designer and the manufacturer have so largely remained in separate compartments. . . . German industrial design . . . has been founded on a minute study of the English Arts and Crafts movement. . . . The great German type founding industry, for instance, has been based on a study of the printing of William Morris [and] T. J. Cobden-Sanderson."[8]

[8] Anonymous, *A Proposal for the Foundation of a Design and Industries Association* (?London, ?1916), p. 6.

The values of the movement needed to be preserved, but to be concentrated more on the user than the maker, to move on from concern for the artists, no matter what skill was being practiced, to a greater concentration on the users. This was recognized as early as 1901, if not before, in Frank Lloyd Wright's seminal talk, "The Art and Craft of the Machine." (It is striking that Wright would omit the plurals, suggesting the uniformity of the machine.) In his somewhat incoherent prose, Wright pledged his allegiance to the Morris dictum of simplicity but claimed that it was possible to achieve only in a democratic society through the machine. In *News from Nowhere* Morris had attacked Edward Bellamy's vision of a mechanistic future. He would have been aware of the dangers of Wright's claims. But Wright argued that Morris's aims needed to be achieved through means he would not have liked—as implied by his own designs.[9]

Morris realized that "'demi-semi-Socialism'" might triumph, "which would improve the *condition* of the working-class while leaving its *position* unchanged."[10] Ironically, he and his disciples were crucial forces in "transforming the products of capitalist industry, of which he had no hope whatever. . . . Both the quality and the design of capitalist-produced goods have improved out of recognition since the 1880's."[11] In some senses the working classes, who were growing restive in that decade of uncertainties, were partially bought off by the more attractive world that Morris and the Arts and Crafts practitioners helped bring about.

As Paul Thompson has remarked, the Arts and Crafts movement attempted to solve the problems that Morris had raised.[12] The attempt was not successful; what was achieved

[9] Edgar Kaufmann and Benn Raeburn, ed. *Frank Lloyd Wright: Writings and Buildings* (New York, ?1960), pp. 55-73.

[10] E. P. Thompson, *Communism*, pp. 7-8.

[11] Sir Frederic Osborn, "Vote of Thanks" for Nikolaus Pevsner. "Architecture and William Morris," *Journal of the Royal Institute of British Architects* 64 (March, 1957), 177.

[12] Paul Thompson, *The Work of William Morris* (New York, 1967), p. 76.

was far less than Morris had wished, but it was a move in a commendable direction. Through the small-scale activities of a few groups—among them, those I have discussed here— and the role that Morris played as an inspiring and energizing force we were put upon a certain path, as "Pilgrims of Hope," and given some reason to believe that art might infuse life.

· APPENDIX ·

The Arts and Crafts

AN EXHIBITION AT WILLIAM MORRIS'S
BY W. B. YEATS

Providence Sunday Journal (Providence, R.I.) Oct. 26, 1890

THE MOVEMENTS most characteristic of the literature and art and to some small extent of the thoughts, too, of our century has been romanticism. We all know the old formal classicism gave battle to it and was defeated when Hernani's horn rang out on the French stage. That horn has been ringing through the world ever since. There is hardly a movement in which we do not hear its echo. It marked the regained freedom of the spirit and imagination of man in literature. Since then painting in its turn has flung aside the old conventions. The arts of decoration are now making the same struggle. They have been making it for some years under the leadership of William Morris, poet, Socialist, romance writer, artist and upholsterer, and in all ways the most many-sided man of our times. But for these "arts and crafts" exhibitions of which this is the third year, the outer public would hardly be able to judge of the immense change that is going on in all kinds of decorative art and how completely it is dominated by one man of genius. Last Saturday was the private view. The handsome rooms of the New art gallery with their white pillars and leaping fountain were crowded by much that is best and the most thoughtful of London society—above all with whatever is "advanced" in any direction—literature, politics, art. It was this future paying homage to one man who

had turned aside for a little from his dreams of a Eutopia of Socialism for the poor, to create a reality of art scarcely less beautiful for any rich man who cares for these heavy tapestries and deep-tiled fireplaces, for these hanging draperies and stained-glass windows that all seem to murmur of the middle ages, and the "olden times long ago." Only a small part of the exhibits are from Morris & Co. and yet all the numberless people who send work, from the well-known firm that made the huge fireplace in the north gallery to the lady who illu-minated the copy of Coventry Patmore's poems in the bal-cony, are under the same spell. The melancholy beauty of "The Earthly Paradise" is everywhere. "The Idle Singer of an Empty Day" has neither sung nor wrought idly.

The south gallery is chiefly notable for the cartoons for stained-glass and for Cobden Sanderson's book binding. Along the south wall goes a huge design by Burne-Jones for a win-dow at Jesus College, Cambridge. The window itself is to be executed by Morris & Co. The subject is the ninefold "Hi-erarchy" of angels, archangels, cherubim, seraphim, thrones, dominions, principalities, powers and vertues. It is full of medieval symbolism difficult for modern ignorance to re-member and understand. The figures are of course full of that peculiar kind of subtle expression and pensive grace that runs through all Burne-Jones's work, but it is hard to judge of the final effect with its blazing and jewel-like color from these uncolored drawings. One can but remember the windows from the same hand at Oxford and fill in the reds, and gold, and blues out of one's head; but then the Oxford windows I have in mind were done when Burne-Jones was young, and his manner almost indistinguishable from that of Rossetti, whereas these angels and archangels are in his most recent and decorative style. They have not the intensity of feeling of the early work, but are, on the other hand, much less crabbed in drawing and crowded in composition. In the same room are other window designs from the same hand—would that they were colored—of subjects like "The Annunciation of the Shepherds," "Lazarus and Mary," "Rachel and Jacob."

The windows themselves in each instance being the work of Morris & Co. The case of artistic book covers is charming. In few handicrafts has there been greater need of reform, the book covers of this century have been for the most part pretentious and foolish, with their gilding smeared hither and thither in purposeless and conventional forms. These Cobden Sanderson books are, however, simple and artistic, but also not cheap. One expects illuminated pages like G. M. Kenter's six specimen sheets of Morris' romance, "The Roots of the Mountains" to be as dear as you please, but there seems to be no reason why the covers of books should not be designed by good artists and yet remain not altogether beyond the purse of the poor student for whom, after all, books chiefly exist. In comparison to the immense bills for paper, and printing, publishing, illustrating, and writing, the expense of the cover designer should count for little.

The feature of the west gallery is distinctly a huge green marble mantle piece, with a sculptured figure of Fotique's "Undine" in the centre. In some ways, perhaps, the most interesting exhibit of all is the work of Messrs. Farmer and Brindsley. In the same room is Mr. Parnell's contribution, the Irish national banner, designed by Walter Crane. The subject is the "Sunburst," breaking into a Celtic cross, enclosed by an Irish harp, surrounded with the motto "Children of the Gael shoulder to shoulder," the four quarters of the banner contain the shields of the four provinces. In the right hand is Mr. Parnell's now familiar autograph. The banner may look fine enough when blown out in the wind but it certainly looks over-glaring in color and formal in design among the soft greens and rich golds of estheticisms.

In the north gallery is the furniture, oaken and cushioned alcoves, deep fireplaces panelled with every kind of form and colors, heavy curtains, carved writing tables and desks and all stamped with the same signet of romanticism and medievalism. There is nothing to remind one that the formal classicism of the eighteenth century, with its legacy to the nine-

teenth, of dismal mahogany and pallid coloring ever existed anywhere.

Upstairs in the balcony are more book bindings and book illumination, too, to make us remember that the art of the old world has been revived in our day. There is also an etching from Madox Brown's "Dream of Sardanapalus," a picture seldom seen, though among the finest he has painted, and to my mind much more interesting than his big cartoons. In the south gallery, "The Baptism of Eadwins," a picture that I cannot persuade myself to like chiefly, I think, because I have taken a violent hatred for "Eadwins" himself, with his clerical beard, and because I do not know what he has done with his feet in that very small fount they have immersed him in. Not that the cartoon is not full of that curious realism of pose and fullness of light that marks the Father of Pre-Raphaelites.

On the whole, then we have in this exhibition the last echo of Hernani's horn—the long-waited-for deliverance of the decorative arts.

· SELECTED BIBLIOGRAPHY ·

MANUSCRIPT SOURCES

Arts and Crafts Exhibition Society Papers, Victoria and Albert Museum Library.

Art Workers Guild Papers, Art Workers Guild, London.

C. R. Ashbee Collection, King's College, Cambridge.

Sanford and Helen Berger Collection, Carmel, California.

A. H. Mackmurdo Papers, William Morris Gallery, Walthamstow. See *Catalogue of the A.H. Mackmurdo and the Century Guild Collection.* London, 1967.

William Morris Papers, William Morris Gallery, Walthamstow. See *Catalogue of the Morris Collection* London, 1969.

William Morris Papers, Hammersmith Public Library, London. See *Descriptive Lists of Deposited Records: Material relating to William Morris from the collection of H. Buxton Forman.* London, 1972.

Papers of William Morris and his circle are to be found principally in the Bodleian Library, Oxford; the British Library, London; the Henry E. Huntington Library, San Marino; the J. Pierpont Morgan Library, New York; the Victoria and Albert Museum Library, London.

PRINTED SOURCES

Arts and Crafts Exhibition Society. *Catalogue,* 5 vols. London, 1888-1896.

Ashbee, C. R. *An Endeavour Towards the Teaching of John Ruskin and William Morris.* London, 1901.

Benson, W.A.S *Drawing: Its History & Uses, with a Memoir by the Hon. W.N. Bruce.* Oxford, 1925.

Blomfield, Reginald. *Memoirs of an Architect.* London, 1932.

Briggs, Asa, ed. *William Morris: Selected Writings and Designs.* London, 1962.

Cobden-Sanderson, T. J. *The Arts and Crafts Movement.* London, 1905.

———. *Four Lectures.* Edited by John Dreyfus. San Francisco, 1974.

———. *The Journals of Thomas James Cobden-Sanderson 1879-1922.* 2 vols. London, 1926.

Crane, Walter. *An Artist's Reminiscences.* London, 1907.

———. *The Claims of Decorative Art.* London, 1892.

———. *From William Morris to Whistler.* London, 1911.

Crane, Walter and Lewis F. Day. *Moot Points: Friendly Disputes Upon Art & Industry.* London, 1903.

Horne, Herbert, ed. *The Hobby Horse.* 8 vols. 1886-1893.

Glasier, J. Bruce. *William Morris and the Early Days of the Socialist Movement.* London, 1921.

Image, Selwyn. *An Address . . . Before the Art-Workers' Guild on the Twenty-Fifth Anniversary of the Guild's Foundation.* ?London ?1909.

———. *Letters.* Edited by A. H. Mackmurdo. London, 1932.

———. *The Poems of Selwyn Image.* Edited by A. H. Mackmurdo. London, 1932.

Lethaby, William. *Architecture, Mysticism and Myth.* London, 1975. First published 1891.

Lethaby, William, A. H. Powell and F. L. Griggs. *The Life and Work of Ernest Gimson.* Stratford-on-Avon, 1924.

———. *Philip Webb and His Work.* London, 1979. First published 1935.

Morris, William. *Collected Works.* Edited by May Morris, 24 vols. London, 1910-1915.

———. *The Ideal Book.* Edited by William S. Peterson. Berkeley, 1982.

———. *The Letters of William Morris to His Family and Friends.* Edited by Philip Henderson. London, 1950.

———. *The Unpublished Lectures of William Morris.* Edited by Eugene D. LeMire. Detroit, 1969.

Morris, William. *William Morris: Artist, Writer, Socialist.* Edited by May Morris. 2 vols. Oxford, 1936.

———, ed. *Arts & Crafts Essays,* London, 1893.

Muthesius, Hermann. *The English House.* Translated by Janet Seligman. London, 1979. Originally published Berlin, 1904-1905.

Rhys, Ernest. *Everyman Remembers.* London, 1931.

Rowley, Charles. *Fifty Years of Work Without Wages.* London, ?1919.

Russell, Gordon. *Designer's Trade.* London, 1968.

Shaw, George Bernard. *William Morris as I Knew Him.* New York, 1936.

Stirling, A.M.W. *The Richmond Papers.* London, 1926.

Transactions of the National Association for the Advancement of Art and its Application to Industry. 3 vols. London, 1888-1891.

Vallance, Aymer. *William Morris: His Writings and His Public Life and Record.* London, 1898.

SECONDARY SOURCES

Anscombe, Isabelle and Charlotte Gere. *Arts and Crafts in Britain and America.* London, 1978.

Aslin, Elizabeth. *The Aesthetic Movement.* New York, 1969.

Bell, Quentin. *Schools of Design.* London, 1963.

———. *Victorian Artists.* Cambridge, Mass., 1967.

Bøe, Alf. *From Gothic Revival to Functional Form.* Oslo, 1957.

Bradley, Ian. *William Morris and His World.* New York, 1978.

Brandon-Jones, John. *C.F.A. Voysey: A Memoir.* London, n.d.

———. *C.F.A. Voysey: Architect and Designer.* London, 1978.

Callen, Anthea. *Women Artists of the Arts and Crafts Movement.* New York, 1979.

Campbell, Louise. "Herbert Horne and the Arts and Crafts Movement." Undergraduate thesis, University of Sussex, Brighton, 1974.

Campbell, Margaret. *Dolmetsch: The Man and His Work*. Seattle, 1975.

Chandler, Alice. *A Dream of Order*. Lincoln, 1970.

Clark, Fiona. *William Morris: Wallpapers and Chintzes*. London, 1973.

Cole, G.D.H. *William Morris as a Socialist*. London, 1960.

Comino, Mary. *Gimson and the Barnsleys*. London, 1980.

Coulson, Anthony J. *A Bibliography of Design in Britain 1851-1970*. London, 1979.

Crow, Gerald H. *William Morris Designer*. London, 1934.

Davey, Peter. *Arts and Crafts Architecture*. London, 1980.

Faulkner, Peter. *Against the Age: An Introduction to William Morris*. London, 1980.

————. *William Morris and W. B. Yeats*. Dublin, 1962.

Faulkner, Peter, ed. *William Morris: The Critical Heritage*. London, 1973.

Fletcher, Ian. "Bedford Park: Aesthete's Elysium?" in *Romantic Mythologies*. Edited by Ian Fletcher. London, 1967.

————. "Herbert Horne: The Earlier Phase," in *English Miscellany*. Edited by Mario Praz. Rome, 1970.

[Floud, Peter]. *Catalogue of An Exhibition of Victorian and Edwardian Decorative Arts*. London, 1952.

Franklin, Colin. *Emery Walker*. Cambridge, 1973.

————. *The Private Presses*. London, 1969.

Fredeman, W. E. *Pre-Raphaelitism: A Bibliocritical Study*. Cambridge, Mass., 1965.

Gaunt, William and M.D.E Clayton-Stamm. *William De Morgan*. London, 1971.

Girouard, Mark. *The Victorian Country House*. Oxford, 1971.

Goldzamt, Edmund. *William Morris et l'architecture moderne*. Warsaw, 1967.

Goodwin, K. L. "The Relationships Between the Narrative Poetry of William Morris, His Art-and-Craft-Work, and his Aesthetic Theories." D.Phil. dissertation, Oxford University, 1969.

Haslam, W.M.P. "A. H. Mackmurdo's Artistic Theory" M.A.

thesis report, Courtauld Institute of Art, London University, 1968.

Henderson, Philip. *William Morris*. London, 1952.

Jones, Peter d'A. *The Christian Socialist Revival, 1877-1914*. Princeton, 1968.

Kaye, Barrington. *The Development of the Architectural Profession in Britain*. London, 1960.

Kirchhoff, Frederic. *William Morris*. Boston, 1979.

Kornwolf, James D. *M. H. Baillie Scott and the Arts and Crafts Movement*. Baltimore, 1972.

Lambourne, Lionel. *Utopian Craftsmen*. Salt Lake City, 1980.

Lancaster, Osbert. *Homes Sweet Homes*. London, 1939.

Liberman, Michael Raymond. "William Morris's News from Nowhere: A Critical and Annotated Edition." Ph.D. dissertation, University of Nebraska, Lincoln, 1971.

Lindsay, Jack. *William Morris*. London, 1975.

Lucas, John, ed. *Literature and Politics in the Nineteenth Century*. London, 1971.

Lynd, Helen Merrill. *England in the Eighteen-Eighties*. New York, 1945.

MacCarthy, Fiona. *All Things Bright and Beautiful*. Toronto, 1972.

MacDonald, Stuart. *The History and Philosopy of Art Education*. London, 1970.

Mackail, J. W. *The Life of William Morris*. 2 vols. London, 1899.

Macleod, Robert. *Style and Society*. London, 1971.

Madsen, S. T. *Sources of Art Nouveau*. Oslo, 1956.

Massé, H.J.L.J. *The Art-Workers' Guild 1888-1934*. Oxford, 1935.

Meier, Paul. *William Morris: The Marxist Dreamer*. Translated by Frank Gubb. 2 vols. Brighton, 1978.

Minihan, Janet. *The Nationalization of Culture*. New York, 1977.

Morton, Jocelyn. *Three Generations in a Family Textile Firm*. London, 1971.

Naylor, Gillian. *The Arts and Crafts Movement*. London, 1971.

Nelson, James G. *The Early Nineties: A View from the Bodley Head.* Cambridge, Mass., 1971.

Parry, Linda. *William Morris Textiles.* New York, 1983.

Pierson, Stanley. *Marxism and the Origins of British Socialism.* Ithaca, 1973.

Pye, David. *The Nature and Art of Workmanship.* Cambridge, 1968.

Pevsner, Nikolaus. "The Late Victorians and William Morris." *The Listener.* August 9, 1951.

———. *Pioneers of Modern Design.* Harmondsworth, 1960.

———. *Studies in Art, Architecture and Design*, Volume II, *Victorian and After.* New York, 1968.

Richardson, Margaret. *Architects of the Arts and Crafts Movement.* London, 1983.

Saint, Andrew. *Richard Norman Shaw.* New Haven, 1976.

Schaefer, Herwin. *Nineteenth Century Modern.* New York, 1970.

Service, Alastair. *Edwardian Architecture.* London, 1977.

Sewter, Charles. *The Stained Glass of William Morris.* 2 vols. New Haven, 1974, 1975.

Spencer, Isobel. *Walter Crane.* London, 1975.

Summerson, John. *The Turn of the Century.* Glasgow, 1976.

Sussman, Herbert L. *Victorians and the Machine.* Cambridge, Mass., 1968.

Taylor, John Russell. *The Art Nouveau Book in Britain.* Cambridge, Mass., 1966.

Thompson, E. P. *William Morris: Romantic to Revolutionary.* New York, 1977.

Thompson, Paul. *The Work of William Morris.* New York, 1967.

Thompson, Susan Otis. *American Book Design and William Morris.* New York, 1977.

Tickner, Sylvia Elizabeth [Lisa]. "Selwyn Image: Life, Work and Associations." Ph.D. dissertation, Reading University, 1970.

Trilling, Lionel. "Aggression and Utopia: A Note on William Morris's *News from Nowhere*," *The Pschoanalytic Quarterly* 42, 1973.

Watkinson, Ray. *William Morris as Designer*. London, 1967.

Willis, Kirk. "The Introduction and Critical Reception of Marxist Thought in Britain, 1850-1900." *Historical Journal* 20, 1977.

Victorian Poetry. William Morris, Number 13, Fall-Winter, 1975.

Yeo, Stephen. "The Religions of Socialism" *History Workshop* 4, Autumn, 1977.

CATALOGUES

The Aesthetic Movement and the Cult of Japan. London, 1972.

Art and Work: An Exhibition of Art, Craft and Design 1884-1975. London, 1975.

The Arts and Crafts Movement, 1890-1930. London, 1973.

The Arts and Crafts Movement in America 1876-1916. Edited by Robert Judson Clark. Princeton, 1972.

Ernest Gimson. Leicester, 1969.

Ernest Gimson and the Cotswold Group of Craftsmen. Leicester, 1978.

George Howard and his Circle. Carlisle, 1968.

Marble Halls. London, 1973.

William Morris and the Art of the Book. New York, 1976.

Morris and Company. London, 1979.

Centenary of William Morris. London, 1934.

Morris & Co. Stanford, 1975.

The Morris Work Book, The Morris Essay Book. Stanford, 1975.

Morris & Company in Cambridge. Cambridge, 1980.

William Morris & Kelmscott. London, 1981.

Textiles by William Morris and Morris & Co. 1861-1940. Birmingham, 1981.

The Typographical Adventure of William Morris. London, 1957.

The Turn of the Century 1885-1910. Cambridge, Mass., 1970.

BIBLIOGRAPHY

ARTIFACTS

Objects by the craftsmen discussed can be found in many museums in Great Britain, and some in Europe and the United States. The most important collections are in London at the Victoria and Albert Museum and at the William Morris Gallery, Walthamstow.

INDEX

Library of Congress Cataloging in Publication Data

Stansky, Peter, 1932-
Redesigning the world.

Bibliography: p. Includes index.
1. Morris, William, 1834-1896—Influence. 2. Arts and crafts movement.
3. Design—England—History—19th century. 4. Decorative arts—
England—History—19th century. 5. Art and society—England—
History—19th century. I. Arts and Crafts Exhibition Society. II. Title.
NK1142.S7 1985 745'.0942 84-42558
ISBN 0-691-06616-7